Advertising Annual 2004 Graphis Mission Statement: *Graphis* is committed to presenting exceptional work in international design, advertising, illustration and photography. Since 1944, we have presented individuals and companies in the visual communications industry who have consistently demonstrated excellence and determination in overcoming economic, cultural and creative hurdles to produce true brilliance.

AdvertisingAnnual2004

CEO & Creative Director: B. Martin Pedersen

Editor: Michael Porciello

Art Director: Lauren Prigozen
Design & Production: Luis Diaz, Jennifer Kinon and Andrea Vélez
Design Interns: Sanaâ Akkach, Julian Jaramillo and Esteban Salgado

Photographer: Alfredo Parraga

Published by Graphis Inc.

This book is dedicated to
Roy Grace

(opposite) Magazine ad for Hewlett Packard by Goodby, Silverstein & Partners page 62-63 and (next page) 'Rosie the Riveter' beefed up for the Ad Council by BBDO New York, page 143.

Contents Inhalt Sommaire

Remarks: We extend our heartfelt thanks to contributors throughout the world who have made it possible to publish a wide and international spectrum of the best work in this field. Entry instructions for all Graphis Books may be requested from: **Graphis Inc.**, 307 Fifth Avenue, Tenth Floor, New York, New York 10016, or visit our Web site at www.graphis.com.

Anmerkungen: Unser Dank gilt den Einsendern aus aller Welt, die es uns ermöglicht haben, ein breites, internationales Spektrum der besten Arbeiten zu veröffentlichen. Teilnahmebedingungen für die Graphis-Bücher sind erhältlich bei: **Graphis Inc.**, 307 Fifth Avenue, Tenth Floor, New York, New York 10016. Besuchen Sie uns im World Wide Web, www.graphis.com.

Remerciements: Nous remercions les participants du monde entier qui ont rendu possible la publication de cet ouvrage offrant un panorama complet des meilleurs travaux. Les modalités d'inscription peuvent être obtenues auprès de: **Graphis Inc.**, 307 Fifth Avenue, Tenth Floor, New York, New York 10016. Rendez-nous visite sur notre site web: www.graphis.com.

Roy Grace
(December 5, 1936 - February 26, 2003)

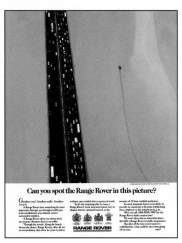

Can you spot the Range Rover in this picture?

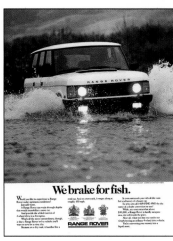

We brake for fish.

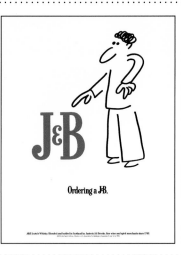

Ordering a J&B.

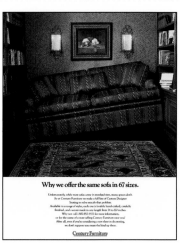

Why we offer the same sofa in 67 sizes.

Roy Grace was born December 5, 1936. He graduated from the High School of Art & Design in New York, and from Cooper Union. ■ He became a trustee of Cooper Union, as well as an Outstanding Alumnus, and a recipient of the St. Gauden's Award, the school's highest honor. Mr Grace was also on the board of the Smithsonian National Museum of American History. ■ What made Roy Grace unique among advertising art directors was his skill in strategic thinking, made all the more potent by the powerful executions that came to characterize his work. ■ Roy joined Doyle Dane Bernbach Advertising as an Art Director in 1964, and was responsible for much of the brilliant Volkswagen advertising during the '60s and '70s. He was also honored for his work on Alka Seltzer, American Tourister, IBM, and Mobil. By 1986 Mr. Grace had become Creative Director of DDB Worldwide as well as Chairman of DDB/NY. ■ In 1986, when agencies were merging, multiplying, growing bigger, and bigger still, Roy left DDB to open a small agency. Grace & Rothschild was highly creative, highly personalized, and offered advertising that was powerful enough to magnify media budgets, and inventive enough to create enduring awareness. The agency is best known for accounts such as J&B and the Mount Sinai Medical Center. G&R was also responsible for the U.S. introduction of the Range Rover, and the 14 years of Land Rover advertising that followed. ■ Among the hundreds of exceptional commercials created by Roy during his extraordinary career are the "Spicy Meatball/Mama Mia" commercial for Alka Seltzer, and the Volkswagen "Funeral" spot. These, and many, many others, have become more than merely excellent pieces of advertising—they have crossed over to become defining elements of the national culture, and images deeply embedded in the American psyche. ■ Twenty-five of Ad Age's "100 Best Commercials of all Time" are Roy Grace's. Four of the commercials in the permanent collection of New York's Museum of Modern Art are also his. ■ Over a hundred of his commercials are in the Museum of Television and Radio's permanent collection, and Roy Grace is in the Hall of Fame of both the Art Directors Club and the One Club. ■ In addition to all his professional accomplishments, it has to be said that Roy Grace was also a man of tremendous intellect, irresistible wit and uncompromising character. These aren't just words—he was a rare and marvelous man. ■ On February 26, 2003 Roy Grace died of Prostate Cancer at The Memorial Sloan Kettering Cancer Center in New York City. He is survived by a family that meant everything in the world to him—his wife, Marcia; his daughter, Jessica; and his son, Nicholas. ■ He will be profoundly missed by everyone who knew him, by everyone who loved him, and by everyone who values brilliance. *Diane Rothschild, partner, Grace and Rothschild*

A B C D E F
G H I J K L
M N O P Q
R S T U V
W X Y Z

J&B neat.

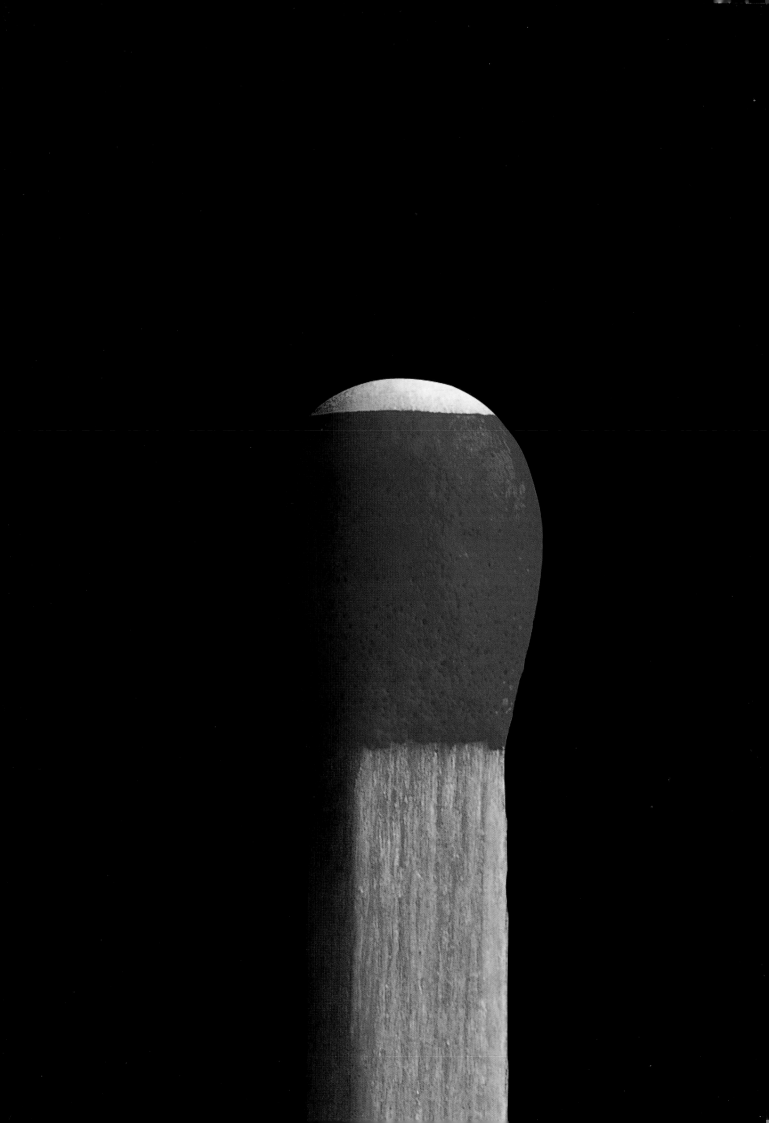

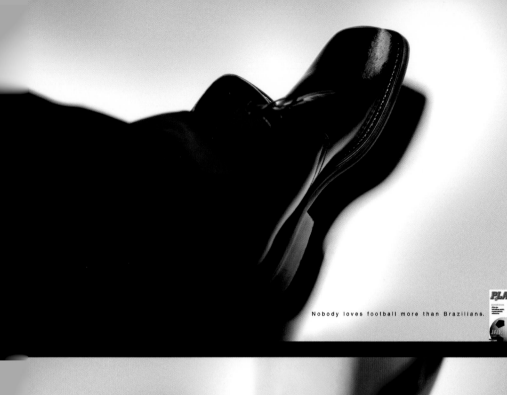

Nobody loves football more than Brazilians.

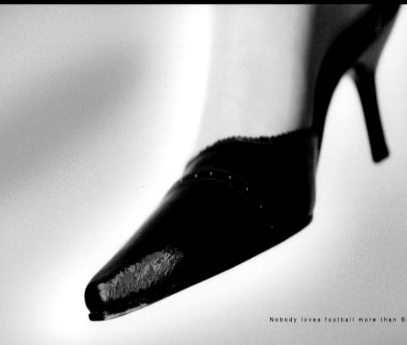

Nobody loves football more than Brazilians.

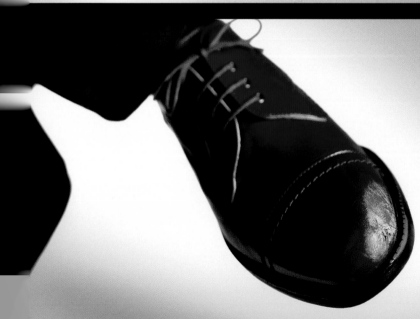

Nobody loves football more than Brazilians.

Q&A with Rita Corradi and J.R. D'Elboux, Young & Rubicam Brazil

Since September 2001, Rita Corradi and J.R. D'Elboux have shared Y&R's Creation Direction. They have been partners since her arrival at Y&R . ■ Rita has an undergraduate degree in Advertising from the Escola Superior de Propaganda e Marketing in São Paulo. She began working as a trainee at W/Brasil (Washington Olivetto's agency) in 1986. A year later, she was hired as a copywriter in a small but highly esteemed agency called Grad/Dammann. She worked there for 3 years with a Brazilian advertising legend: Hans Dammann. She got experience and also her first awards. Her goal was to learn from creation professionals that she had always admired, so Rita spent two years at DM9/DDB, four at DPZ and two years at Almap/BBDO, working with Nizan Guanaes, Murilo Felisberto and Marcello Serpa & Alexandre Gama, respectively. During all this period, she attended clients such as Volkswagen, Alpargatas, Apple Computers, Elma Chips, Kibon Ice Cream, Wella, Itaú Insurance, Rosset Fabrics, Estrela Toys, Microsoft, Fundação S.O.S. Mata Atlântica. ■ Due to a big interest in Visual Communications and Photography, which he developed while studying for his undergraduate degree in Architecture and Urbanism at the University of São Paulo, D'Elboux opted for a career as an Art Director at DPZ Propaganda in 1985. During the ten years at DPZ, he attended clients such as Banco Itaú, Souza Cruz, Sadia, J&J, Mobil, GM, Nestlé, Estrela, McDonald's and Heublein. In1990, he won his first award, the Professional of the Year Award from Rede Globo de TV, for a spot created for Gradiente.■ In 1995 Corradi and D'Elboux were both invited to join Y&R Brazil, where their clients have included, among others, Ford Motors, Gradiente Sound and TVs, Abril Publishing, Citibank, Colgate, Clorox, Danone, DuPont, Kraft Foods, Telefonica, Varig Airlines, AT&T, Banco Real, Bauducco Biscuits, Ceval Foods, Wyeth Whitehall, Brazilian Newspaper Association, Philip Morris, ANJ and Ericsson.

Cite an example of one of the best ads you've ever created; What makes it a good ad?

The Newspaper Campaign, "It makes you a much more interesting person," that was created for the National Newspaper Association. It's a good synthesis of the product's benefit.

Which ad or campaign (by someone else) do you most admire?

There are so many that it would be unfair to choose one.

Who was your past mentor/inspiration in advertising? Who do you most admire in your profession today?

Corradi: Hans Dammann, Nizan Guanaes, Muriolo Felisberto, Ruy Lindenberg. D'Elboux: Francesc Petit, Murilo Felisberto, Helga Miethke.

What inspires you?

Working with a product that we believe in and for a client that knows how to value this work.

How important is research/planning in creating great ads? How much should one rely on intuition and gut instinct?

Good planning is half the battle for a great idea. Research, when used with good sense, could bring interesting input to creation. As far as intuition and instincts, one should rely on both.

Do you consider advertising to be an art, a science—or both? (If both, does it lean more one way than the other?)

Art is art, science is science and advertising is advertising.

Is controversy a good thing for some advertisers? Is there any subject or source material that should be off-limits to advertisers?

Benetton used controversy as a strategy and it turned out to be a good thing for them, because they made the news with it. But a good idea is still better than the majority of controversial ones. If everyone decided to adopt controversy as a creative path, it would soon become so commonplace that it would not be controversial anymore. Nothing should be prohibited. But ethics and good sense should always prevail.

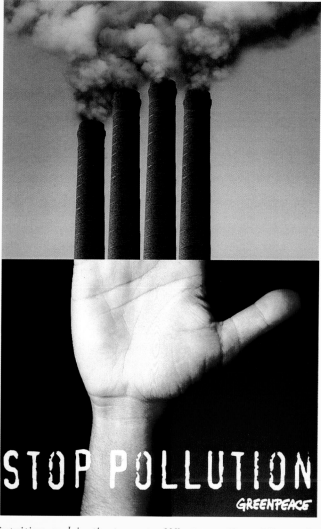

STOP POLLUTION
GREENPEACE

What is the most unusual form you've seen an ad take (i.e. sidewalk ads, etc.)? Do you think it was effective?

An ad made in Brazil for Nike where, on top of litter baskets in the street, a small sign with the Nike logo and the "Just do it" slogan simulating a basketball backboard and hoop. It was a simple and entertaining idea, and one which was doubly effective: it associated Nike with basketball/sports and, at the same time, it motivated people to throw litter into garbage cans.

Do you think advertising creators have a responsibility to the public?

Yes, of course. It's evident, obvious, elementary and without a shadow of a doubt. It's a shame that not all creative professionals (and announcers) remember this with the same fervor that they dedicate themselves to advertisement (and marketing).

If an ad is well-liked, by the public, and wins awards, yet the product does not sell as a result, what (if anything) can we conclude from that?

Campaign is good, product is bad.

What creative philosophy do you communicate to a student audience? a professional audience? a client?

The same thing for everybody: be creative.

Will advertising continue to merge & blend with entertainment content – and is that a good thing for the audience?

Yes. Because from the moment in which people don't ask to see advertisements, the minimum that an ad should do is entertain them, amuse them and not be an intrusive and undesirable bore, which insults their intelligence.

What will spark the next "Creative Revolution" in advertising?

Intelligence will always revolutionize.

(opposite page) Ad Campaign for Placar magazine (above) 'Stop Pollution' public service ad for Greenpeace (next page left) 'For Strong Headaches Advil' campaign for Whitehall (next page right) 'Keep off the Grass' campaign for Arno Lawnmowers (all) by Young & Rubicam Brazil

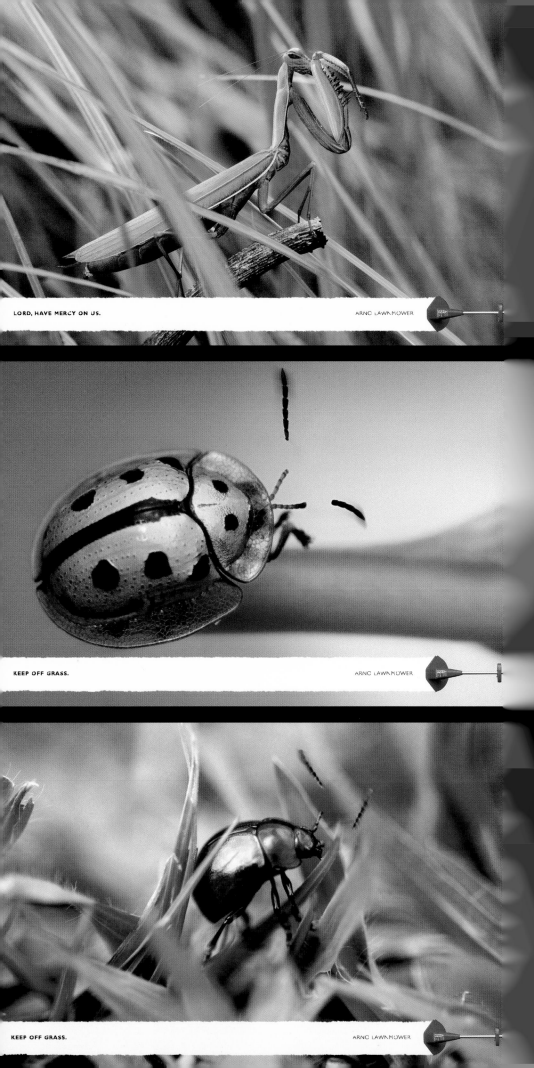

LORD, HAVE MERCY ON US.

ARNO LAWNMOWER

KEEP OFF GRASS.

ARNO LAWNMOWER

KEEP OFF GRASS.

ARNO LAWNMOWER

Q&A with Alex Bugosky, Crispin, Porter & Bogusky

In 1987, Alex started at Crispin & Porter as an Art Director. At the time, he was 24. Five years later, Alex was promoted to Creative Director. Back then, CP&B was a hot local shop doing a lot of interesting local work. Today, we have offices in Miami and Los Angeles and clients from coast to coast. In the last few years, CP&B's client list has grown to include the BMW MINI line of automobiles, IKEA, Sirius Satellite Radio, Molson Beer, AOL, Moviefone and the "Truth" anti-tobacco campaign which is considered by experts to be the most effective social marketing effort in history. ■ Under Alex's creative direction, the agency has won over four hundred creative awards including One Show, Communication Arts and Cannes Lions and been named one of the fifteen best creative agencies in the United States by the American Association of Advertising Agencies by being nominated for the John O'Toole Award for ten of the past thirteen years. In the past four years, the agency has been named Adweek's "Agency of the Year" for the Southeast three times. In 2001 and 2003, CP&B was named Advertising Age's Creativity Magazine "Agency of the Year". He has been profiled in Luerzer's Archive, Communication Arts, Graphis, Adweek and Creativity. His work has been featured in The New York Times, The Wall Street Journal, USA Today, Newsweek, TIME, Adweek, Brandweek, Advertising Age and Creativity as well as on national television and radio. In 2002, Alex was inducted into the American Advertising Federation's Hall of Achievement.

Cite an example of one of the best ads you've ever created; What makes it a good ad?

It's very difficult for me to think of any one ad I could think enough of to nominate it as one of the "best." I think more in terms of campaigns designed to solve problems by changing behavior. Advertising can do this. There are plenty of cynics that say advertising has no effect. Some of the problems we have as an industry are because a lot of the cynics actually work in advertising doing the very work they are so cynical of. An ad isn't a joke. It might be funny, and often the best are. It might make you cry. But to me it's not really good unless it changes the way you think or act.

Which single ad or ad campaign done by someone else do you most admire?

I admire a lot of what I see. Too many things to list. Sometimes it's a big national campaign but very often it's the stuff that comes from small, struggling companies that still haven't lost their bravado.

Who was your past mentor/inspiration in advertising?

My mentors have been my father and Chuck Porter. Inspiration has come from my wife and Lee Clow.

Who do you most admire in your profession today?

I admire the clients that have the courage to do what they believe in. No testing. Just intelligence and a bit of gut. We have a few. There aren't more than a couple of handfuls left, though.

What inspires you?

Boredom.

How important is research/planning in creating great ads?

Research and planning are hugely important. They're the raw materials you need to make the work. The more smart people working on a campaign the better. The chances of creating something brilliant can only go up as you add knowledge as long as it's true. But testing advertising after it's been created is at best a waste of money.

How much should one rely on intuition and gut instinct?

Gut instinct gets a bad wrap in our society. It's also known as Emotional Intelligence. And it is usually a better indicator of personal success than IQ. So should we pay attention to it? I would strongly encourage it.

Do you consider advertising to be an art, a science–or both? (If both, does it lean more one way than the other?)

Unfortunately, it's usually neither one. But at it's best it's art. Highly funded art with a mission to move the masses. And the money behind it makes it very powerful. But calling advertising "art" doesn't make it art any more than just calling a painting "art" makes it art. Sometimes a painting is just a painting. And usually an ad is just an ad. Which work transcends and which is just an ad we can guess at but it will probably take a hundred years of perspective to figure out.

Is controversy a good thing for some advertisers?

Yes. And most are too afraid of it.

Is there any subject or source material that should be off-limits to advertisers?

Sure, but I dislike, and hate rules.

What is the most unusual form you,ve seen an ad take (i.e. sidewalk ads, etc.)? Do you think it was effective?

I hate to mention our own work. I've avoided it here pretty well until now and I hope people will excuse it, but we did something with our client at MINI that I really love. As a form of out-of-home we bought the cover of the Weekly World News, and created a series of articles about a MINI that is stolen by Bat Boy (a WWN character who is a half bat and a half boy). It's hard to measure but it created some buzz in the press and a lot of commotion on the independent MINI message boards we monitor.

Do you think advertising creators have a responsibility to the public?

Of course. What we do works. We should each decide if what we're advertising is something we believe in. And then when we're creating the advertising we should remember the world will be either a little worse or a little better with that advertising in it. Why not shoot for the later?

If an ad is well-liked by the public and wins awards, yet the product does not sell as a result, what (if anything) can we conclude from that?

The ad or the product wasn't right.

What creative philosophy do you communicate to a student audience? a professional audience? a client?

It's the same for all three:
Find all the lies and falsehoods that stand in the way of you having a real conversation with the consumer. Then set out to remove them.

Will advertising continue to merge & blend with entertainment content, and is that a good thing for the audience?

It probably will and it's a shame. Product placement is in most cases a fairly lame form of advertising. And in a lot of cases it's making entertainment worse too, as they struggle to force fit anything with a big number attached. All while normally rational marketers, wooed by the Hollywood glamour make decisions about their brand associations they would never make under normal circumstances. It's a real lose-lose opportunity.

The Mini Cooper, photographed by Mark Laita (red and yellow) and Daniel Hartz (blue) for ads by Crispin, Porter and Bogusky. See pages 16-19 for full ads.

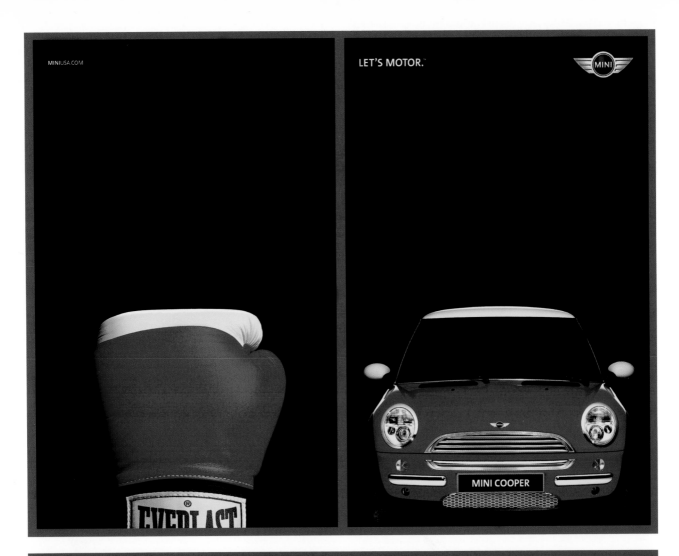

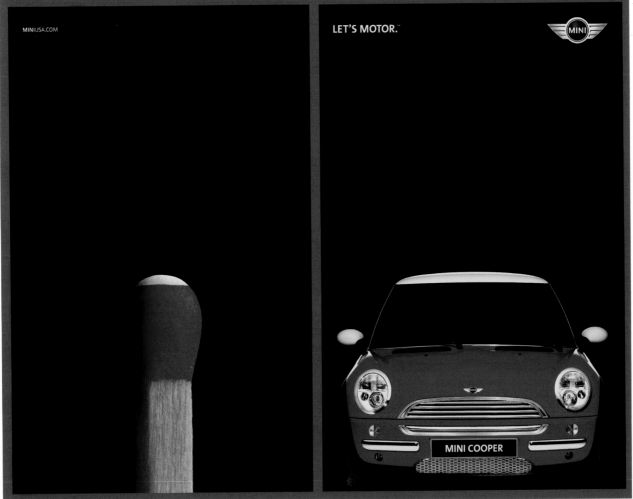

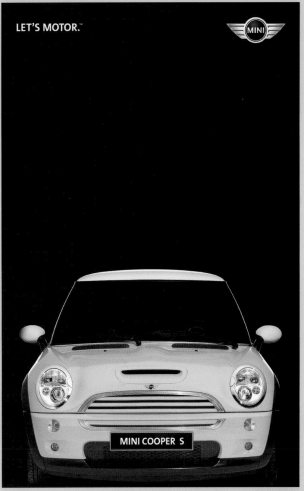

LET'S MOTOR.™

MINI COOPER S

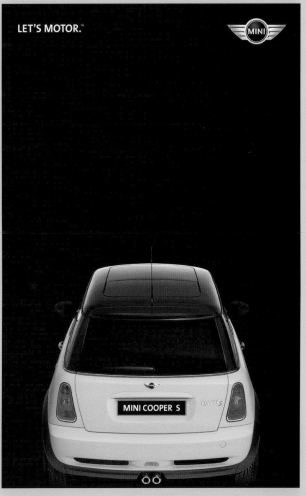

LET'S MOTOR.™

MINI COOPER S

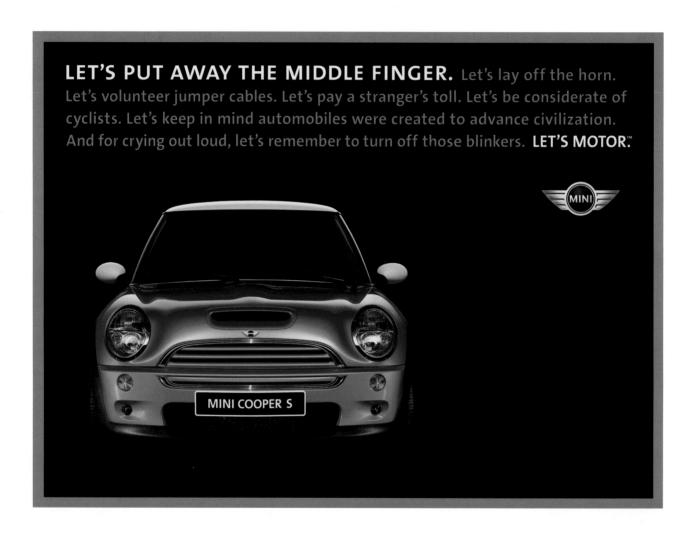

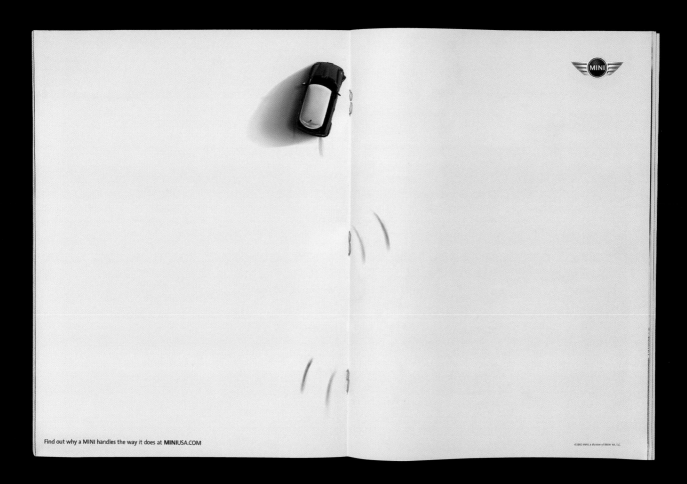

Find out why a MINI handles the way it does at MINIUSA.COM

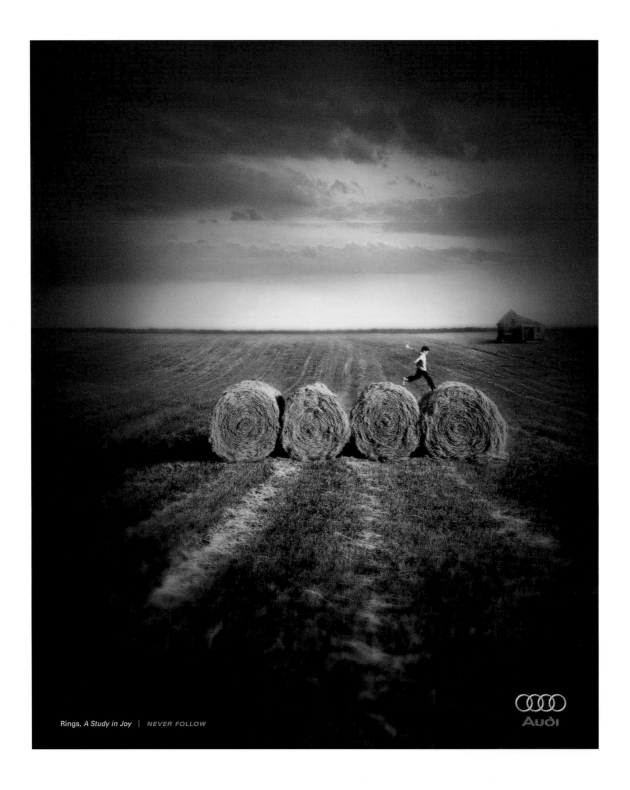

Rings, *A Study in Joy* | *NEVER FOLLOW*

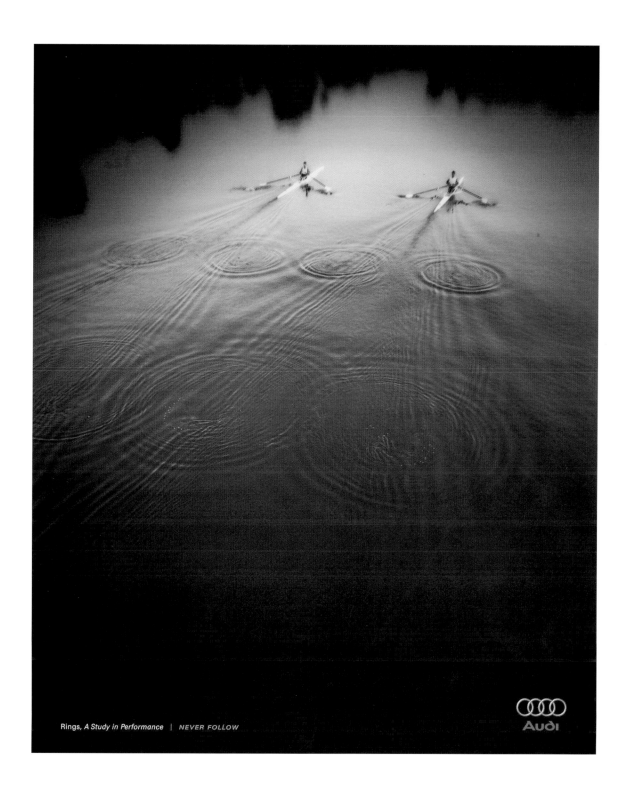

Rings, *A Study in Performance* | *NEVER FOLLOW*

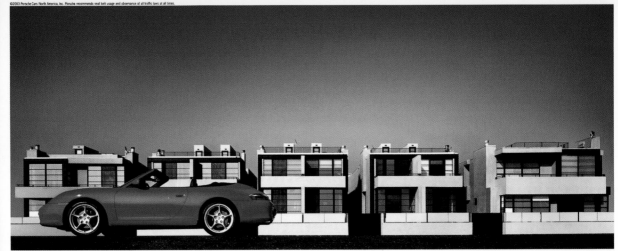

The pressure to compromise. The 911 Carrera Cabriolet is what results from never once yielding
to it. The pure shape. The way the sounds and sensations of the drive resonate in the open cockpit.
It wasn't, isn't, and never will be for everyone. Contact us at 1-800-PORSCHE or porsche.com.

**The demands of the mass market
have been noted and ignored.**

PORSCHE

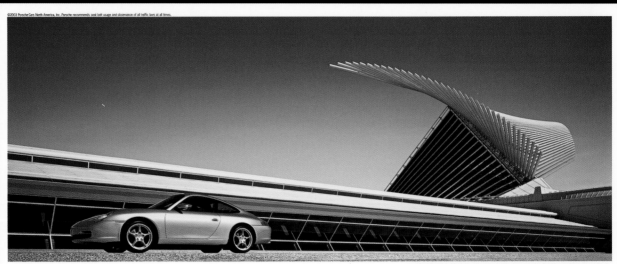

Consider this bold collaboration. You and the incomparable 911 Carrera. Wrap yourself in the
driver's seat, feel the surge of the hand-assembled, rear-mounted 320-hp engine, and every twist
and bend of the road becomes pure artistry. Contact us at 1-800-PORSCHE or porsche.com.

Art not imitating anything.

PORSCHE

(this spread) Agency: Carmichael Lynch Creative Director: Jud Smith Art Directors: Hans Hansen and Jeff Terwilliger Photographer: Georg Fischer Copywriters: Eric Sorensen and Sheldon Clay Client: Porsche Cars North America

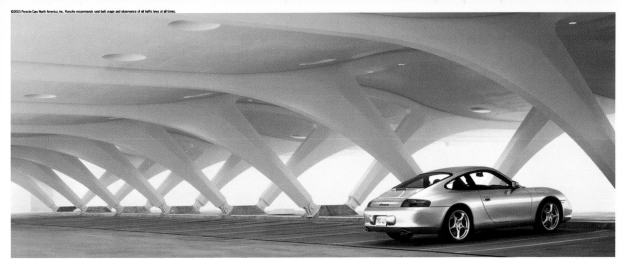

Maybe it's the way the flawless shape works on a pair of eyes. Or the time it takes the blood in your veins to cool after a drive. This much is certain. Once experienced, the 911 Carrera will never let you go. Contact us at 1-800-PORSCHE or porsche.com.

Is it humanly possible to walk away without looking back?

PORSCHE

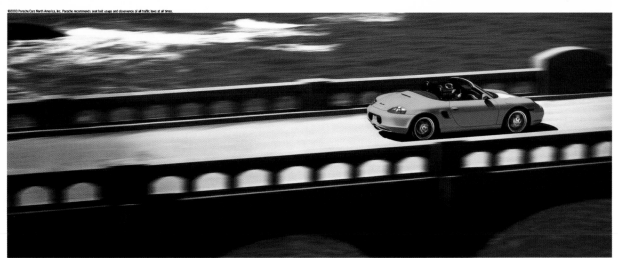

Places you've always wanted to go. Things you've always meant to do. It's never too late to make it right. The new Boxster. An elegantly re-sculpted exterior. A meatier 225-hp boxer engine. A more adventurous existence starts at $42,600. Contact us at 1-800-PORSCHE or porsche.com.

What's the story of your life, starting now?

PORSCHE

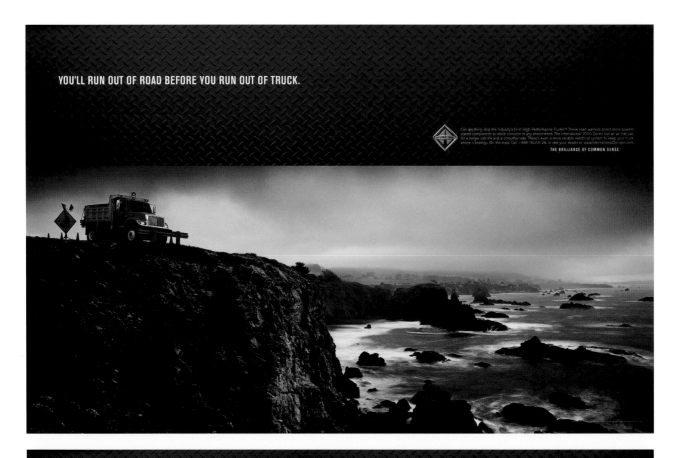

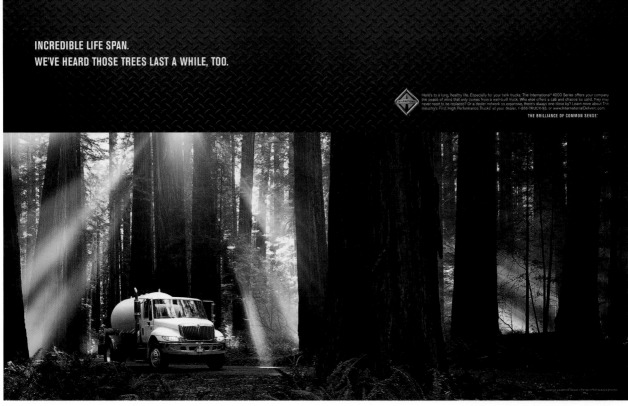

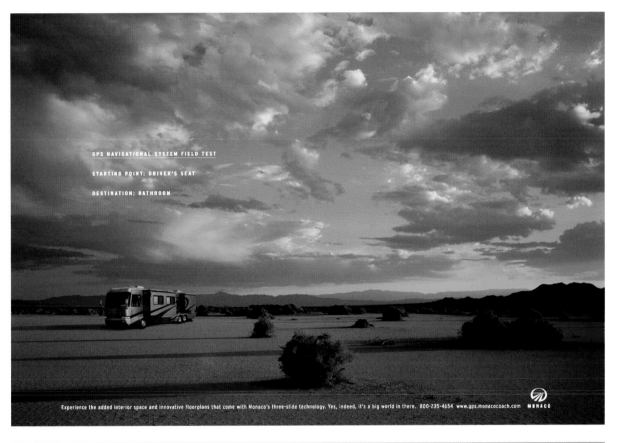

GPS NAVIGATIONAL SYSTEM FIELD TEST

STARTING POINT: DRIVER'S SEAT

DESTINATION: BATHROOM

Experience the added interior space and innovative floorplans that come with Monaco's three-slide technology. Yes, indeed, it's a big world in there. 800-235-4654 www.gps.monacocoach.com MONACO

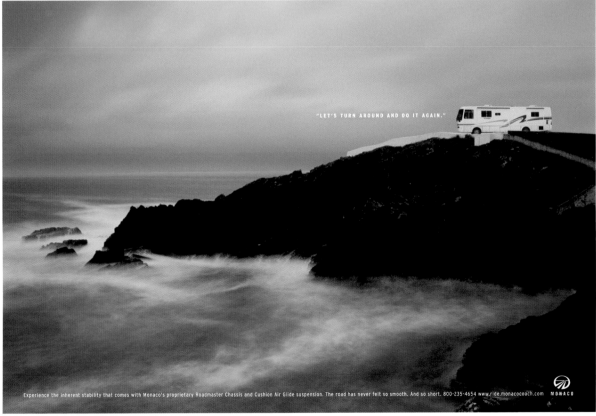

"LET'S TURN AROUND AND DO IT AGAIN."

Experience the inherent stability that comes with Monaco's proprietary Roadmaster Chassis and Cushion Air Glide suspension. The road has never felt so smooth. And so short. 800-235-4654 www.ride.monacocoach.com MONACO

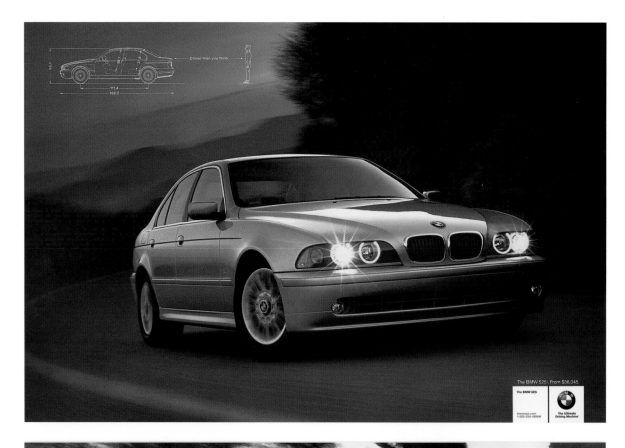

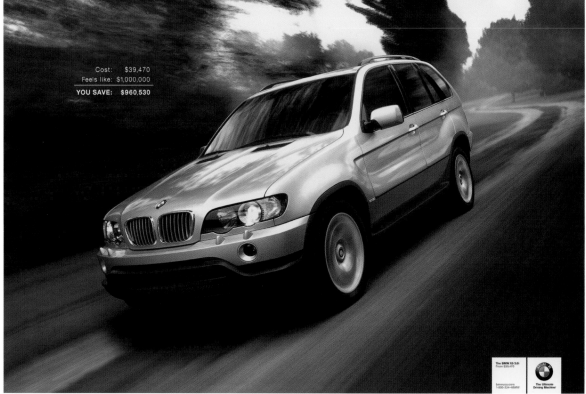

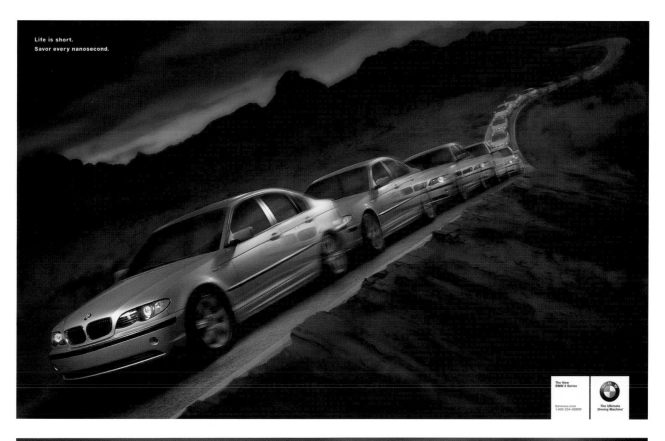

Life is short.
Savor every nanosecond.

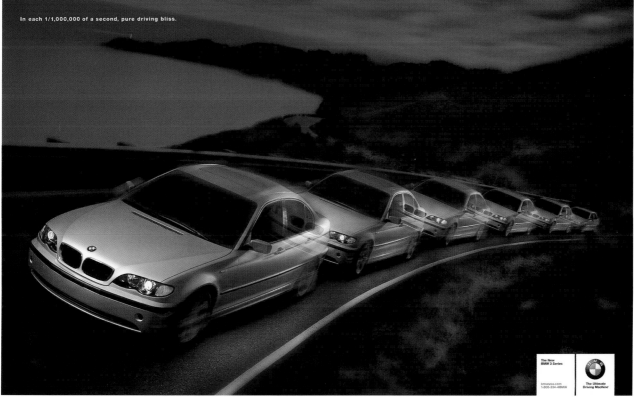

In each 1/1,000,000 of a second, pure driving bliss.

(top) Agency: Fallon Creative Director: Bruce Bildsten Art Director: Scott O'Leary Copywriter: Mike Gibbs Client: BMW of North America
(bottom) Agency: Fallon Creative Director: Scott O'Leary Art Director: Bruce Bildsten Copywriter: Mike Gibbs Client: BMW of North America

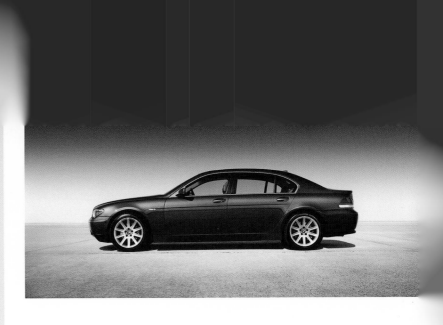

The best road trips are never planned.

The broadest grins emerge from the narrowest corners.

And old, forgotten roads can create the fondest memories.

In this car, you appreciate everything.

The New 7. A new perspective on driving.

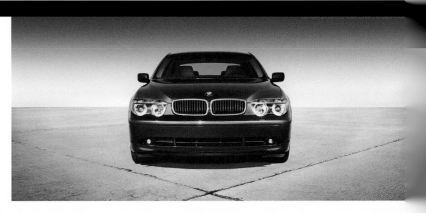

An elevated on-ramp can be sculpture.

Odd-numbered highways tend to have more curves.

At the right speed, your heartbeat will match the seams in the road.

In this car, you notice everything.

The New 7. A new perspective on driving.

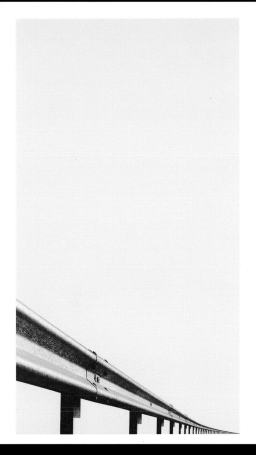

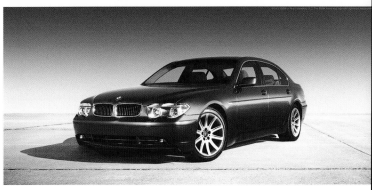

On warm days, tire and road are the closest of friends.

Turns are more than a change of direction.

And guard rails, the crowd that cheers you on.

In this car, you experience everything.

The New 7. A new perspective on driving.

The New
BMW 7 Series

bmwusa.com
1-800-334-4BMW

The Ultimate
Driving Machine®

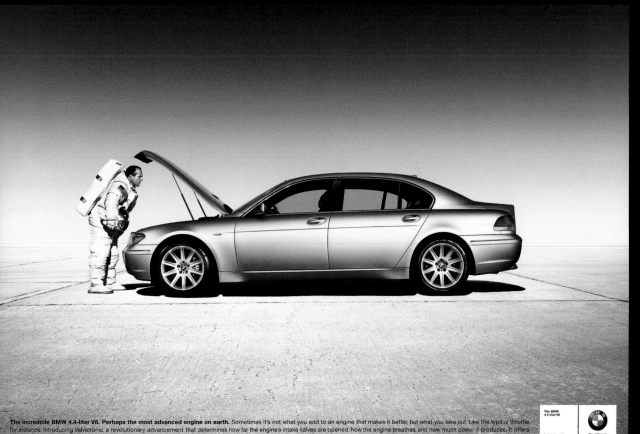

The incredible BMW 4.4-liter V8. Perhaps the most advanced engine on earth. Sometimes it's not what you add to an engine that makes it better, but what you take out. Like the typical throttle, for instance. Introducing Valvetronic, a revolutionary advancement that determines how far the engine's intake valves are opened, how the engine breathes, and how much power it produces. It offers dramatic improvements in all the areas that really matter: power, responsiveness, and efficiency. The 4.4-liter, 325-hp V8 from BMW. Possibly the best V8 in the universe. Or at least on this planet.

The BMW
4.4-liter V8

bmwusa.com
1-800-334-4BMW

The Ultimate
Driving Machine®

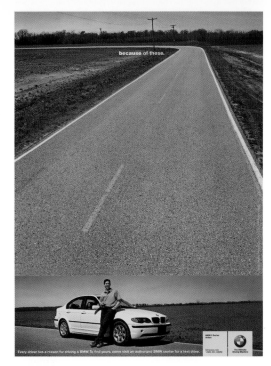

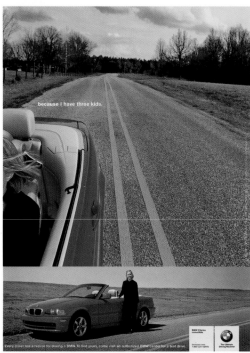

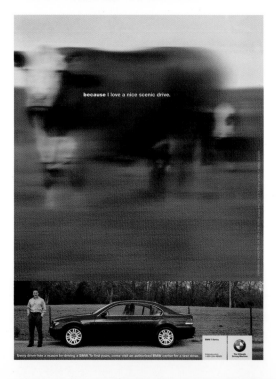

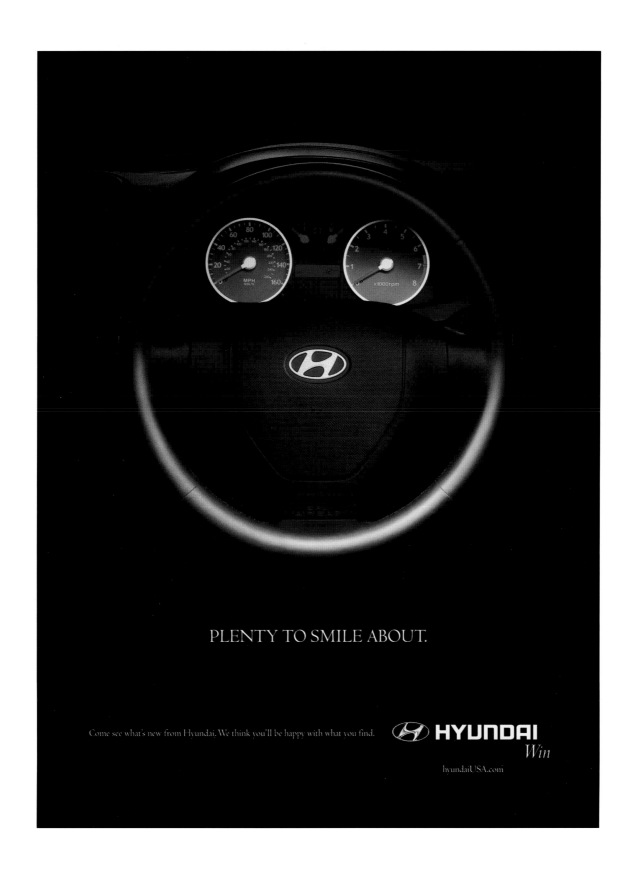

PLENTY TO SMILE ABOUT.

Come see what's new from Hyundai. We think you'll be happy with what you find.

HYUNDAI
Win

hyundaiUSA.com

Thunderbird

Thunderbird

2003 Arizona International Auto Show - January 1-5, at the Phoenix Civic Plaza

See what's new for Ford in 2003. Like the cherry Thunderbird and the all new Forty-Nine concept car.

arizona ford dealers

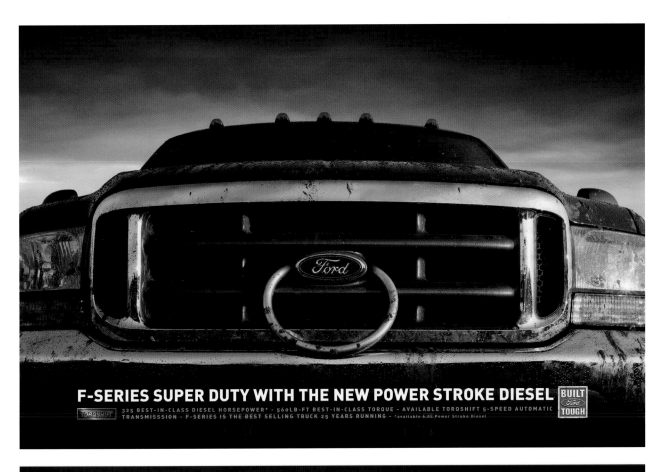

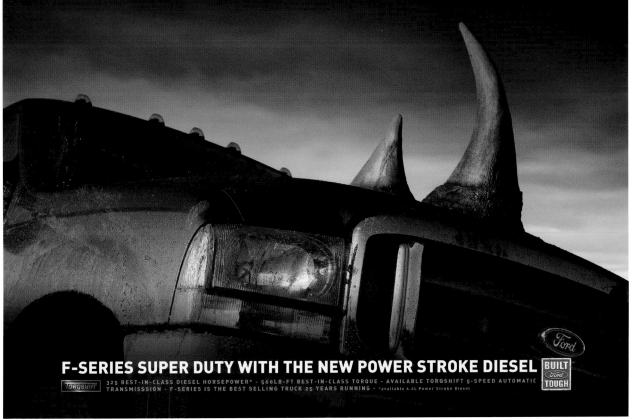

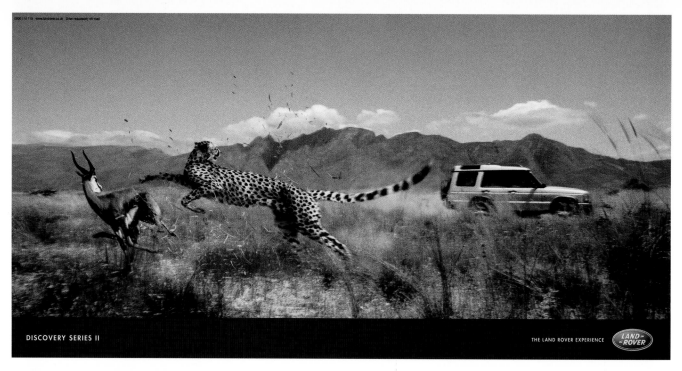

DISCOVERY SERIES II

THE LAND ROVER EXPERIENCE

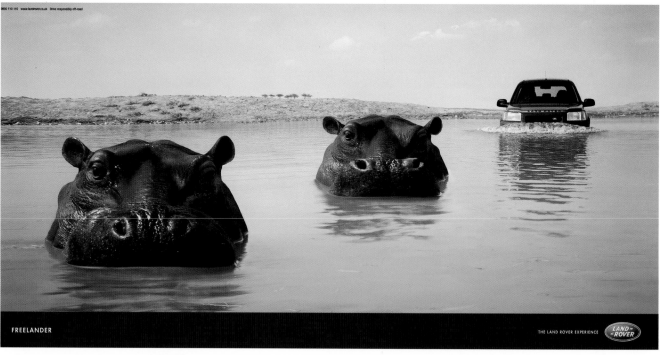

FREELANDER

THE LAND ROVER EXPERIENCE

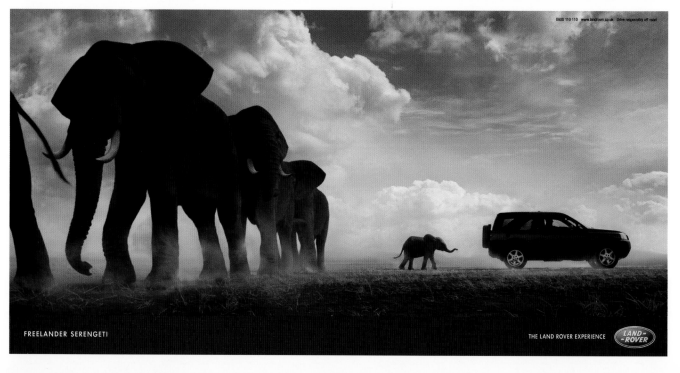

FREELANDER SERENGETI

THE LAND ROVER EXPERIENCE

Agency: Rainey Kelly Campbell Roalfe/Y&R Creative Director: Jerry Hollens Art Director: Mike Bowles Photographer: Nick Georghiou Client: Land Rover

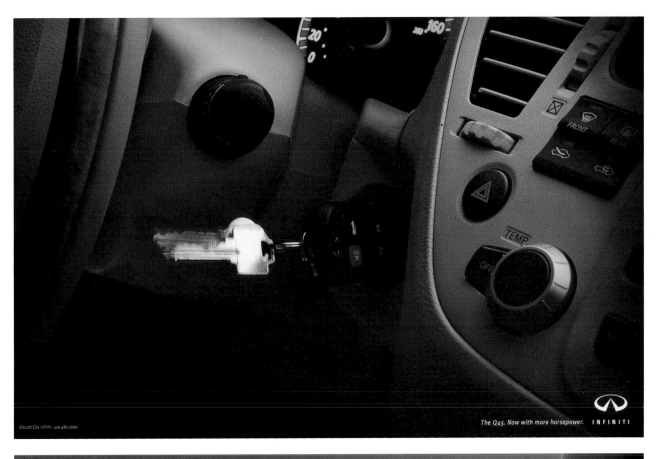

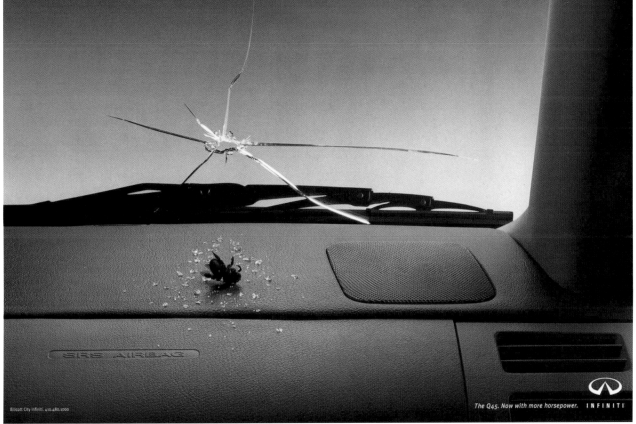

Agency: Sawyer Riley Compton Creative Director: Bart Cleveland Art Director: Laura Hauseman Photographer: Parrish Kohanim Copywriter: Al Jackson Client: Ellicott City Infiniti

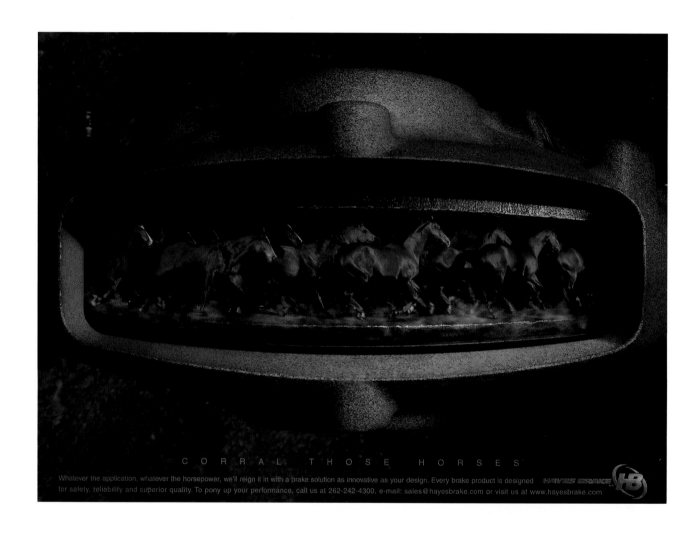

CORRAL THOSE HORSES

Whatever the application, whatever the horsepower, we'll reign it in with a brake solution as innovative as your design. Every brake product is designed for safety, reliability and superior quality. To pony up your performance, call us at 262-242-4300, e-mail: sales@hayesbrake.com or visit us at www.hayesbrake.com

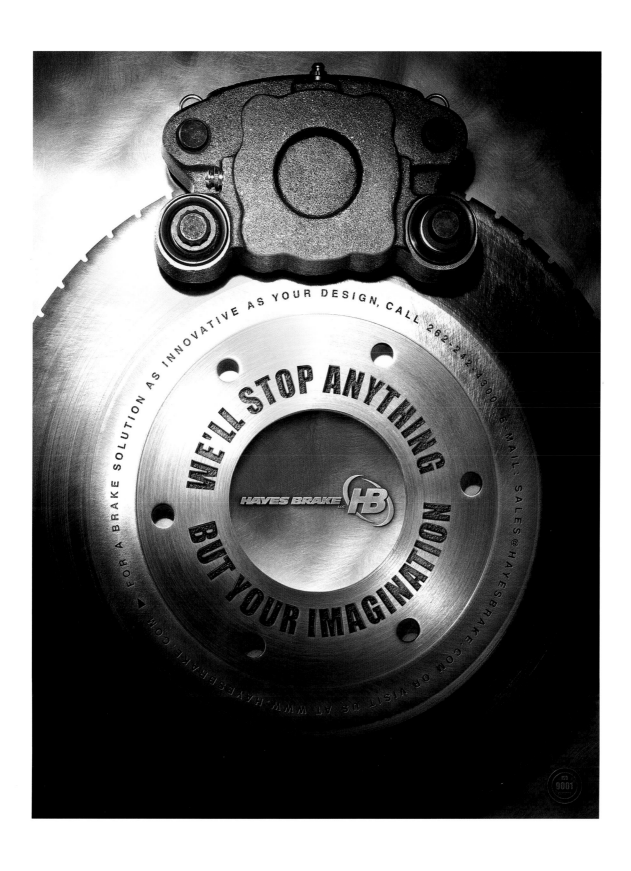

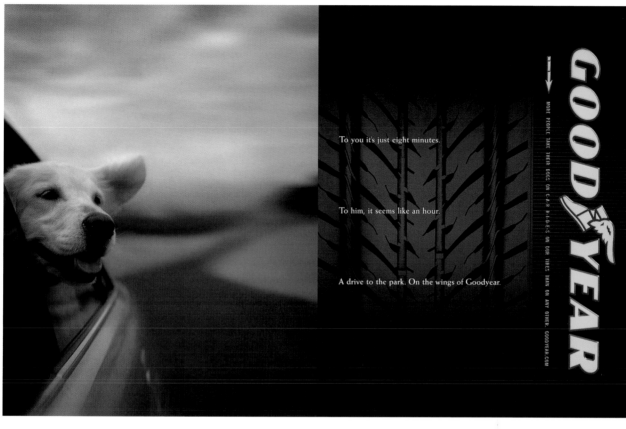

To you it's just eight minutes.

To him, it seems like an hour.

A drive to the park. On the wings of Goodyear.

GOODYEAR

MORE PEOPLE TAKE THEIR DOGS ON C.A.R. R.I.D.E.S ON OUR TIRES THAN ON ANY OTHER. GOODYEAR.COM

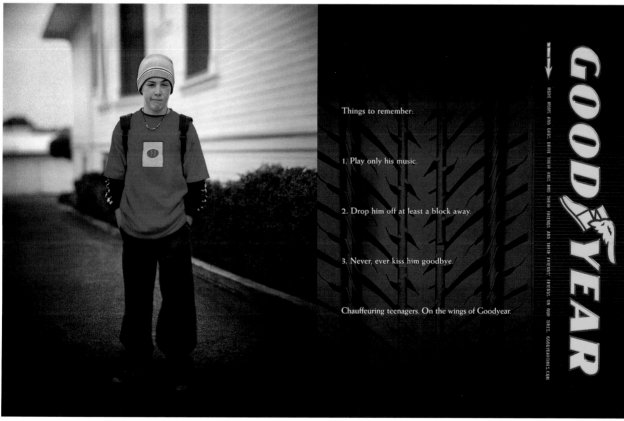

Things to remember:

1. Play only his music.

2. Drop him off at least a block away.

3. Never, ever kiss him goodbye.

Chauffeuring teenagers. On the wings of Goodyear.

GOODYEAR

MORE MOMS AND DADS DRIVE THEIR KIDS AND THEIR FRIENDS' FRIENDS ON OUR TIRES. GOODYEARTIRES.COM

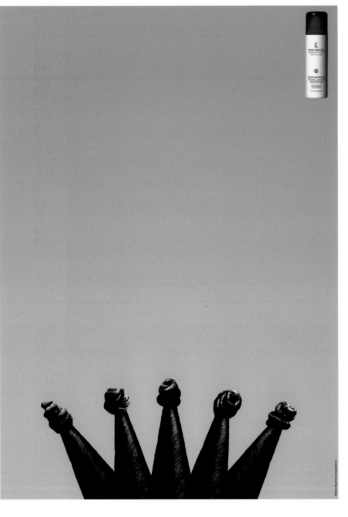

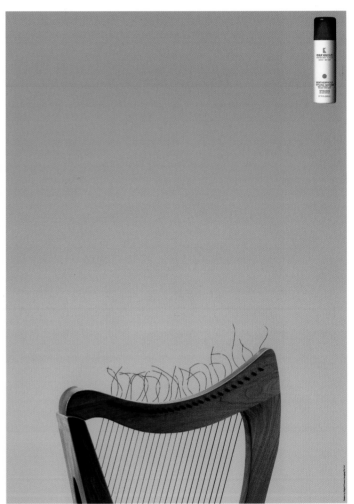

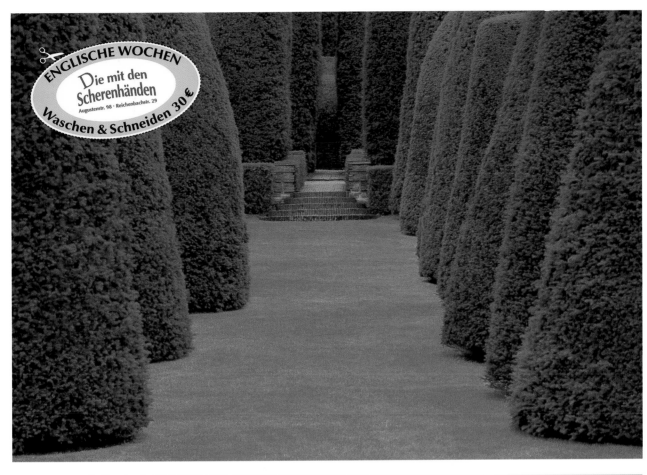

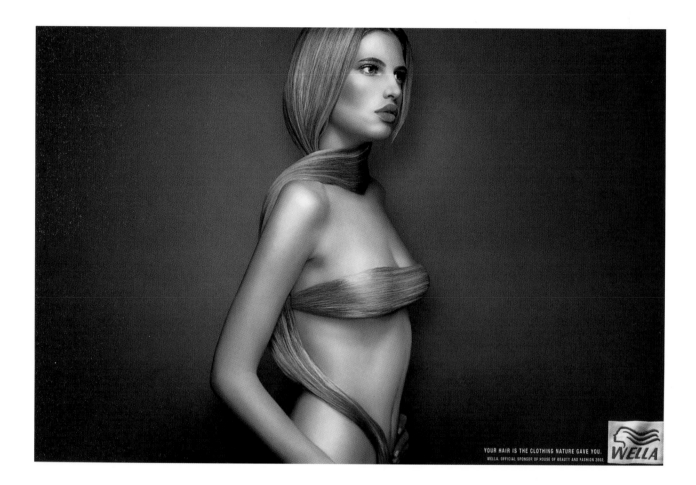

YOUR HAIR IS THE CLOTHING NATURE GAVE YOU.
WELLA. OFFICIAL SPONSOR OF HOUSE OF BEAUTY AND FASHION 2002.

WELLA

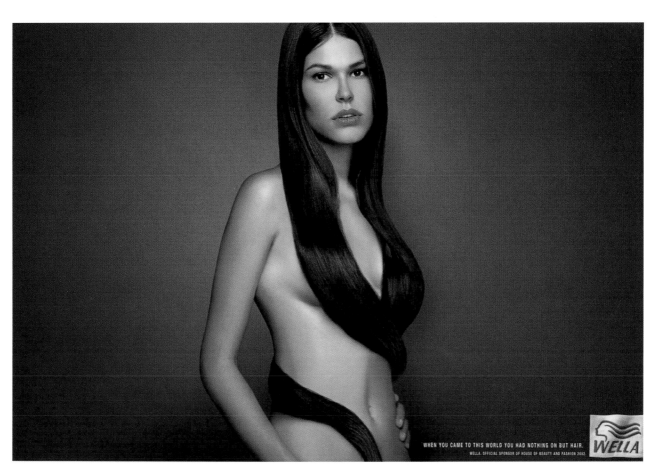

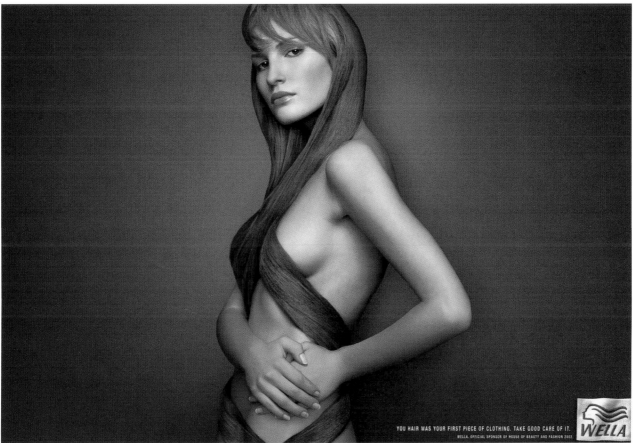

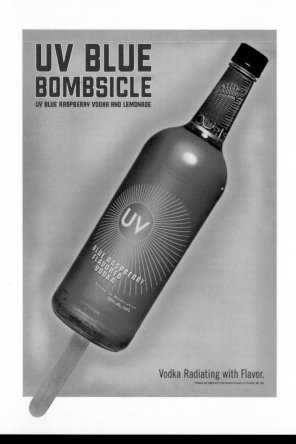

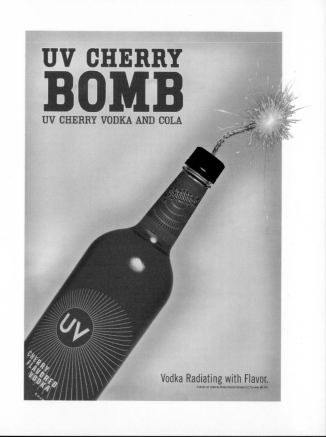

UV CARAMEL
APPLE MARTINI
UV SOUR APPLE VODKA AND BUTTERSCOTCH SCHNAPPS

Vodka Radiating with Flavor.

Produced and bottled by Phillips Products Company LLC, Princeton, MN, USA

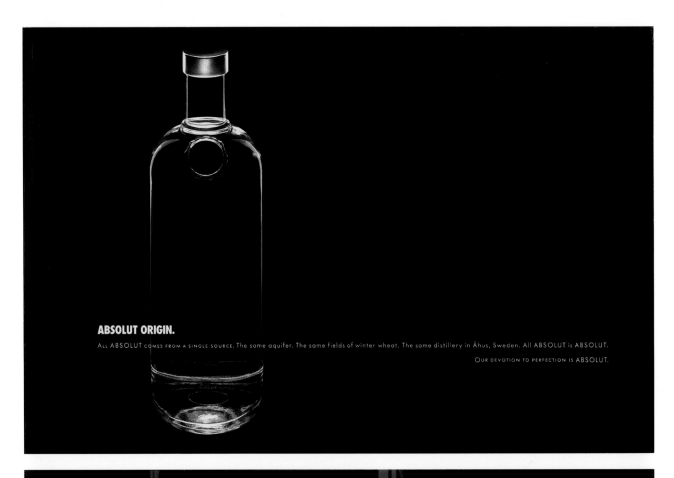

ABSOLUT ORIGIN.

ALL ABSOLUT COMES FROM A SINGLE SOURCE. The same aquifer. The same fields of winter wheat. The same distillery in Åhus, Sweden. All ABSOLUT is ABSOLUT.

OUR DEVOTION TO PERFECTION IS ABSOLUT.

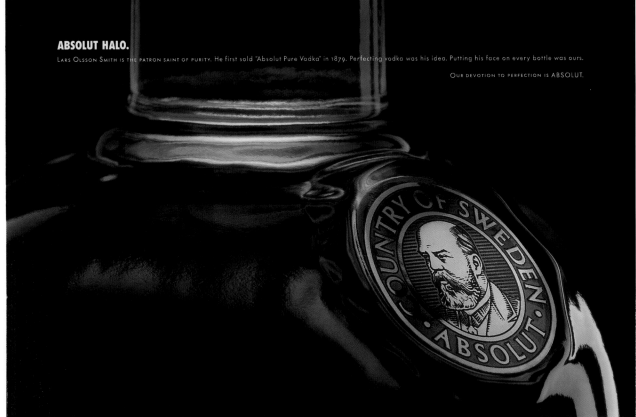

ABSOLUT HALO.

LARS OLSSON SMITH IS THE PATRON SAINT OF PURITY. He first sold "Absolut Pure Vodka" in 1879. Perfecting vodka was his idea. Putting his face on every bottle was ours.

OUR DEVOTION TO PERFECTION IS ABSOLUT.

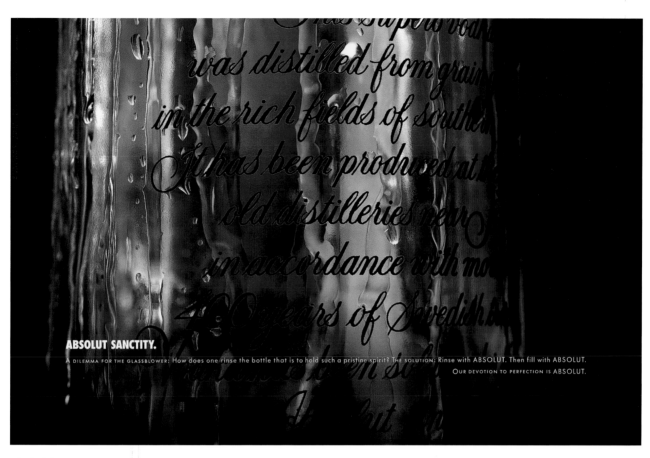

ABSOLUT SANCTITY.
A DILEMMA FOR THE GLASSBLOWER: How does one rinse the bottle that is to hold such a pristine spirit? THE SOLUTION: Rinse with ABSOLUT. Then fill with ABSOLUT.
OUR DEVOTION TO PERFECTION IS ABSOLUT.

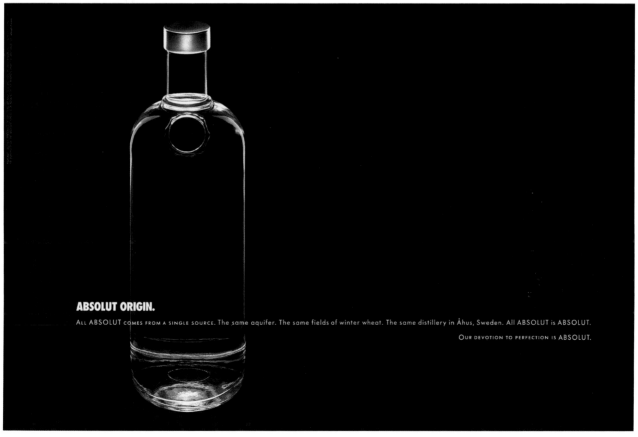

ABSOLUT ORIGIN.
ALL ABSOLUT COMES FROM A SINGLE SOURCE. The same aquifer. The same fields of winter wheat. The same distillery in Åhus, Sweden. All ABSOLUT is ABSOLUT.
OUR DEVOTION TO PERFECTION IS ABSOLUT.

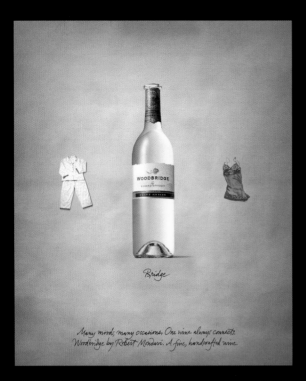

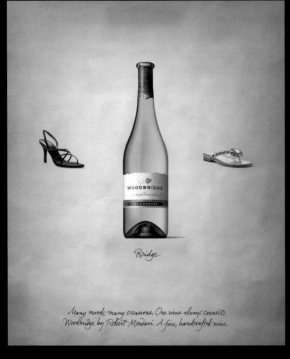

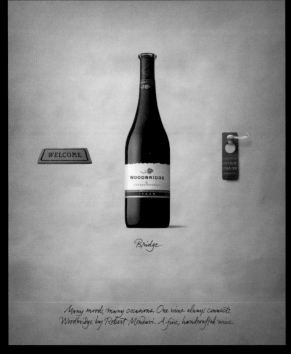

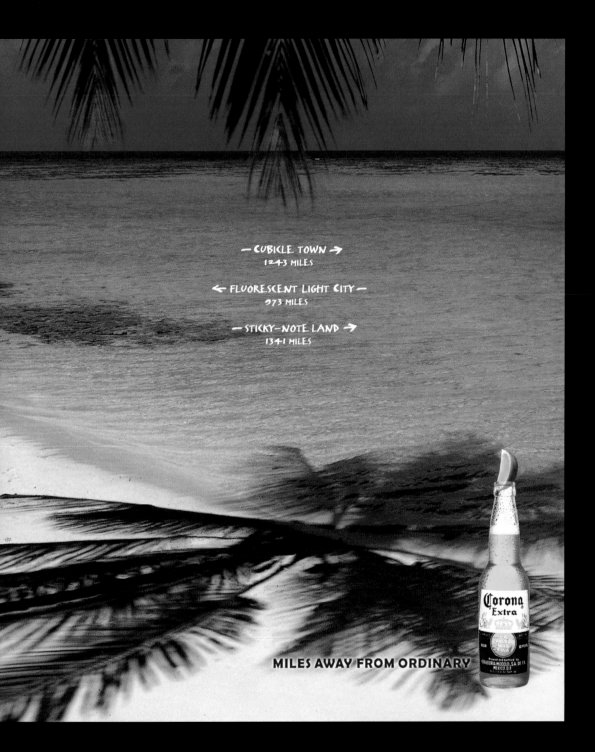

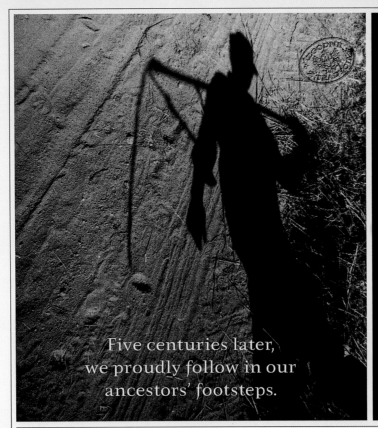

Five centuries later,
we proudly follow in our
ancestors' footsteps.

Handcrafted using traditions over 500 years old, Belvedere is made
from 100% Polish rye and distilled 4 times for a creamy smoothness.

IMPORTED BY MILLENNIUM® IMPORT COMPANY LLC, MINNEAPOLIS, MINNESOTA U.S.A.
100% neutral spirits distilled from rye grain 40% ALC./VOL. (80 Proof) ©2002 Millennium® Import Company LLC

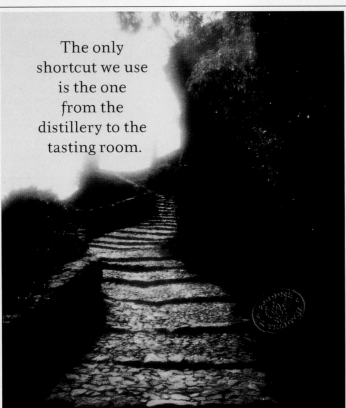

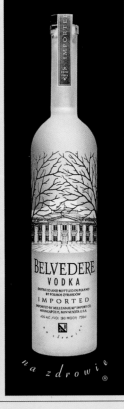

The only
shortcut we use
is the one
from the
distillery to the
tasting room.

Handcrafted using traditions over 500 years old, Belvedere is made
from 100% Polish rye and distilled 4 times for a creamy smoothness.

IMPORTED BY MILLENNIUM® IMPORT COMPANY LLC, MINNEAPOLIS, MINNESOTA U.S.A.
100% neutral spirits distilled from rye grain 40% ALC./VOL. (80 Proof) ©2002 Millennium® Import Company LLC

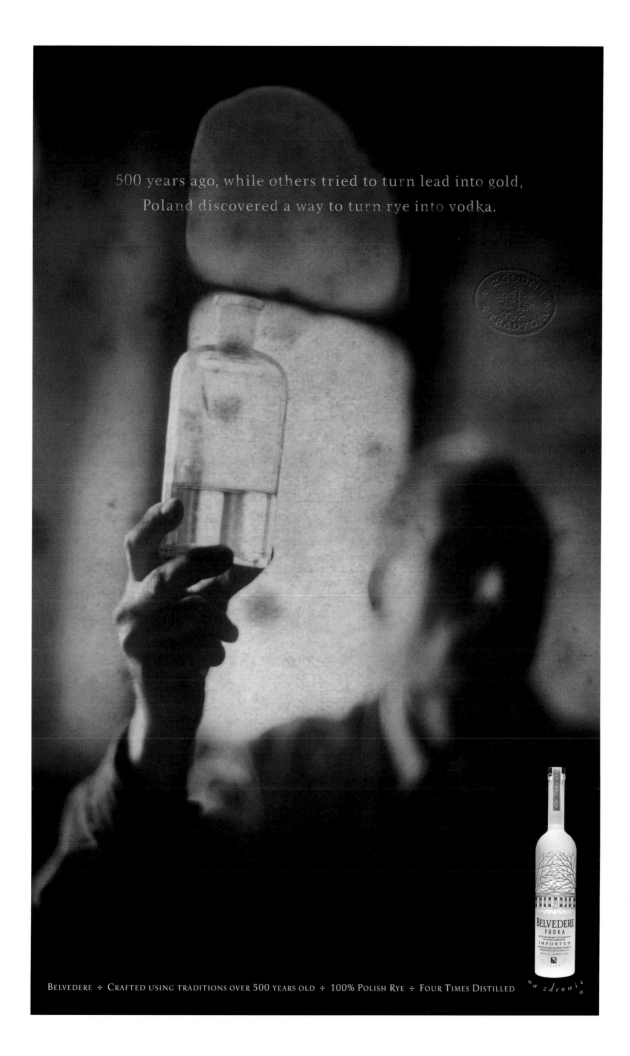

500 years ago, while others tried to turn lead into gold,
Poland discovered a way to turn rye into vodka.

BELVEDERE ✜ CRAFTED USING TRADITIONS OVER 500 YEARS OLD ✜ 100% POLISH RYE ✜ FOUR TIMES DISTILLED

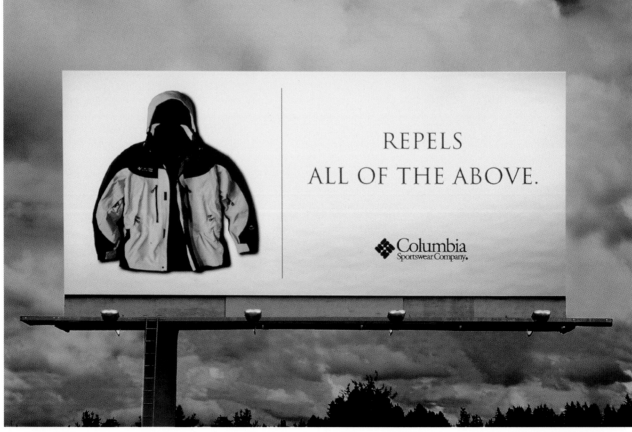

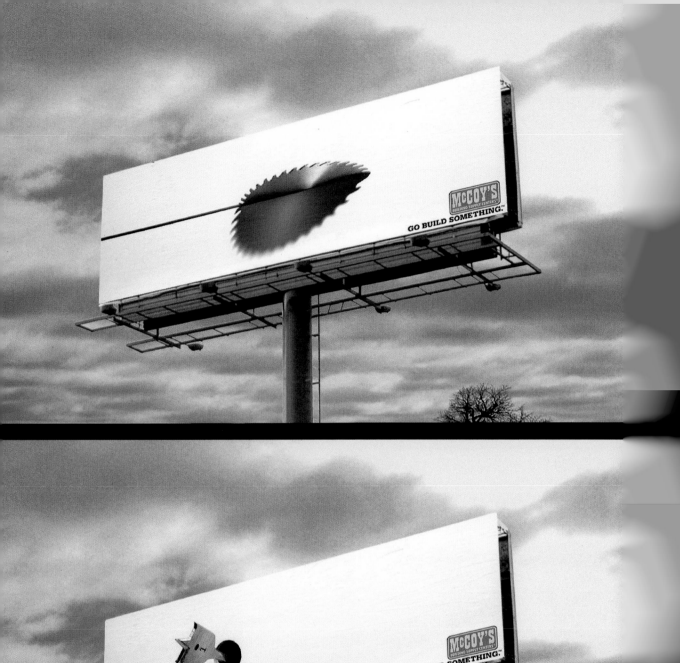
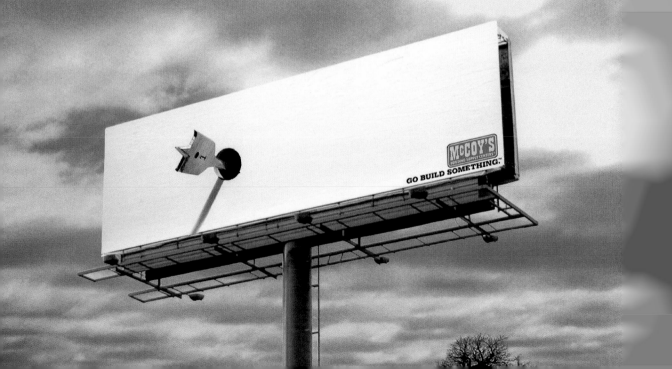

THE GUY AT THE PHOTO LAB

MAY SUDDENLY START VACATIONING THE SAME PLACES YOU DO.

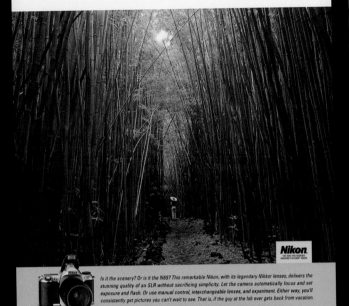

Is it the scenery? Or is it the N65? This remarkable Nikon, with its legendary Nikkor lenses, delivers the stunning quality of an SLR without sacrificing simplicity. Let the camera automatically focus and set exposure and flash. Or use manual control, interchangeable lenses, and experiment. Either way, you'll consistently get pictures you can't wait to see. That is, if the guy at the lab ever gets back from vacation.

Nikon

FOR PHOTOGRAPHERS

WHO ONLY WANT THE SMILE ON THE LEFT

TO BE IN FOCUS.

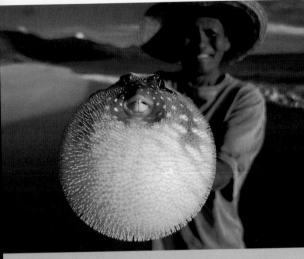

To make unique subjects stand out even more, turn your attention to the N80.™ It's so advanced, it lets you control nearly every aspect of your shot. Five-Area Autofocus puts the sharpness right where you want it. On-Demand Gridlines help you compose shots quickly and effectively. Depth-of-Field Preview lets you see overall picture sharpness. And the N80 is compatible with the full line of Autofocus Nikkor® lenses, including the AF-Nikkor 18-35mm lens used to get the image above. Making it easier than ever to bring out your subject's best attributes, whether you're shooting wildlife, portraits, or somewhere in between.

Nikon

FOR THE PHOTOGRAPHER WHO BELIEVES

SUBJECTS SHOULD ONLY SAY "CHEESE" IN

RESPONSE TO QUESTIONS ABOUT CHEESE.

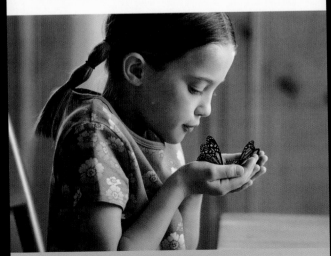

There comes a point when you realize the best way to pose a subject is not to do it at all. That's when it's time to look at the Nikon N80.™ Its Dynamic AF Mode focuses accurately on uncooperative subjects. On-Demand Grid Lines help you determine the perfect composition. And 10-segment 3D Matrix Metering and a built-in Speedlight ensure the right exposure, so subjects look their best every time. Plus a host of other features that allow you not only to capture images but create them. Making the N80 part artistic tool, part work of art.

Nikon

A CAMERA WITH DOZENS OF FEATURES.

INCLUDING ONE THAT LETS YOU IGNORE DOZENS OF FEATURES.

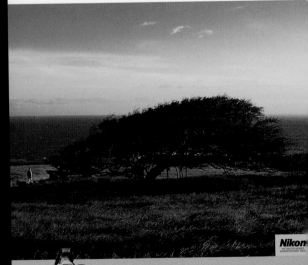

Even the space shuttle has auto pilot. The Nikon N65, with its legendary Nikkor optics, delivers the stunn... picture quality of an SLR without sacrificing simplicity. Let the camera automatically adjust focus, expos... and flash. Or switch over to manual, try out different lenses, and start experimenting. Either way, you'll f... find that this innovative Nikon consistently gives you the one thing that no one can ignore. Amazing pictu...

Nikon

IT MAY BE TIME TO MOVE THE PHOTO ALBUM

TO THE COFFEE TABLE.

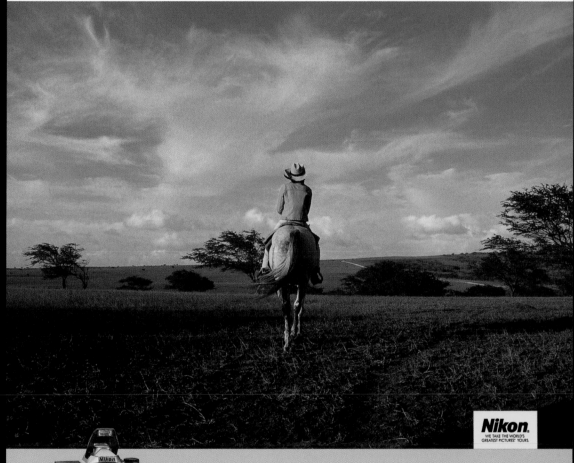

Is it our imagination, or did your vacations just get more interesting? The Nikon N65, with its legendary Nikkor lenses, delivers the stunning images of an SLR without sacrificing simplicity. Let the camera automatically focus and set exposure for daylight and flash. Or use manual control, interchangeable lenses, and experiment. Either way, you'll soon have albums full of Nikon-quality photos. Not to mention a far more attractive coffee table.

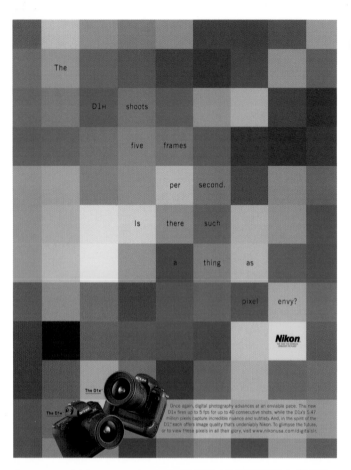

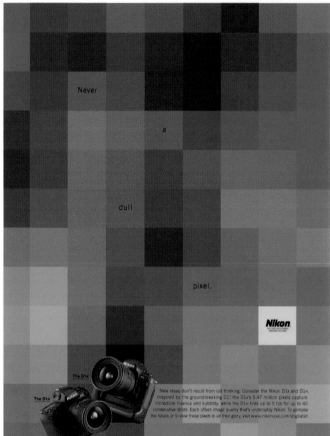

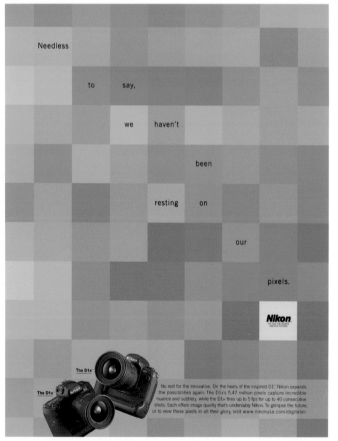

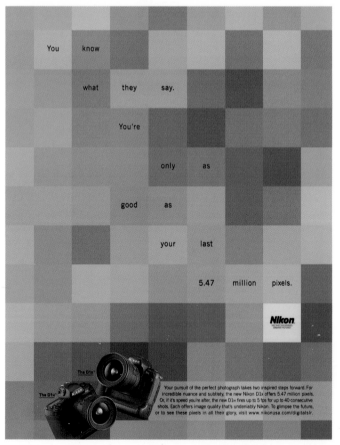

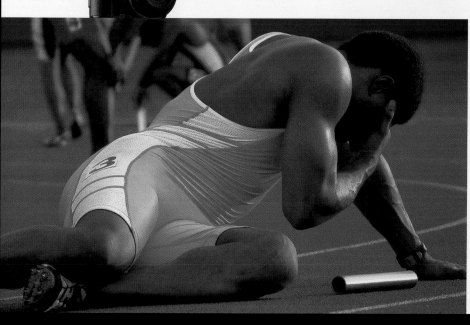

**When they say don't get too close
to your subjects, they mean emotionally.**

There's a reason the phrase is "up close and personal." And with the amazing new 5-megapixel Nikon Coolpix® 5700, you'll never miss an opportunity to get exactly that. It offers an 8x zoom lens (35–280mm equivalent) and optional telephoto converter (420mm equivalent) for astounding long-range capabilities. Both with Nikon's exclusive high-precision Nikkor optics and ED glass for clearer color and contrast. And with Nikon's exclusive 256-segment Matrix Metering, RAW image capture capability, and an electronic through-the-lens viewfinder, you won't need to sacrifice creativity for a brilliantly compact design. To learn more about the surprising capabilities of the Coolpix 5700 or everything else that makes Nikon's line of digital cameras legendary, see your Authorized Nikon dealer or visit us at www.nikoncoolpix.com. And try, just try, to stay emotionally detached.

Optional telephoto converter lens

The Nikon Coolpix 5000 with 28-85mm Zoom-Nikkor lens with enhanced wide angle.

The new Nikon Coolpix 4500 with unique swivel body and 38-155mm 4x Zoom-Nikkor lens.

Nikon.
WE TAKE THE WORLD'S GREATEST PICTURES®

©2002 Nikon Inc.

**You may suddenly begin referring
to vacations as going "on location."**

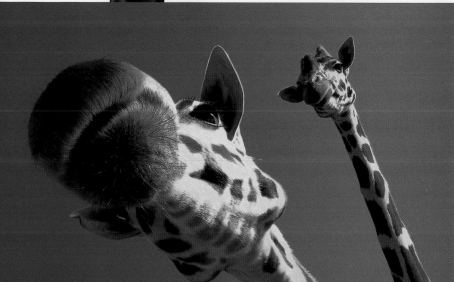

Can a digital camera really help make you a better photographer? It can, if it's as versatile as the new Nikon Coolpix® 4500. With its unique swiveling body, and its ability to handle wide-angle, telephoto, and fisheye lenses, this camera opens up a whole new world of fresh angles and creative opportunities. Explore 16 different scene modes, including multiple exposure. Transfer images to your desktop or the web easily with exclusive NikonView software. And perhaps most importantly, capture the stunning clarity and nuance that only comes from the four-megapixel CCD and Nikkor lenses crafted to our uncompromising standards. To find out more about the Coolpix 4500 and the entire line of Nikon Coolpix Digital cameras, visit your authorized Nikon dealer or www.nikoncoolpix.com. One word of advice, though. Try to resist referring to your spouse as your "photo assistant."

Optional 24mm equivalent wide-angle lens.

The new Nikon Coolpix 5700 with a 35-280mm 8x Zoom-Nikkor lens with ED glass.

The Nikon Coolpix 5000 with 28-85mm Zoom-Nikkor lens with enhanced wide angle.

Nikon.
WE TAKE THE WORLD'S GREATEST PICTURES®

©2002 Nikon Inc.

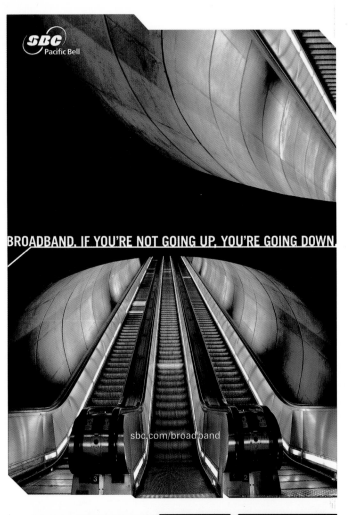

BROADBAND. IF YOU'RE NOT GOING UP, YOU'RE GOING DOWN.

sbc.com/broadband

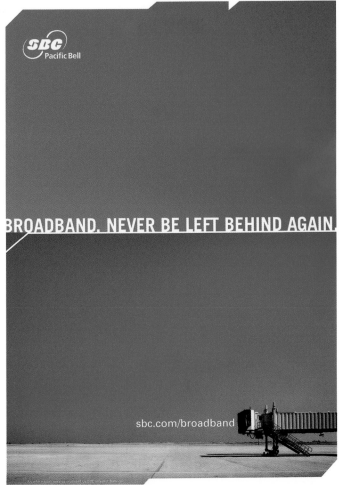

BROADBAND. NEVER BE LEFT BEHIND AGAIN.

sbc.com/broadband

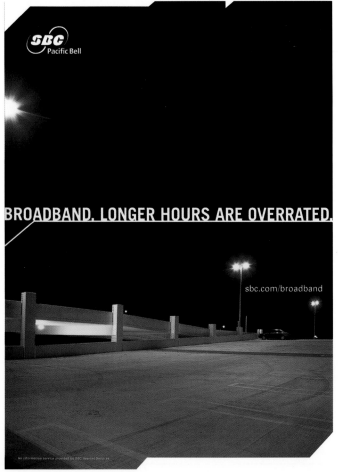

BROADBAND. LONGER HOURS ARE OVERRATED.

sbc.com/broadband

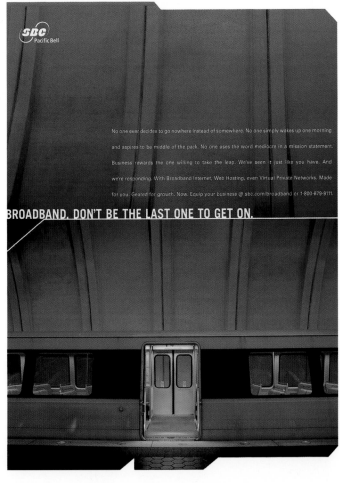

No one ever decides to go nowhere instead of somewhere. No one simply wakes up one morning and aspires to be middle of the pack. No one uses the word mediocre in a mission statement. Business rewards the one willing to take the leap. We've seen it just like you have. And we're responding. With Broadband Internet, Web Hosting, even Virtual Private Networks. Made for you. Geared for growth. Now. Equip your business @ sbc.com/broadband or 1-800-679-9111.

BROADBAND. DON'T BE THE LAST ONE TO GET ON.

'Broadband Bus Shelter Campaign' Agency: Rodgers Townsend Creative Director: Tom Hudder Art Director: Luke Partridge Photographer: James Schwartz Copywriter: Michael McCormick Client: SBC Communications Inc.

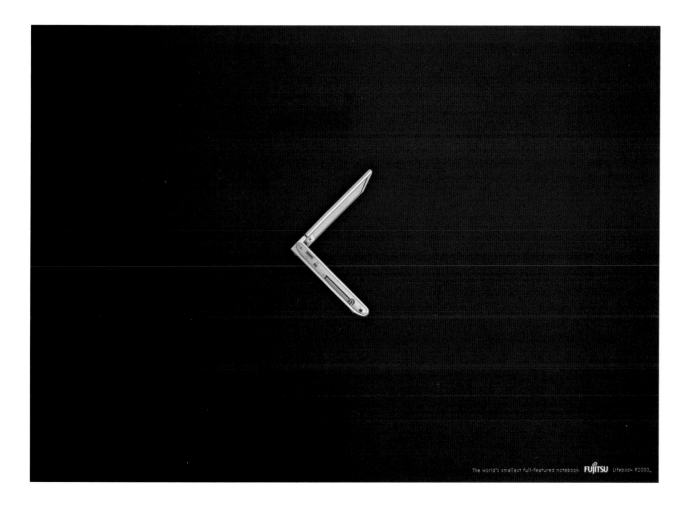

The world's smallest full-featured notebook. FUjITSU Lifebook P2000_

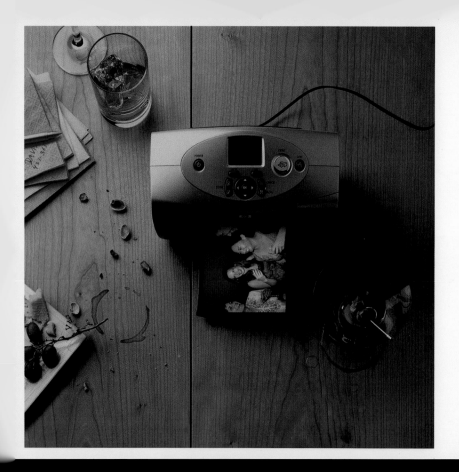

Print pictures while moments are still developing.

print

The hp photosmart 230 photo-printer. Introducing the life of the party: a compact new printer that's completely dedicated to 4x6 photo quality prints. It's small enough to take anywhere and as easy to use as your digital camera, making it invited to almost any function. $249.* www.hp.com/life

hp digital imaging. When it's this easy, why not?

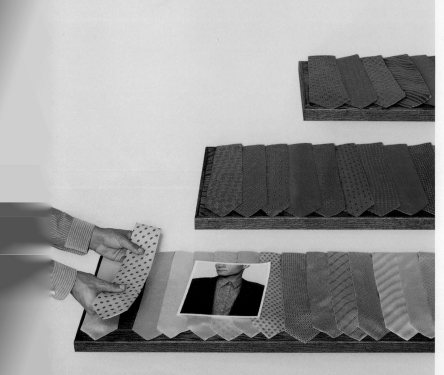

Decrease your margin of fashion error.

print

The hp photosmart 7550 printer delivers photo-quality prints with up to 4800 optimized dpi** or 7-ink printing that can accurately match things as subtle as patterns and textures, while helping you match things as difficult as shirts and ties. $399.** www.hp.com/life

hp digital imaging. When it's this easy, why not?

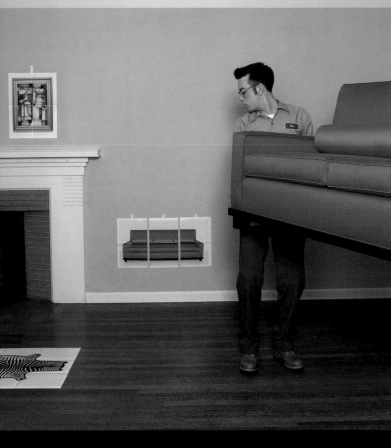

Speak clearly to the movers.

print

The hp psc 2210 all-in-one does all kinds of things normal printers don't, like making proof sheets, scanning images and making photo-quality prints in different shapes and sizes. There's even a tiling option to help you achieve as much realism as the situation calls for. $399* www.hp.com/life

hp digital imaging. When it's this easy, why not?

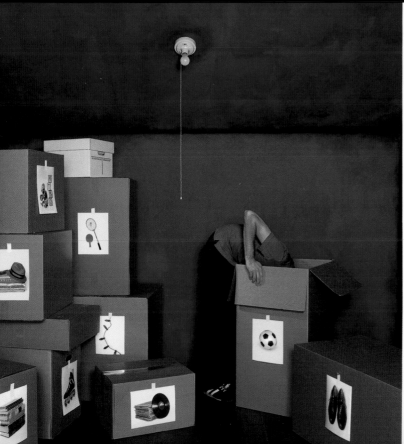

Make cardboard transparent.

hp has a full range of papers, including premium plus photo paper, which, when used with hp's new 6- and 7-ink color printers, can make high quality prints that resist fading for generations—unlike, say, your memory. www.hp.com/life

hp digital imaging. When it's this easy, why not?

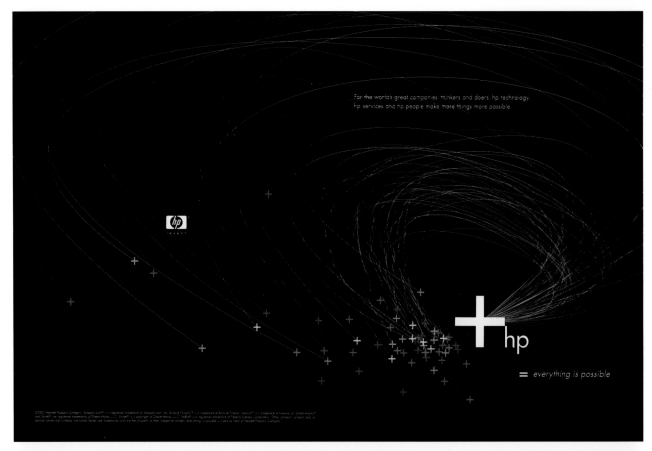

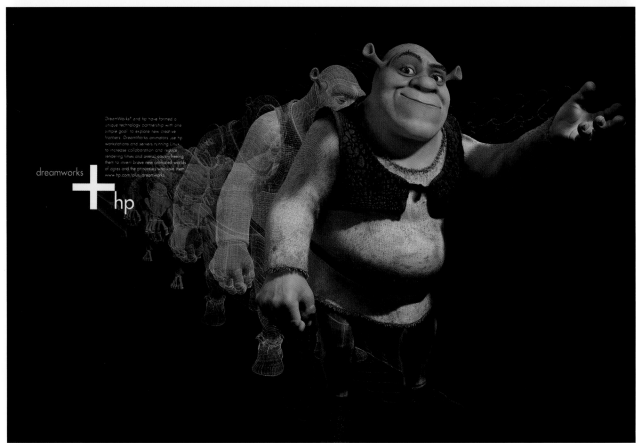

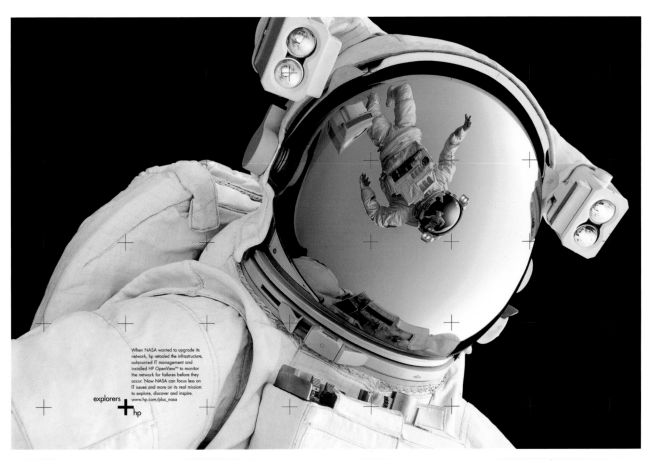

When NASA wanted to upgrade its
network, hp retooled the infrastructure,
outsourced IT management and
installed HP OpenView™ to monitor
the network for failures before they
occur. Now NASA can focus less on
IT issues and more on its real mission:
to explore, discover and inspire.
www.hp.com/plus_nasa

explorers
+ hp

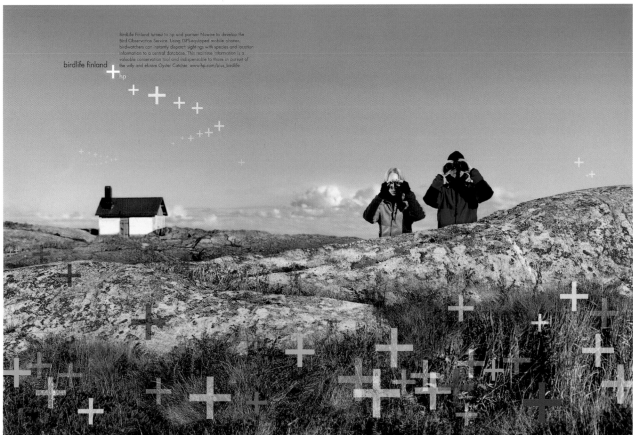

BirdLife Finland turned to hp and partner N-wire to develop the
Bird Observation Service. Using GPS-equipped mobile phones,
birdwatchers can instantly dispatch sightings with species and location
information to a central database. This real-time information is a
valuable conservation tool and indispensable to those in pursuit of
the wily and elusive Oyster Catcher. www.hp.com/plus_birdlife

birdlife finland
+ hp

(this spread) Agency: Goodby, Silverstein & Partners Creative Director: Steve Simpson Art Director: Stephen Goldblatt Photographer: Nadav Kandor Copywriter: Will Elliott Client: Hewlett-Packard

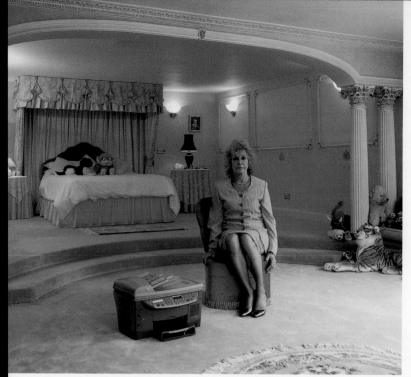

My printer bought a ticket to Barbados.

Just scanned my passport, faxed an order and printed a first-class e-ticket to Barbados.

Well, someone had to use it.

I gave him a stern talking to when I got back.

More printer than you bargained for. The hp all-in-one officejet d145.
Print. Fax. Scan. Copy. Now with automatic two-sided color printing.
$599* www.hp.com/go/allinone

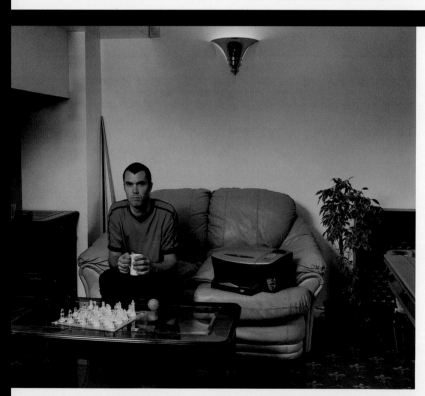

My printer faxed my soccer team.

It said that if it was going to make high quality copies of the team picture and download it to our website than it deserved to be on the team.

We put him on the field when we were ahead by a couple points.

That satisfied him for a while.

More printer than you bargained for. The hp all-in-one psc 2210.
Print. Fax. Scan. Copy. Now with hp proofsheet technology that lets you print multiple-sized photos without using your pc. $399*
www.hp.com/go/allinone

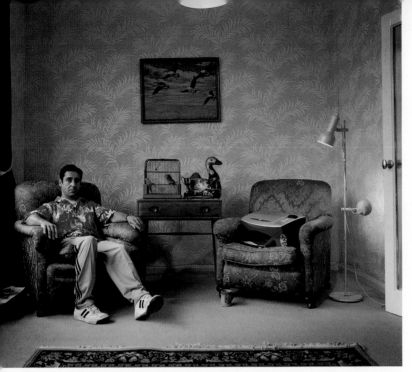

My printer asked if he could go to the copy shop.

He couldn't believe there was a time when people had to drive to a place to scan, copy, fax and print on separate machines.

I sent him a fax that said there was once a time when people couldn't even print their own pictures.

He didn't believe that either.

More printer than you bargained for. The hp all-in-one psc 2210.
Print. Fax. Scan. Copy. Now with hp proofsheet technology that lets you print multiple-sized photos without using your pc. $399.
www.hp.com/go/allinone

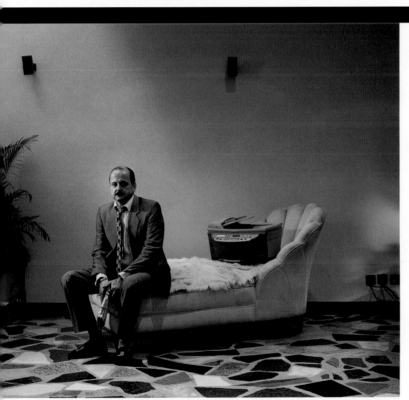

My printer asked me for a raise.

I said, "No way."

My printer then used itself to design and print business cards, letterhead and envelopes, and go into business against me.

Now my wife wants me to go work for my printer.

It's awkward.

More printer than you bargained for. The hp all-in-one officejet d145.
Print. Fax. Scan. Copy. Now with automatic two-sided color printing.
$599. www.hp.com/go/allinone

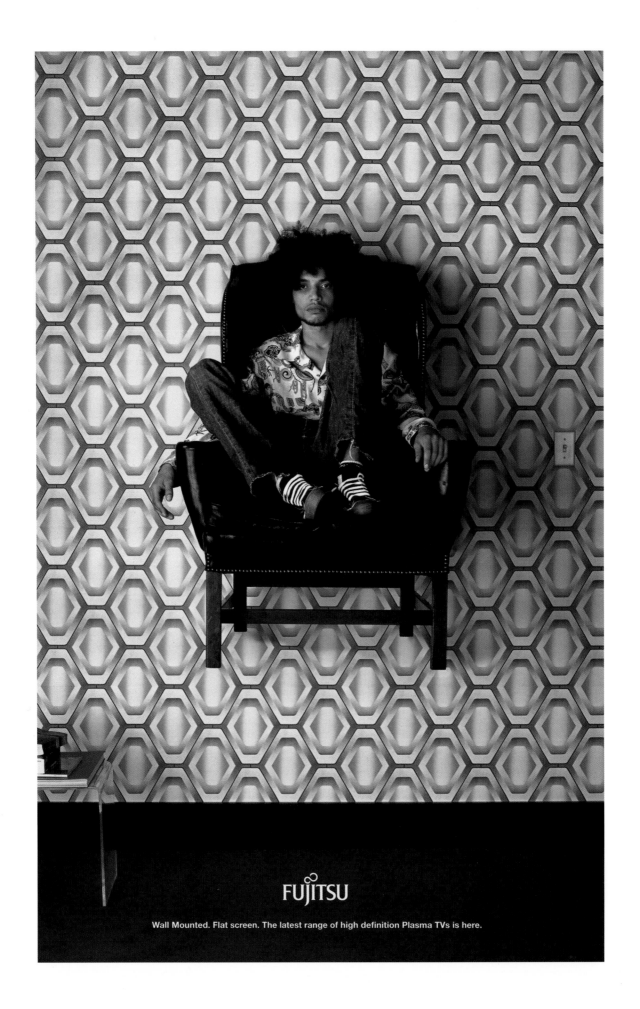

FUJITSU

Wall Mounted. Flat screen. The latest range of high definition Plasma TVs is here.

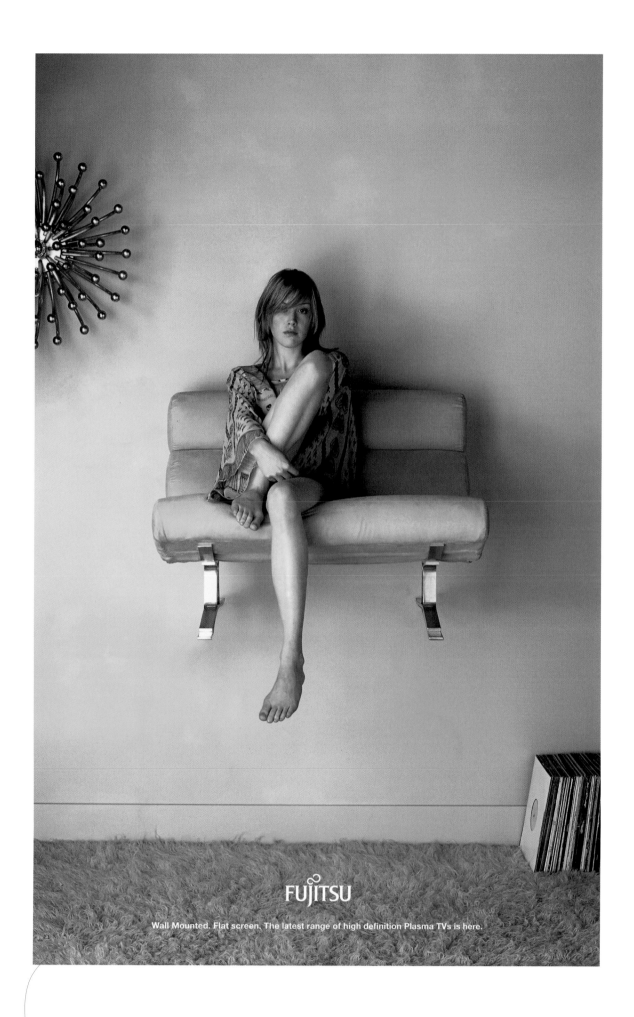

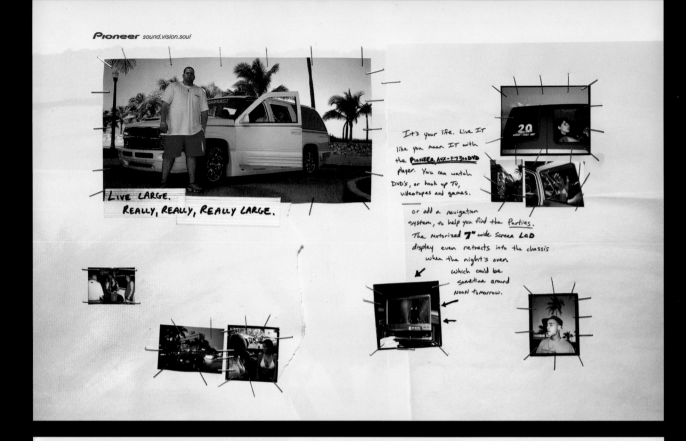

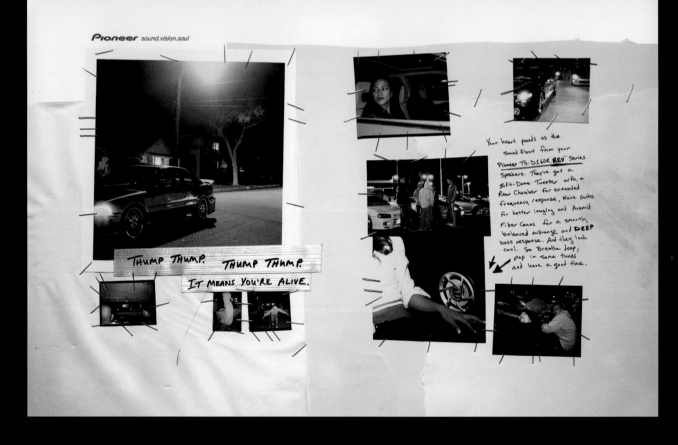

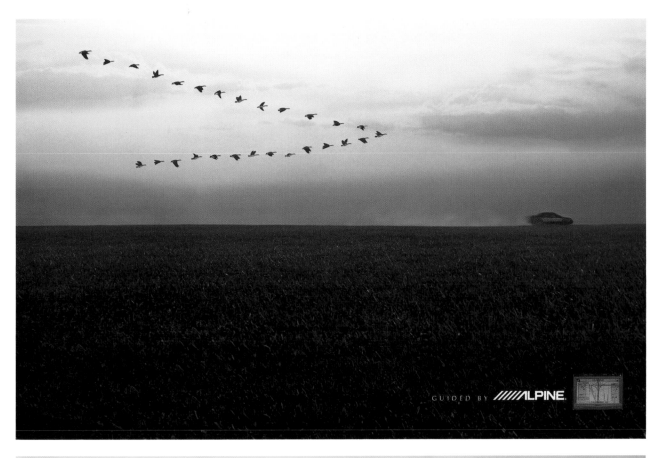

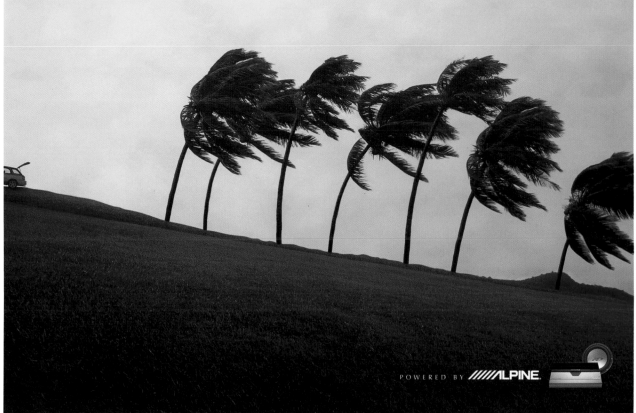

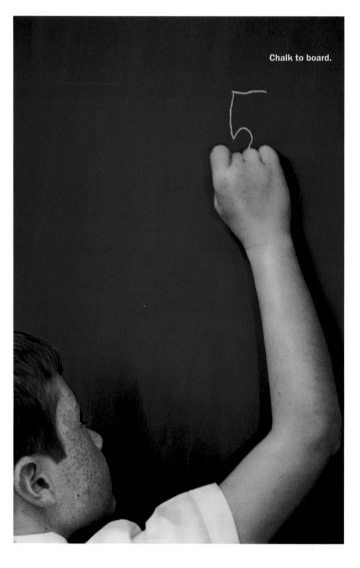

Chalk to board.

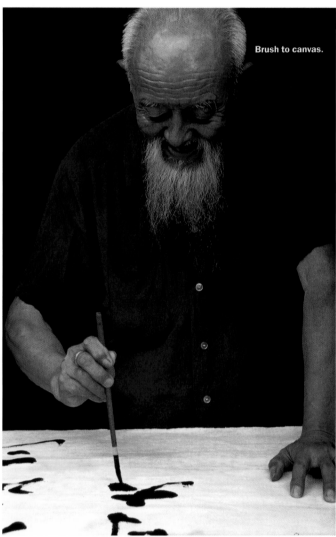

Brush to canvas.

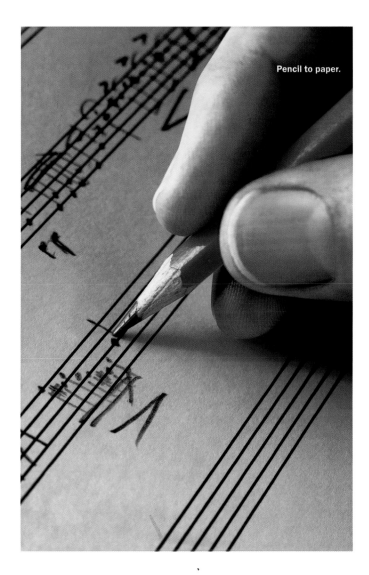

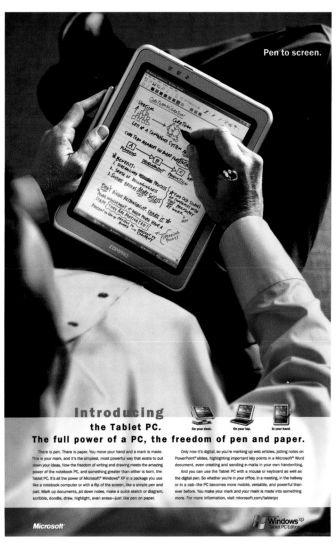

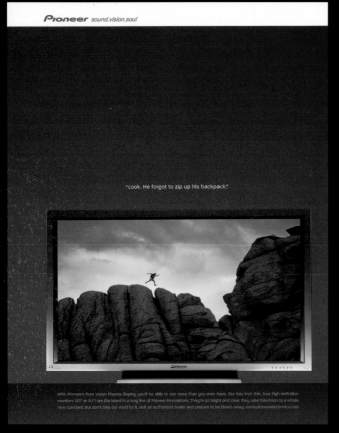

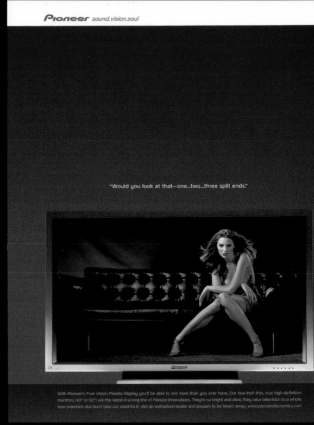

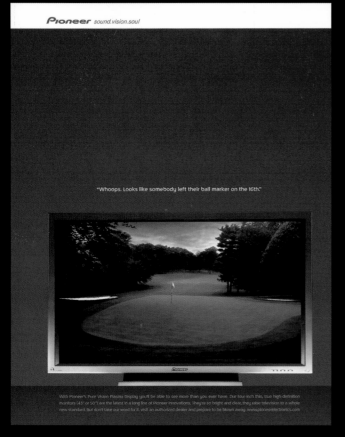

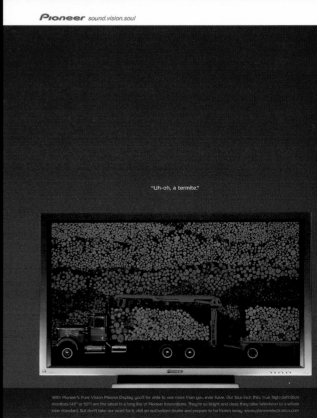

"I wonder if he knows his plates are expired?"

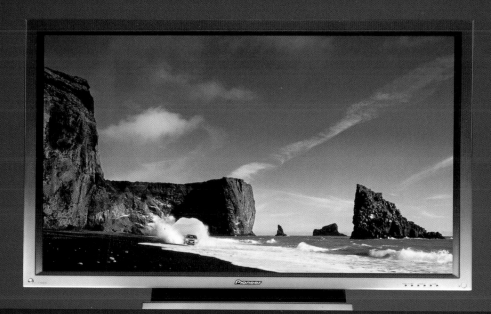

With Pioneer's Pure Vision Plasma Display you'll be able to see more than you ever have. Our four-inch thin, true high-definition monitors (43" or 50") are the latest in a long line of Pioneer innovations. They're so bright and clear, they raise television to a whole new standard. But don't take our word for it, visit an authorized dealer and prepare to be blown away. www.pioneerelectronics.com

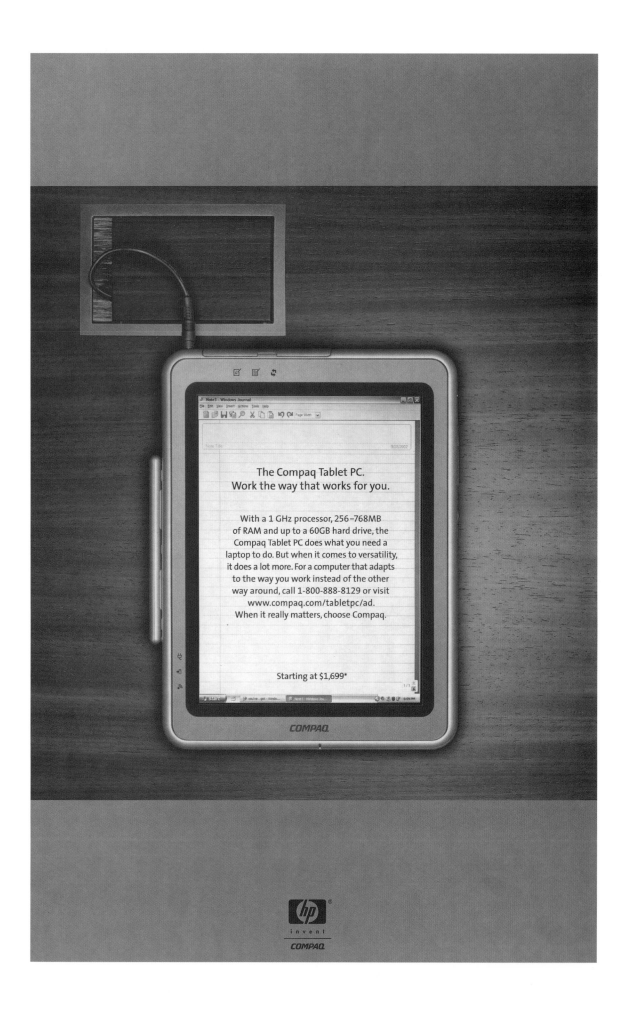

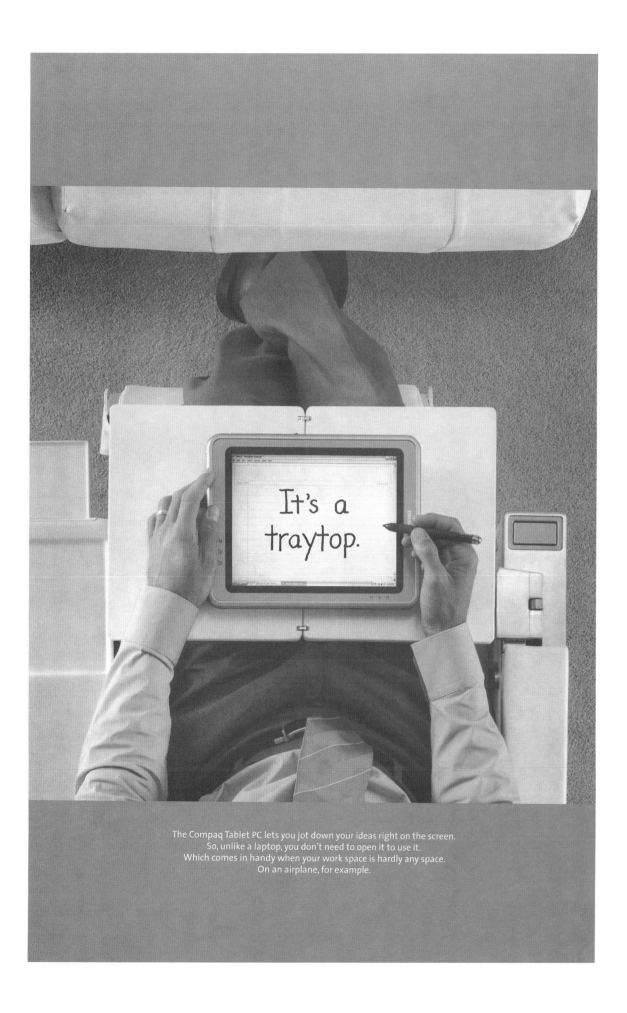

It's a traytop.

The Compaq Tablet PC lets you jot down your ideas right on the screen.
So, unlike a laptop, you don't need to open it to use it.
Which comes in handy when your work space is hardly any space.
On an airplane, for example.

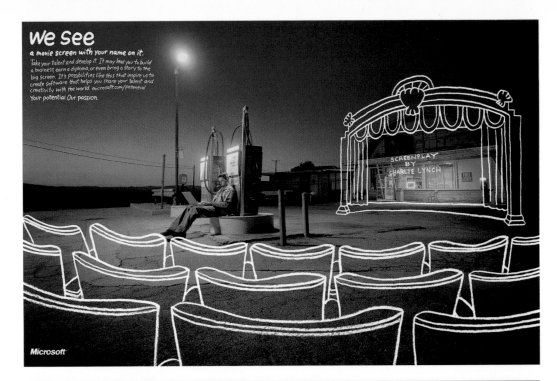

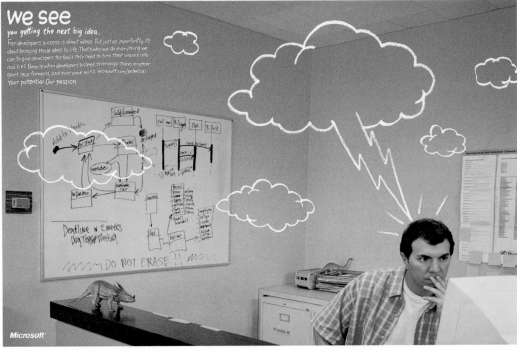

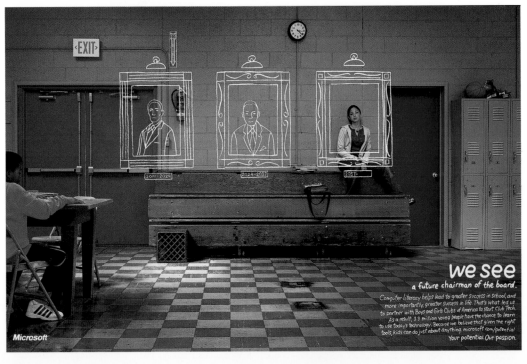

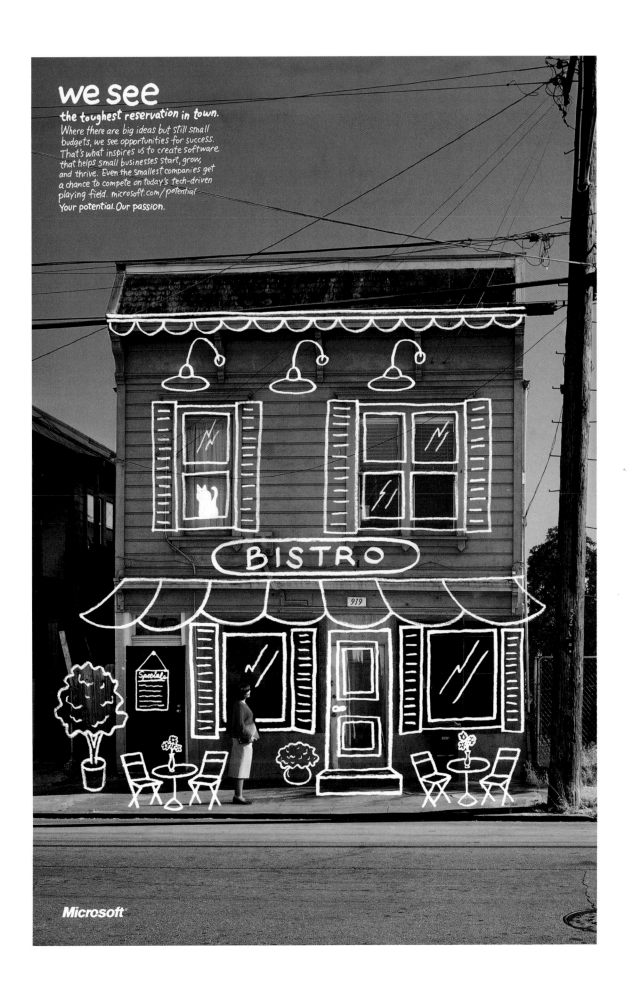

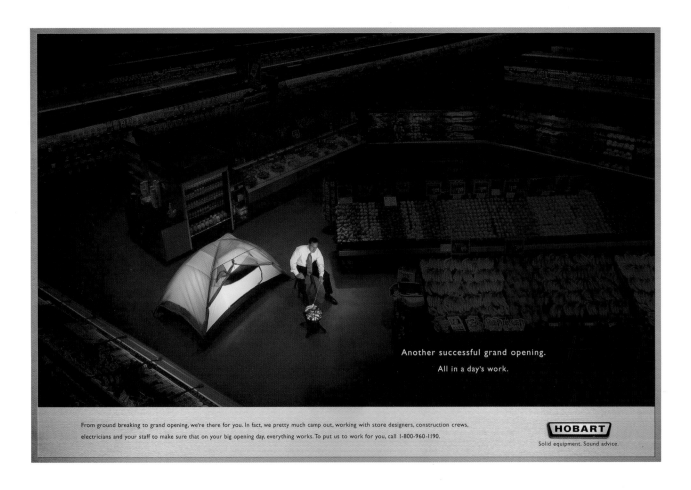

Another successful grand opening.

All in a day's work.

From ground breaking to grand opening, we're there for you. In fact, we pretty much camp out, working with store designers, construction crews, electricians and your staff to make sure that on your big opening day, everything works. To put us to work for you, call 1-800-960-1190.

HOBART

Solid equipment. Sound advice.

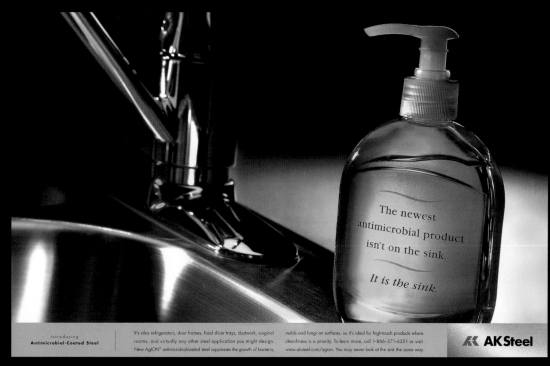

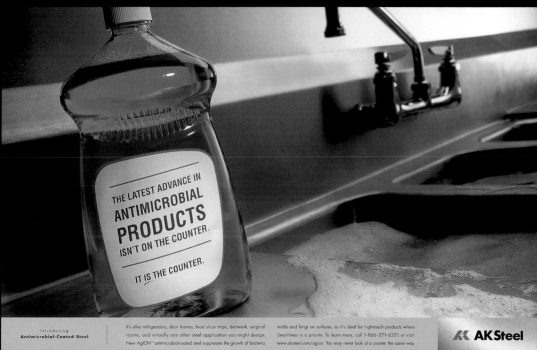

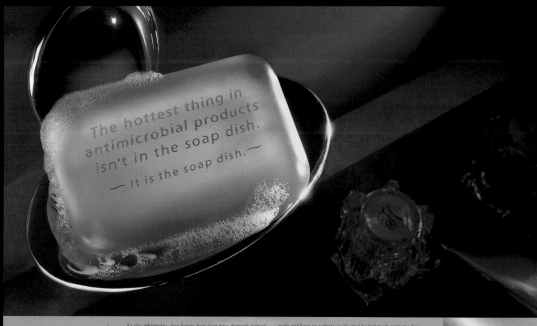

The School of Visual Concepts.

206·623·1560

Taking education beyond the classroom. Textbooks
are a great place to start, but they're no place to stay.
By bringing more of the community into the classroom
and vice versa, our students don't just learn about
the world. They learn from it. walkaboutschool.com

walkabout school
think outside the book

Building more than strong test scores. In addition to the basics like reading,
math and science, we also teach the basics of critical thinking, problem
solving and leadership. Because it's not just knowing the facts that makes
you a success, it's knowing what to do with them. walkaboutschool.com

walkabout school
think outside the book

Growing students into success stories. By using many different teaching methods—not just lectures and worksheets—each student can get the most out of school. After all, when you're exposed to a world of possibilities, you begin to see that anything is possible. walkaboutschool.com

walkabout school
think outside the book

'Barbell,' 'Rocket' and 'Flower' Agency: Olson & Company Creative Director: John Olson Art Director: Mike Caguin Photographer: Danielle Gernes Copywriter: Derek Bitter Client: Walkabout School 'Education 80,81

2002 CUSPIDE ADVERTISING AWARDS
RECOGNIZING EXTRAORDINARY EFFORTS
MAY 13-17 SAN JUAN ART MUSEUM
787-764-9906

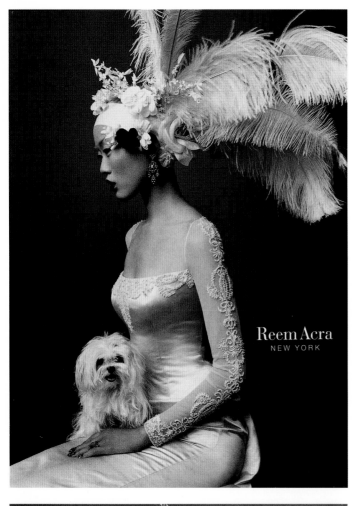

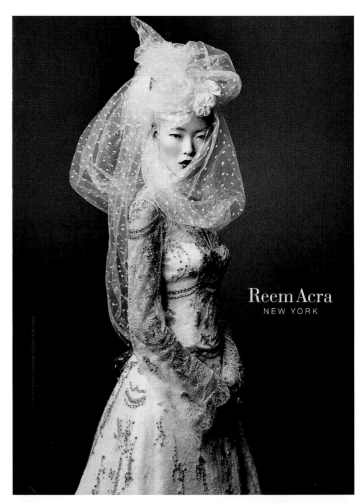

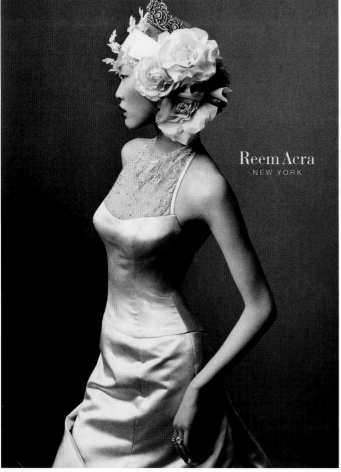

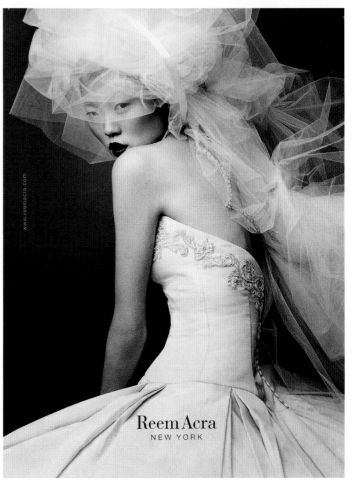

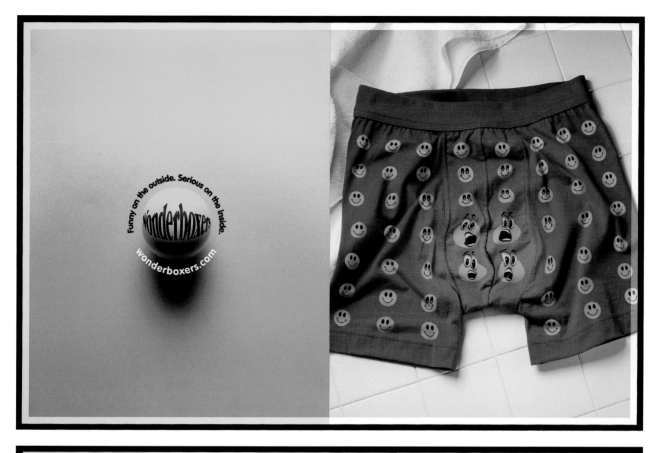

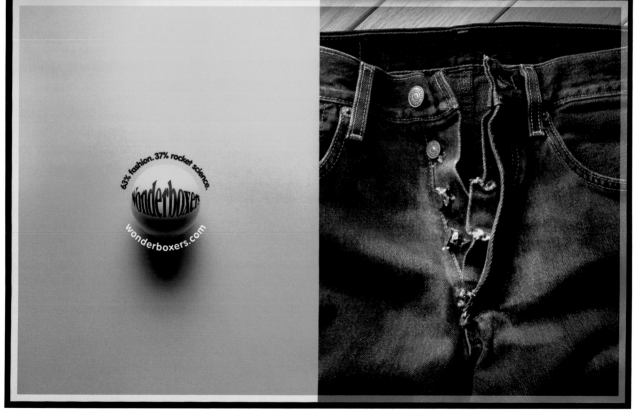

Agency: Hoffman York, Inc. Creative Director: Tom Jordan Art Director: Ken Butts Photographer: Scott Lanza Copywriter: Mark Catterson Digital Artist: Tony Swinney Client: This was a self-promotional ad created for April Fool's Day

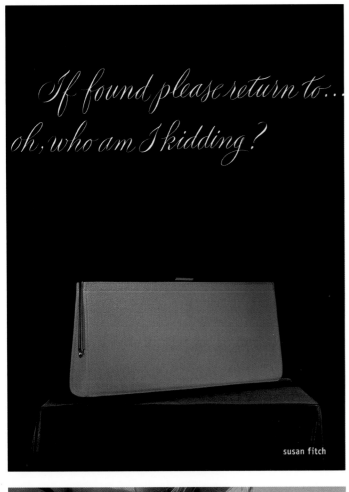

If found, please return to... oh, who am I kidding?

susan fitch

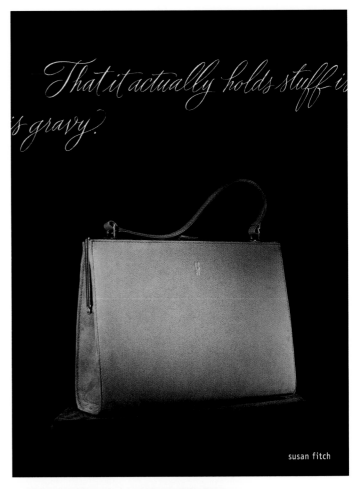

That it actually holds stuff is gravy.

susan fitch

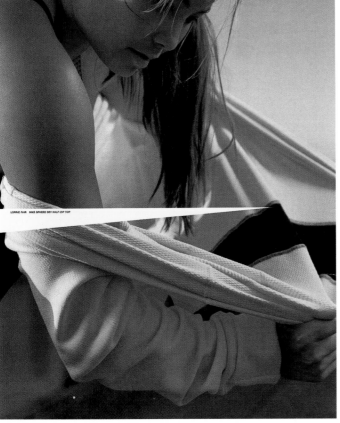

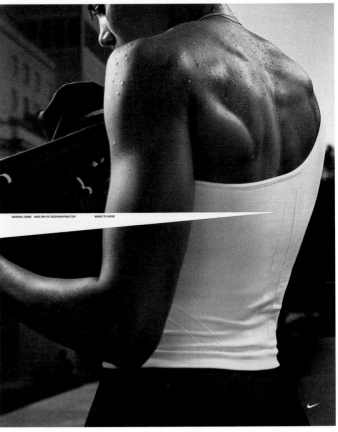

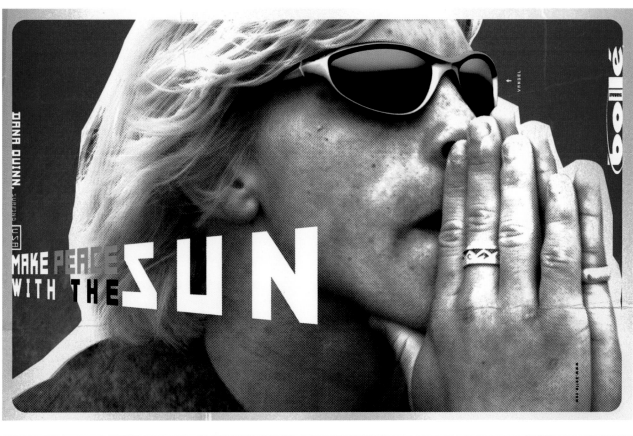

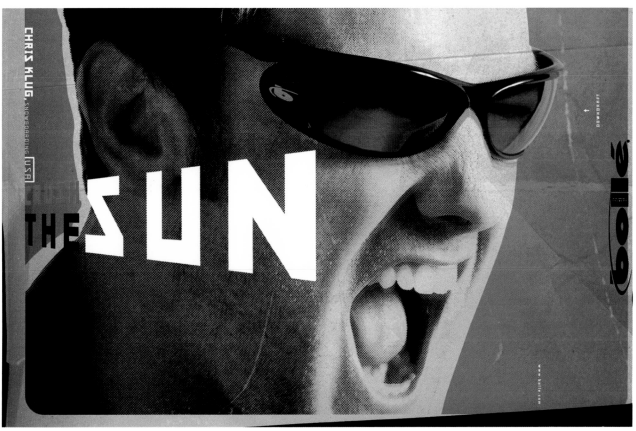

Agency: Muller & Company Creative Director: John Muller Art Director: Jeff Miller Designer: Jeff Miller Photographers: Nic McLean and Michael Regnier Copywriter: Justin Gordner Client: Bollé Peformance Eyewear

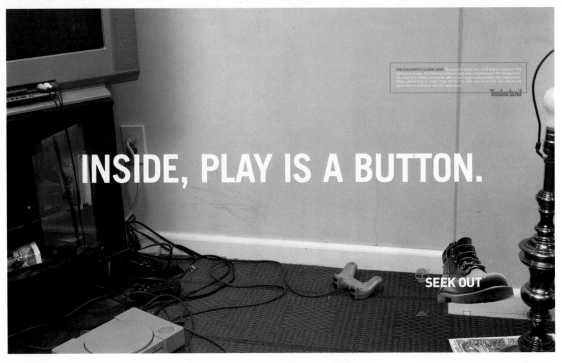

INSIDE, PLAY IS A BUTTON.

SEEK OUT

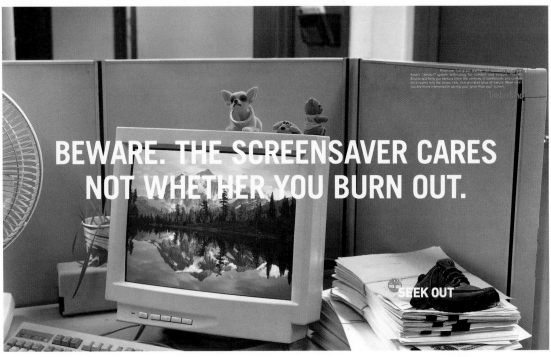

BEWARE. THE SCREENSAVER CARES
NOT WHETHER YOU BURN OUT.

SEEK OUT

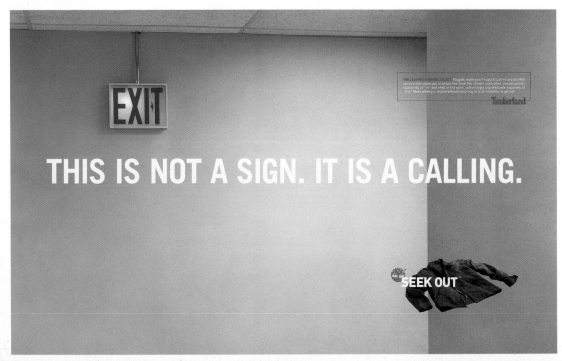

EXIT

THIS IS NOT A SIGN. IT IS A CALLING.

SEEK OUT

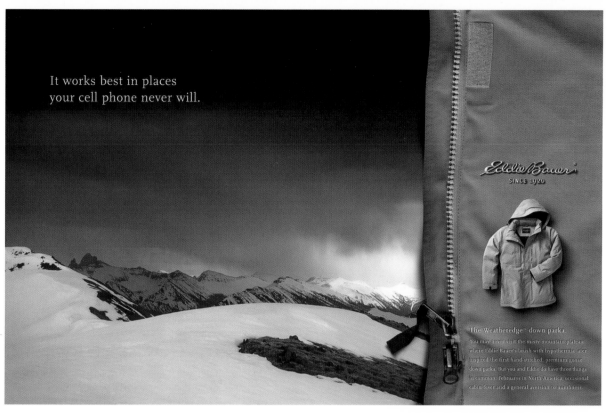

It works best in places
your cell phone never will.

The Weatheredge™ down parka.
You may never visit the misty mountain plateau
where Eddie Bauer's brush with hypothermia later
inspired the first hand-stitched, premium goose
down parka. But you and Eddie do have three things
in common: Februarys in North America, occasional
cabin fever and a general aversion to numbness.

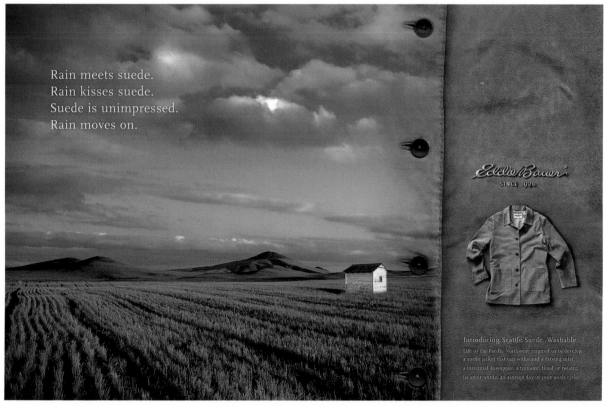

Rain meets suede.
Rain kisses suede.
Suede is unimpressed.
Rain moves on.

Introducing Seattle Suede. Washable.
Life in the Pacific Northwest inspired us to develop
a suede jacket that can withstand a driving mist,
a torrential downpour, a tsunami, flood or twister.
In other words, an average day in your wash cycle.

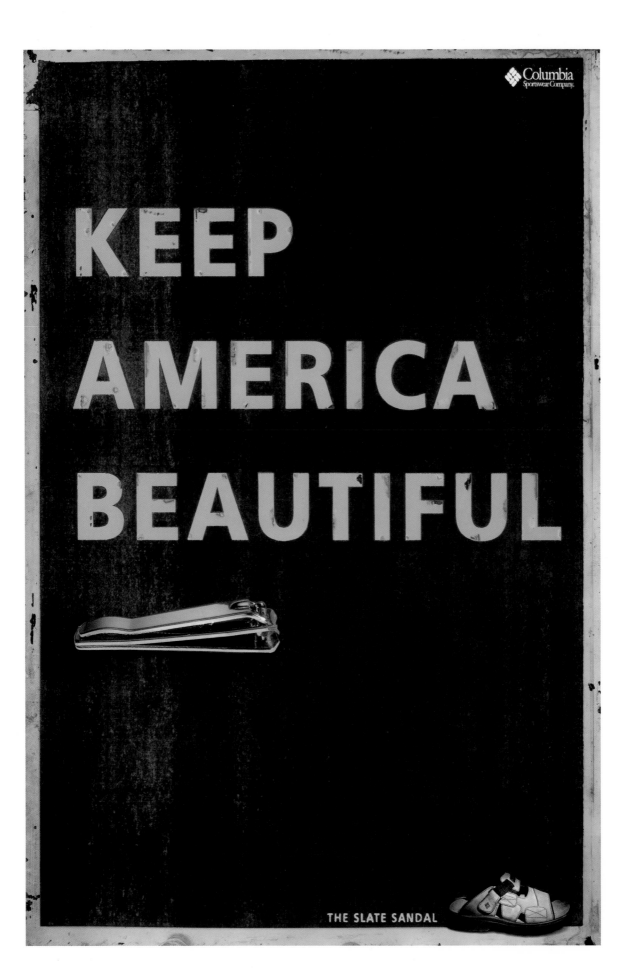

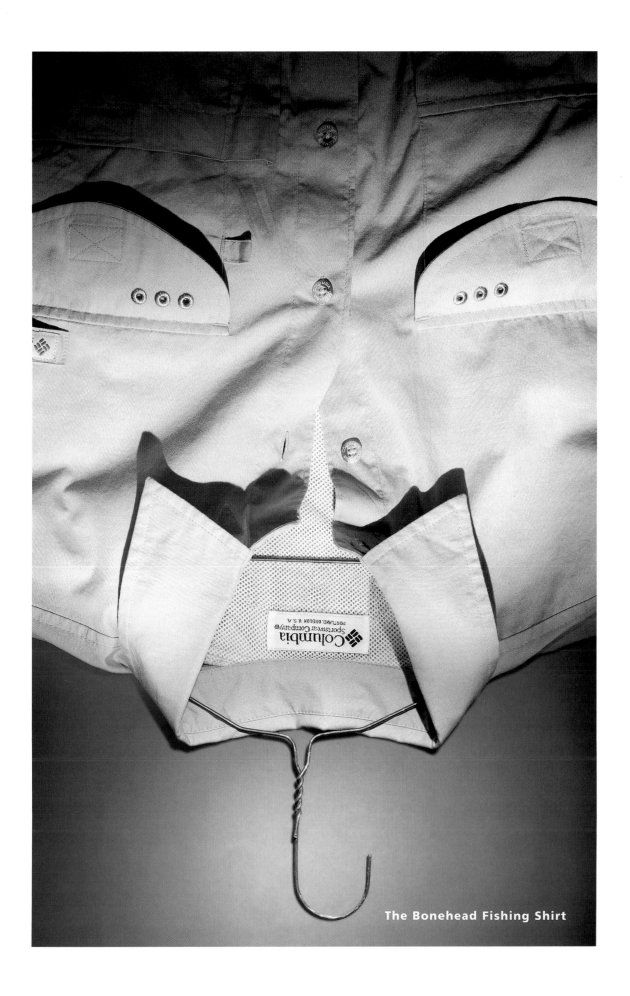

The Bonehead Fishing Shirt

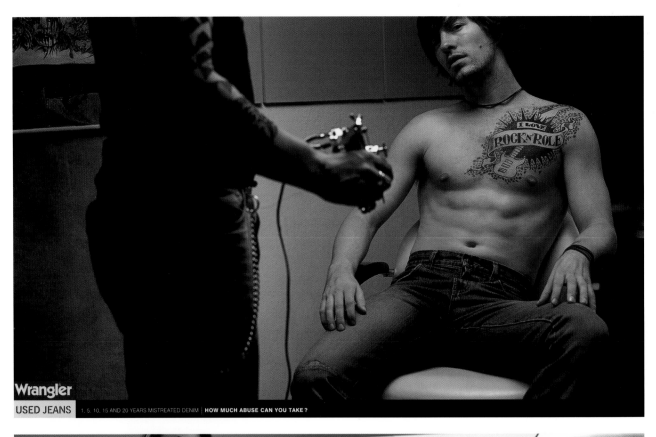

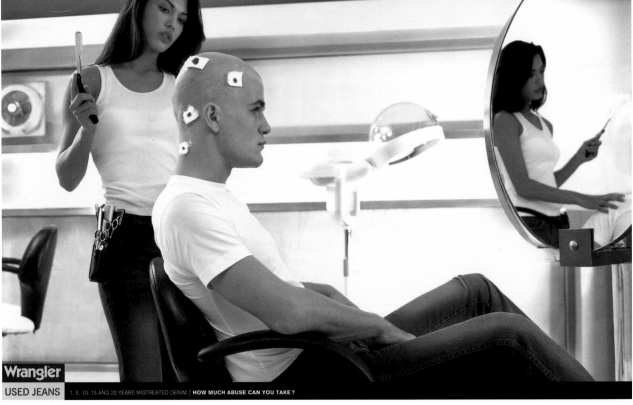

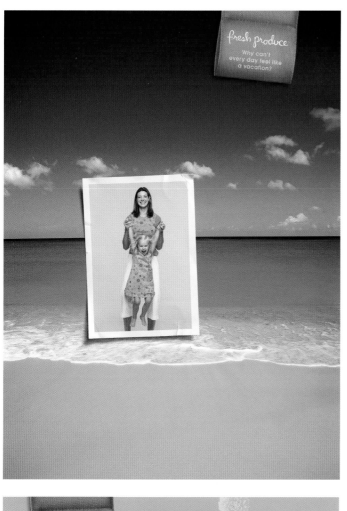

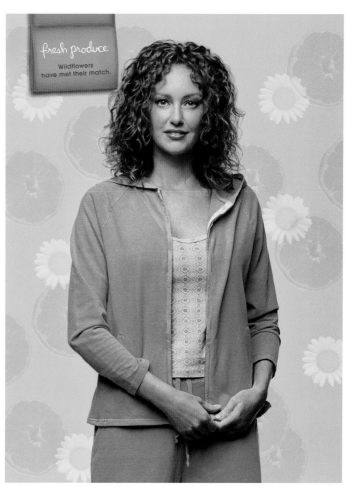

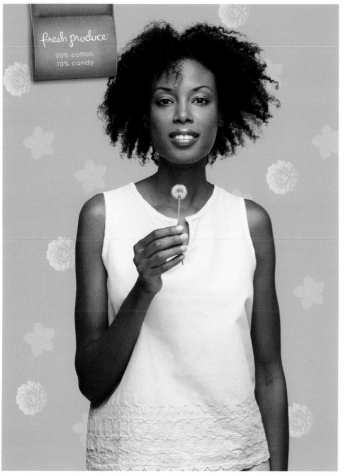

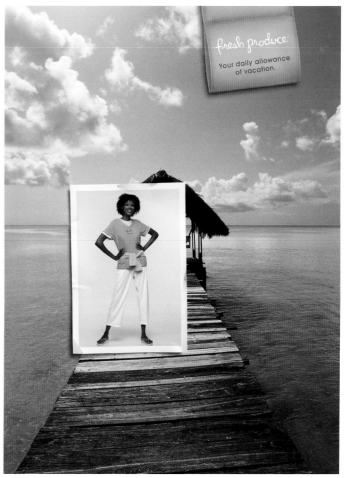

'Everyday,' 'Wildflowers,' 'Daily Allowance' and 'Cotton Candy' Agency: Sukle Advertising and Design Creative Director: Mike Sukle Art Director: KC Koch Photographer: Richard Feldman Copywriter: Jim Glynn Client: Fresh Produce

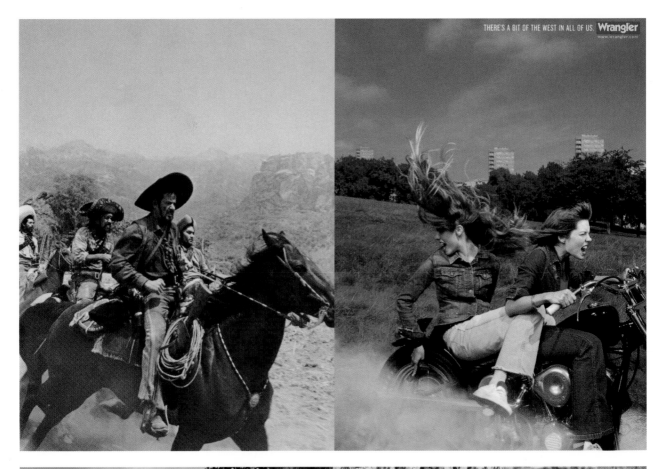

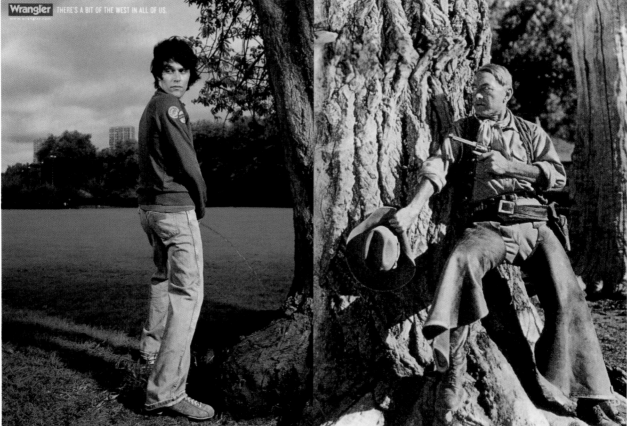

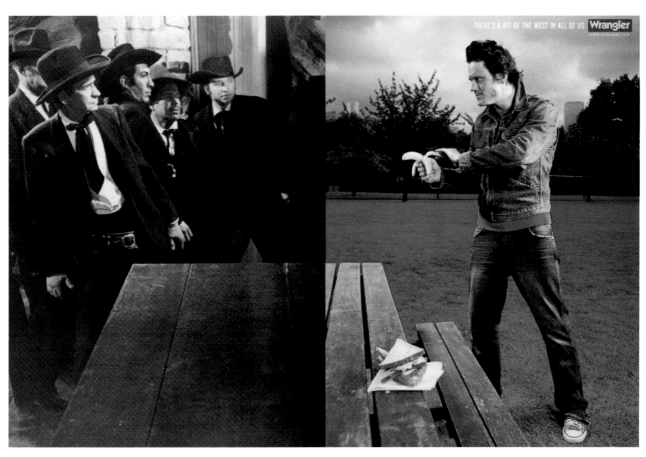

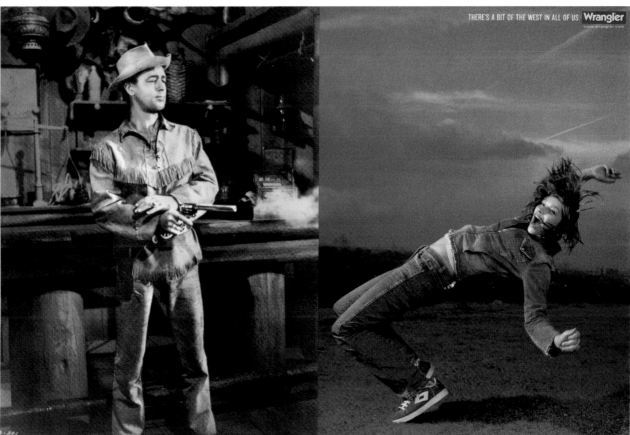

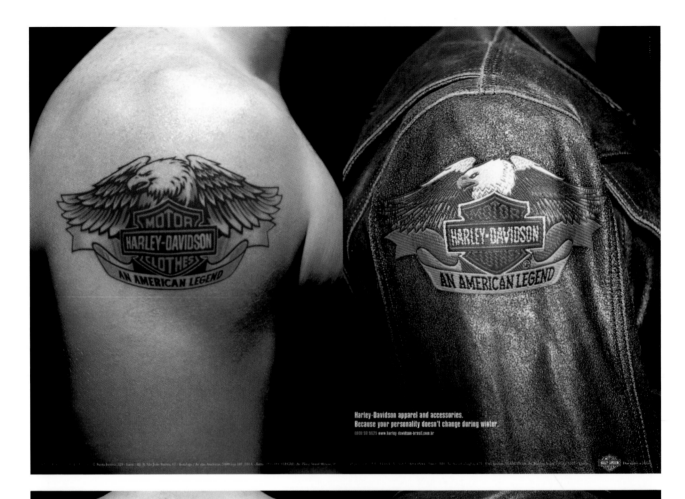

Harley-Davidson apparel and accessories.
Because your personality doesn't change during winter.

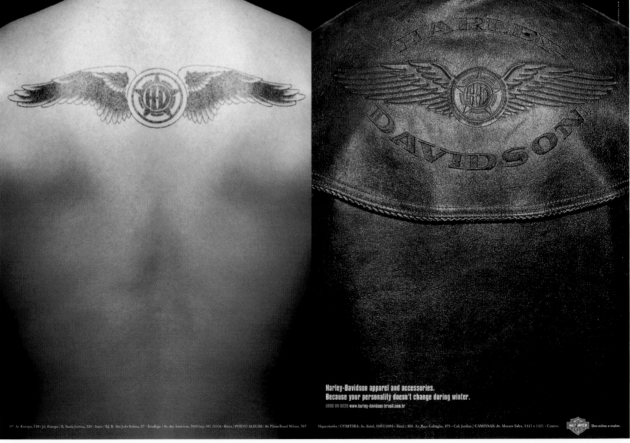

Harley-Davidson apparel and accessories.
Because your personality doesn't change during winter.

(this spread) Agency: Giovanni FCB Creative Director: William Silva Art Director: Omar Caldas Photographers: Edu Rodrigues and Clas Stellfeld Client: Harley-Davidson

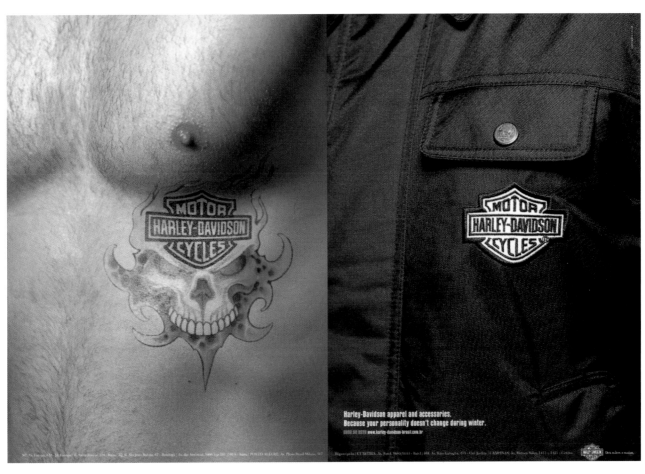

Harley-Davidson apparel and accessories.
Because your personality doesn't change during winter.

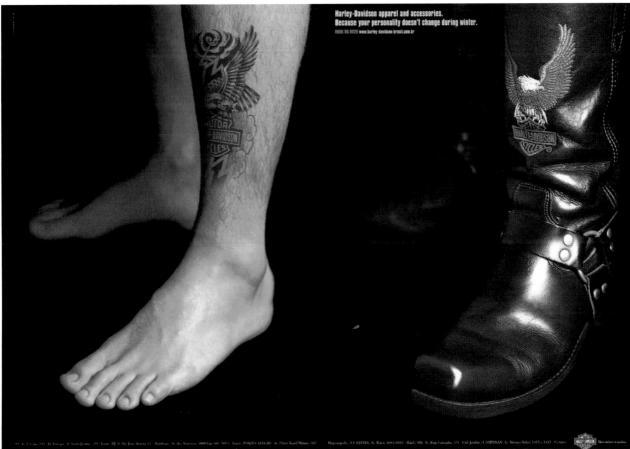

Harley-Davidson apparel and accessories.
Because your personality doesn't change during winter.

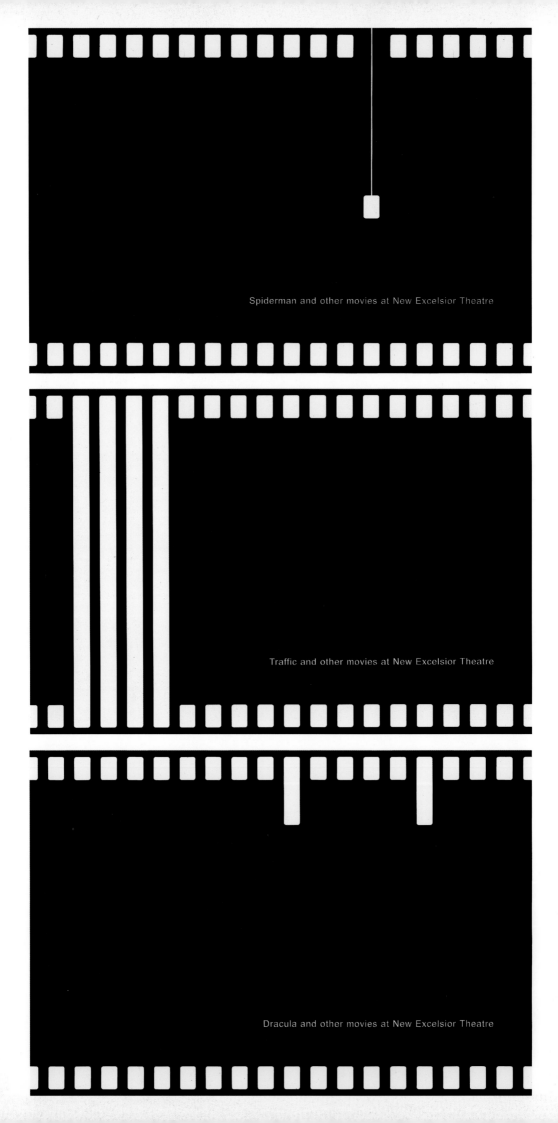

Spiderman and other movies at New Excelsior Theatre

Traffic and other movies at New Excelsior Theatre

Dracula and other movies at New Excelsior Theatre

Agency: Flea Communications Creative Directors: Sachin Bavkar and Sunil Shibad Art Director: Sachin Bavkar Designer: Sachin Bavkar Illustrator: Sachin Bavkar Copywriter: Sunil Shibad Client: New Excelsior Theatre

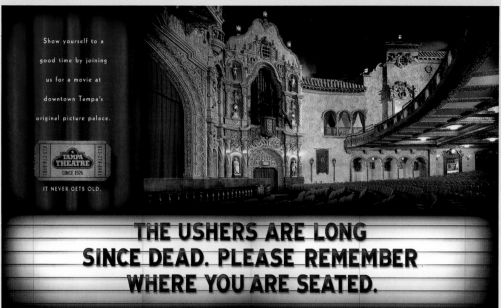

THE USHERS ARE LONG SINCE DEAD. PLEASE REMEMBER WHERE YOU ARE SEATED.

HALFWAY BETWEEN A TRIP TO THE VIDEO STORE AND A NIGHT AT THE OPERA.

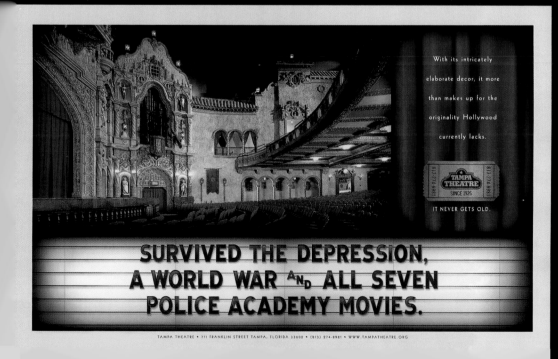

SURVIVED THE DEPRESSION, A WORLD WAR AND ALL SEVEN POLICE ACADEMY MOVIES.

cy Westwayne Creative Director Scott Sheinberg Art Director Tom McMahon Photographers Doug Johns and George Cott Copywriter Matt McGuinness Client Tampa Theatre

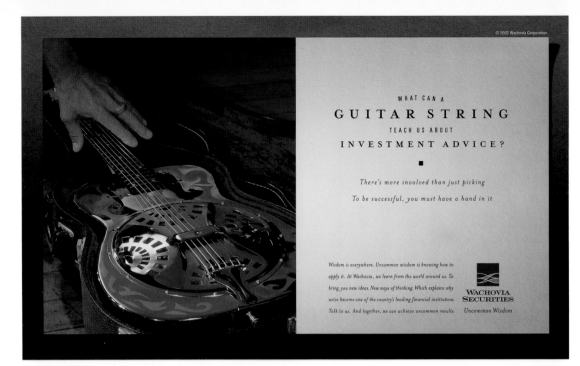

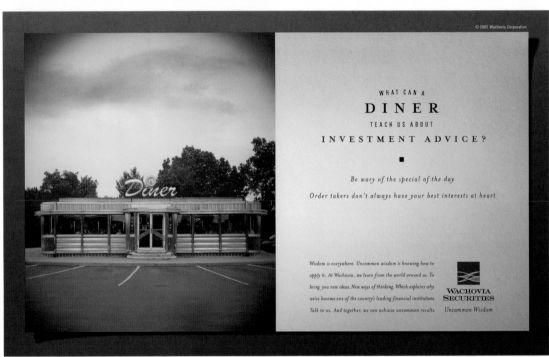

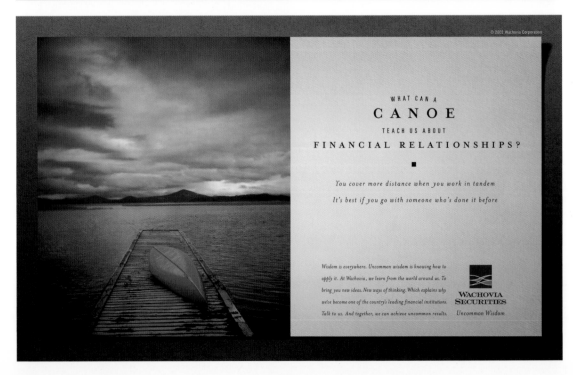

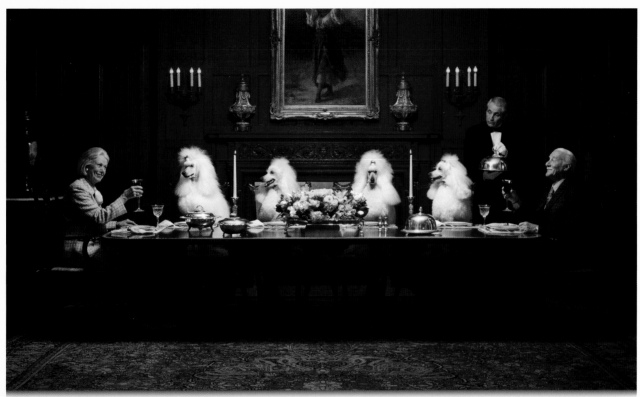

WE UNDERSTAND THE AFFLUENT. | NOT EVERYONE DOES.

They are the rarest clients. They are our only clients. The most complex issues are commonplace to us. For insurance, for investments, for unrivalled expertise, call 877-533-0003.

Lincoln
Financial Group®

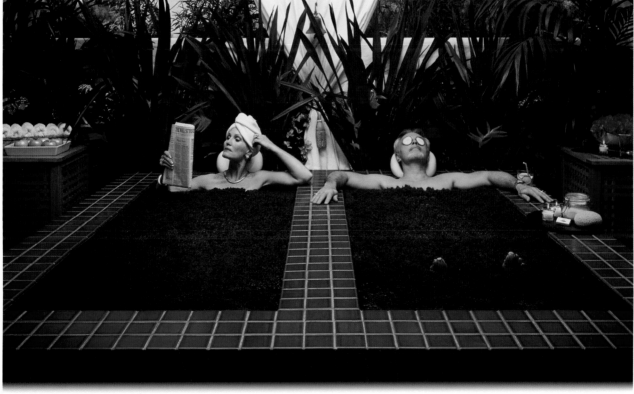

WE UNDERSTAND THE AFFLUENT. | NOT EVERYONE DOES.

We have a long history of meeting sophisticated financial needs and uniquely high expectations. For insurance, for growth, for solutions not found anywhere else, call 877-533-0003.

Lincoln
Financial Group®

Money is serious business.
But nobody said
life has to follow suit.

Life is
more interesting
when the
unexpected
happens.

Not true
for your finances.

So, we offer
online statements
and
free, ongoing
financial guidance.

To keep
your finances
organized.

And your life

from being too
calculated.

Visit us at citi.com.

Live richly.

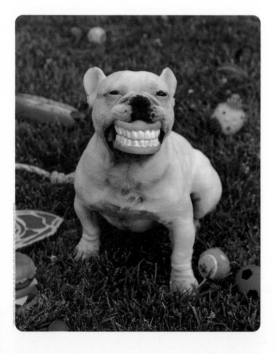

An almost staggering array
of rewards cards.

You must have been awfully
good in another life.

Cash.

Miles.

College savings.

Charge your
monthly bills
and earn
points.

Be rewarded

for something
you're going
to do anyway.

Another way
Citi helps you
use your
credit card

wisely.

1-888-CITICARD
citi.com

Live richly.

If other banks
are all about trust,

why are their pens
attached to chains?

For banking built on relationships,
952-431-4700.

MIDWAY BANK

Member FDIC

To speak directly
to a customer service
representative,

speak directly
to a customer service
representative.

Friendly humans are standing by,
952-431-4700.

MIDWAY BANK

Member FDIC

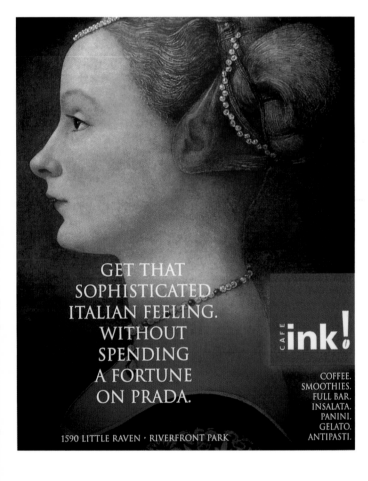

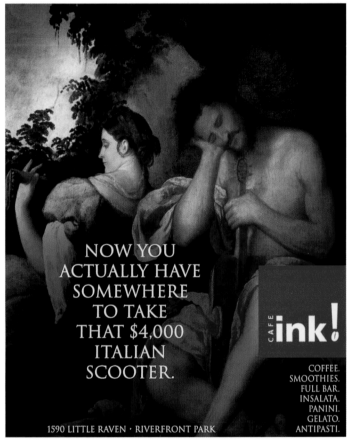

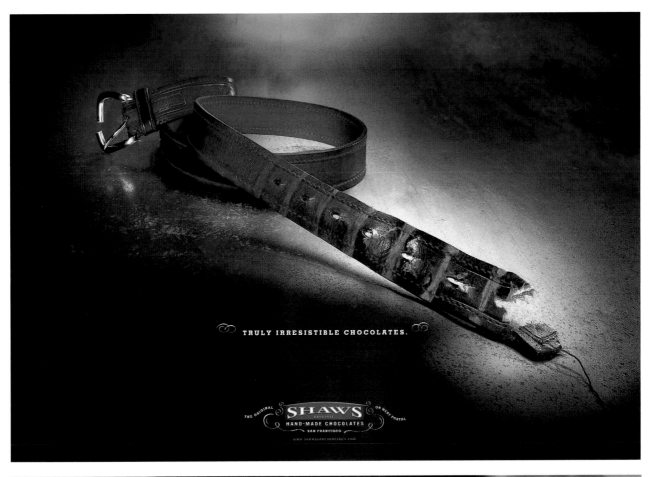

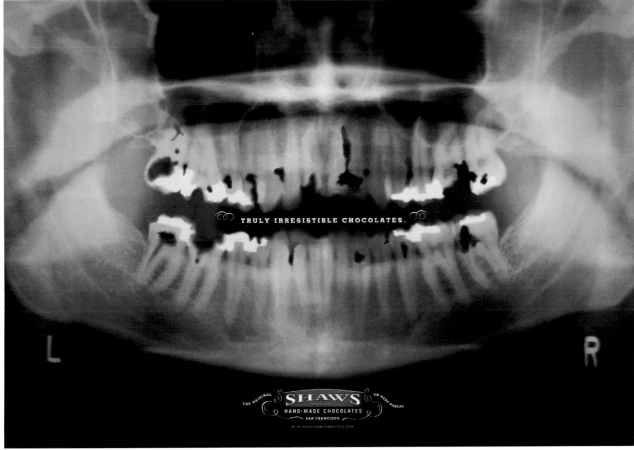

Agency: Theory Creative Directors: Jim McDonough and Jeff Heath Art Director: Jim McDonough Designer: Jim McDonough Photographer: Jim McDonough Copywriter: Giles Hancock Client: Shaw's Hand Made Chocolate

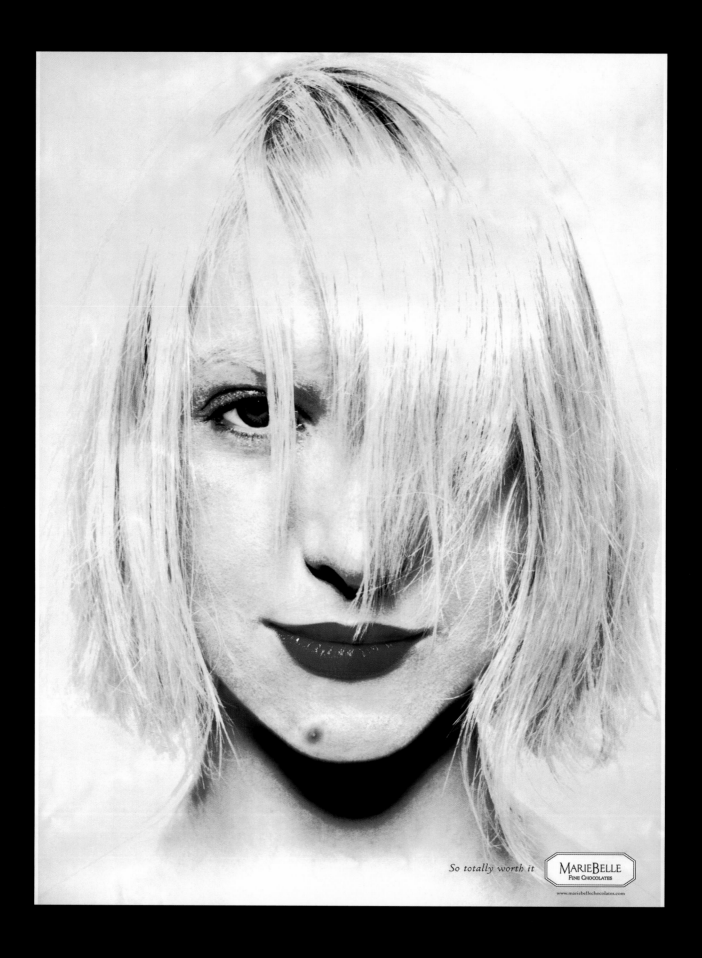

So totally worth it

MARIEBELLE
FINE CHOCOLATES

www.mariebellechocolates.com

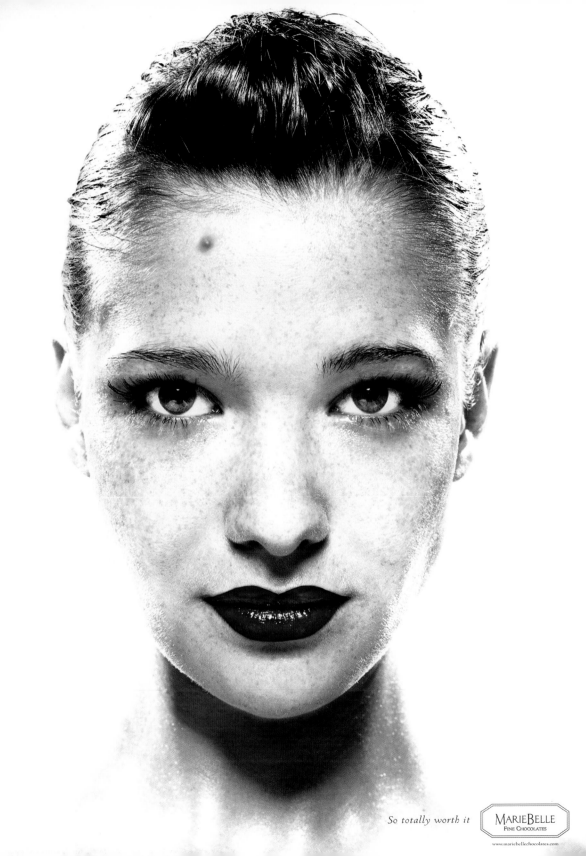

So totally worth it

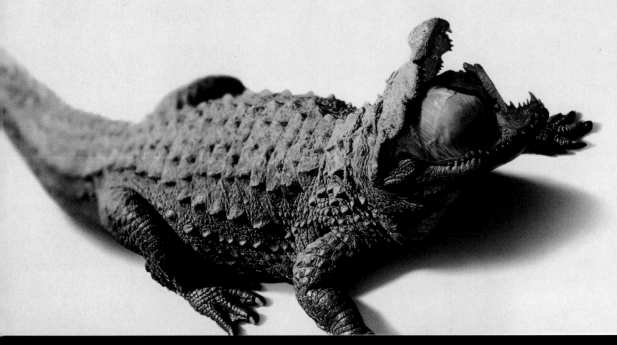

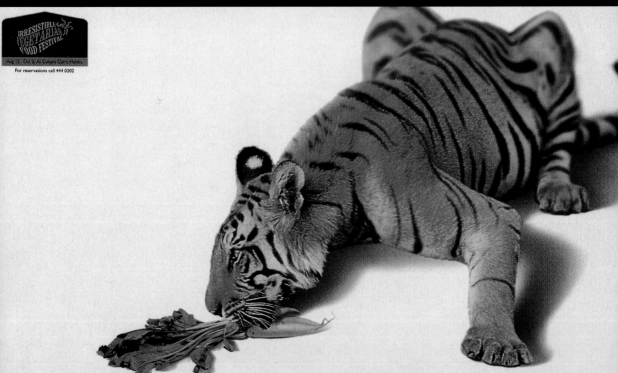

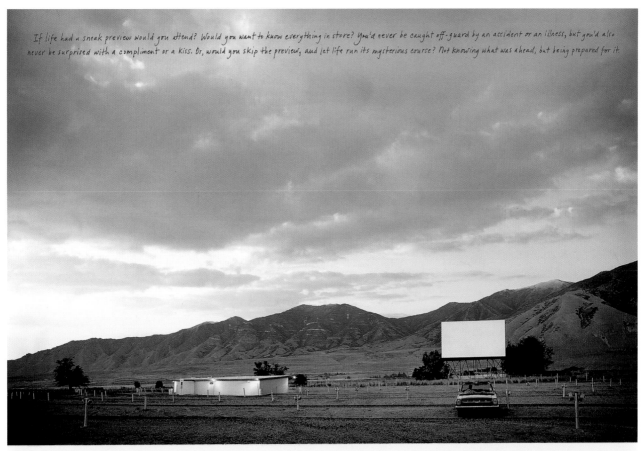

If life had a sneak preview would you attend? Would you want to know everything in store? You'd never be caught off-guard by an accident or an illness, but you'd also never be surprised with a compliment or a kiss. Or, would you skip the preview, and let life run its mysterious course? Not knowing what was ahead, but being prepared for it.

To learn more about a health plan that prepares you for life's uncertainties, visit firsthealth.com ♥ First Health.

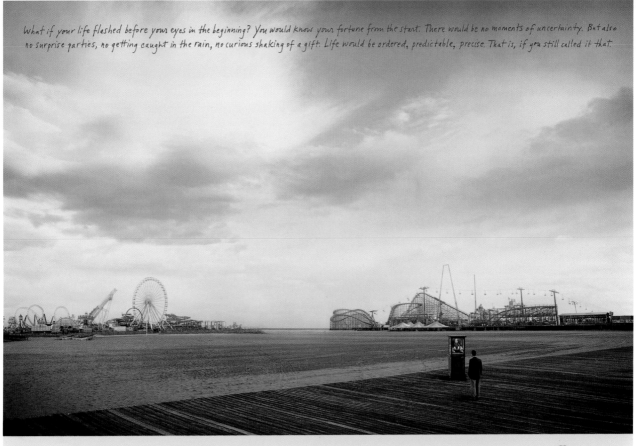

What if your life flashed before your eyes in the beginning? You would know your fortune from the start. There would be no moments of uncertainty. But also no surprise parties, no getting caught in the rain, no curious shaking of a gift. Life would be ordered, predictable, precise. That is, if you still called it that.

To learn more about a health plan that prepares you for life's uncertainties, visit firsthealth.com ♥ First Health.

Agency: Euro RSCG Tatham Partners Creative Director: Jim Schmidt Art Director: Joe Stuart Photographer: William Huber Copywriter: Elyse Maguire Client: First Health Health 110,111

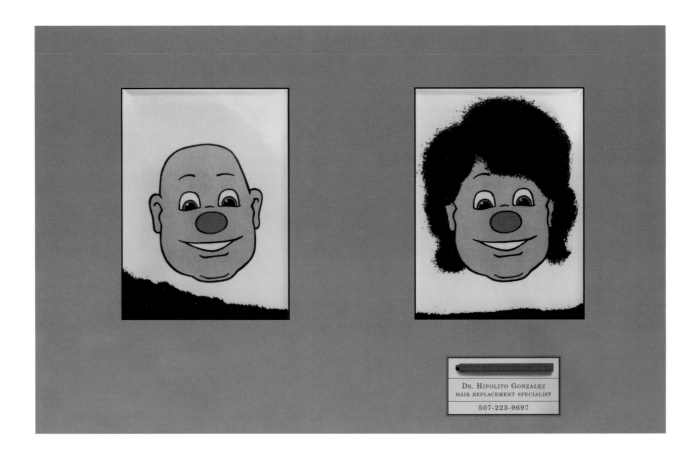

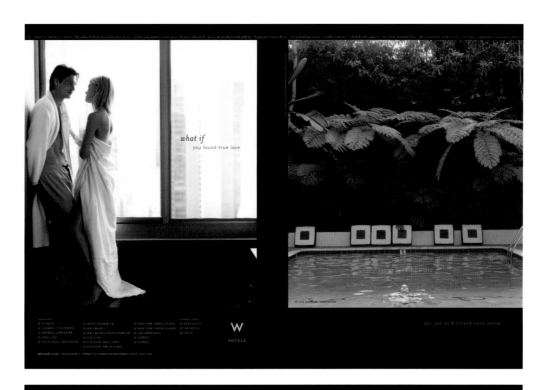

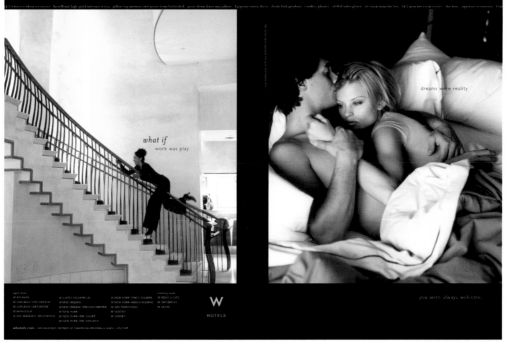

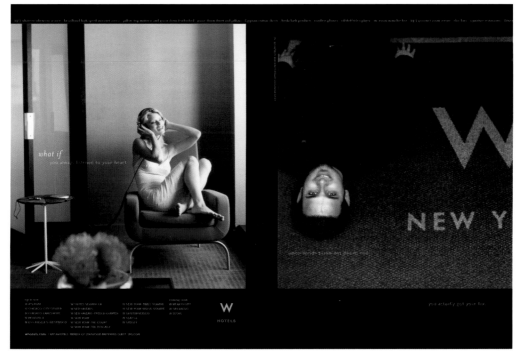

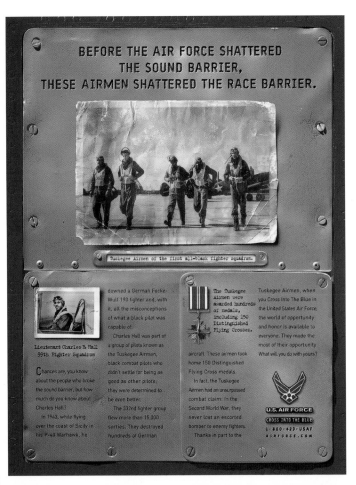

BEFORE THE AIR FORCE SHATTERED THE SOUND BARRIER, THESE AIRMEN SHATTERED THE RACE BARRIER.

Tuskegee Airmen of the first all-black fighter squadron.

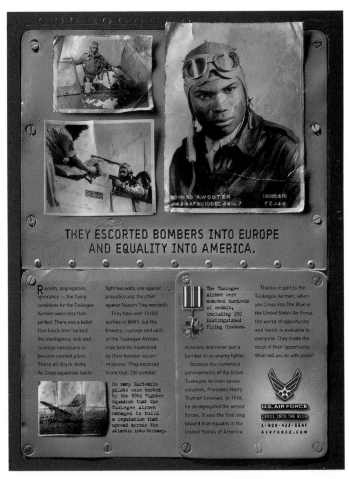

THEY ESCORTED BOMBERS INTO EUROPE AND EQUALITY INTO AMERICA.

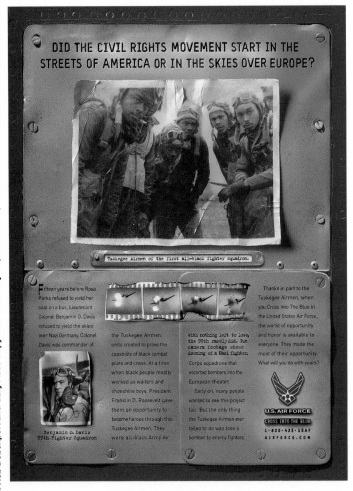

DID THE CIVIL RIGHTS MOVEMENT START IN THE STREETS OF AMERICA OR IN THE SKIES OVER EUROPE?

Tuskegee Airmen of the first all-black fighter squadron.

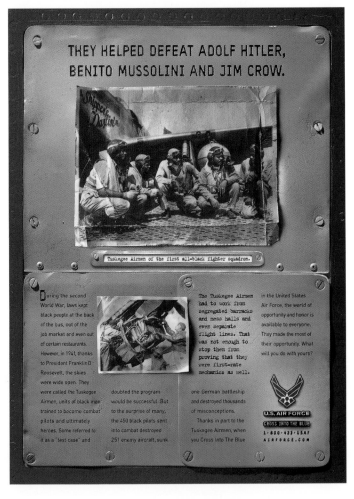

THEY HELPED DEFEAT ADOLF HITLER, BENITO MUSSOLINI AND JIM CROW.

Tuskegee Airmen of the first all-black fighter squadron.

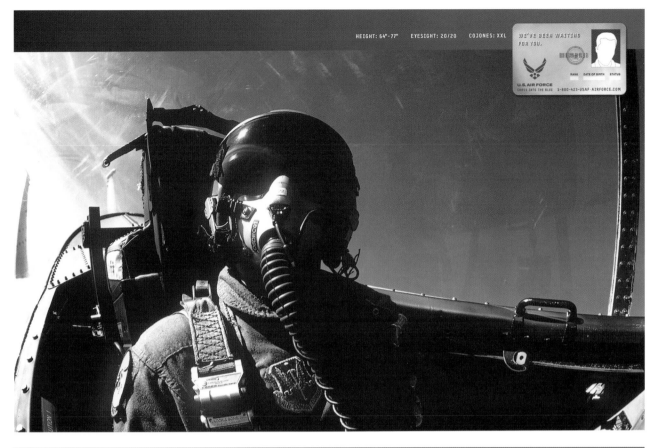

HEIGHT: 64"-77" EYESIGHT: 20/20 COJONES: XXL

WE'VE BEEN WAITING FOR YOU.

U.S. AIR FORCE
CROSS INTO THE BLUE 1-800-423-USAF-AIRFORCE.COM

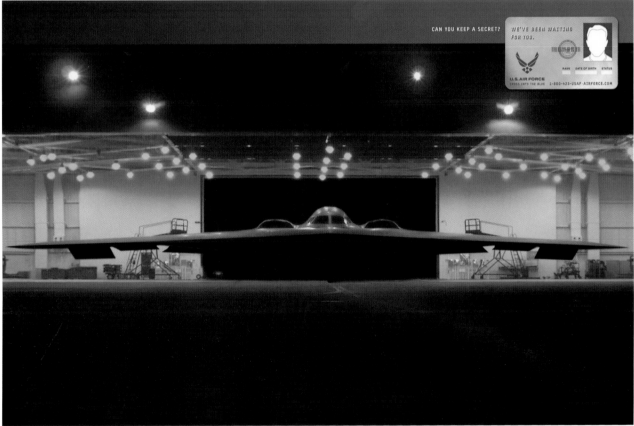

CAN YOU KEEP A SECRET?

WE'VE BEEN WAITING FOR YOU.

U.S. AIR FORCE
CROSS INTO THE BLUE 1-800-423-USAF-AIRFORCE.COM

Agency: GSD&M Creative Director: Brian Born Art Director: Brett Stiles Illustrator: Brett Stiles Copywriter: Chad Berry Group CD: Daniel Russ Client: United States Air Force

A HISTORY OF FRENCH EXPLORATION, COLONIZATION AND ORNAMENTATION.

WITH EVERY VICTORY,
FRENCH SAILORS WERE FILLED
WITH A SENSE of ENNUI.

WITH EVERY DEFEAT, SEAWATER.

17th century French sailors were forced to contend with more than the British navy. A sailor's lack of will and French designers' obsession with artistry were just as deadly. The bottom of the Atlantic, or a tribute to this. As are the lush paintings of French maritime artists and the exquisitely crafted ship models now on exclusive loan from The Musée national de la Marine in Paris.

A 17th century masterwork via the Musée national de la Marine, Paris.

July 12 - Oct 14
For details, visit
www.pem.org

RENDEZ-VOUS with THE SEA
THE GLORY OF THE FRENCH MARITIME TRADITION
AT THE PEABODY ESSEX MUSEUM

East India Square
Salem, MA 01970
978 745 9500

A HISTORY OF FRENCH EXPLORATION, COLONIZATION AND ORNAMENTATION.

FRENCH SHIPS HAVE
THE DISTINCTION of BEING TREASURES
LONG BEFORE THEY SANK
TO THE BOTTOM of the ATLANTIC.

French shipbuilders are considered to be the best in the world. Well, the model ones anyway. Each of the 31 intricately crafted ship models in our rare collection are the product of two dainty little fingers and a single huge, whopping obsession. These one of a kind masterworks are on exclusive loan from the 17th century and the Musée national de la Marine in Paris.

The Queen Victoria at Cherbourg by Léon-Antoine Morel-Fatio, 1858.

July 12 - Oct 14
For details, visit
www.pem.org

RENDEZ-VOUS with THE SEA
THE GLORY OF THE FRENCH MARITIME TRADITION
AT THE PEABODY ESSEX MUSEUM

East India Square
Salem, MA 01970
978 745 9500

A HISTORY OF FRENCH EXPLORATION, COLONIZATION AND ORNAMENTATION.

ONLY THE FRENCH COULD
USE 2/3 of THE
EARTH'S SURFACE AS
AN EXCUSE TO DECORATE.

Like everyone else, the French saw the open seas as a dark, foreboding place. But, it was nothing that a little intricate lattice work or a few lacey throw pillows couldn't overcome. Now you have a chance to lay your eyes upon these unique masterworks of maritime design that are on exclusive loan from the 17th century as well as The Musée national de la Marine in Paris.

A 17th century masterwork via the Musée national de la Marine, Paris.

July 12 - Oct 14
For details, visit
www.pem.org

RENDEZ-VOUS with THE SEA
THE GLORY OF THE FRENCH MARITIME TRADITION
AT THE PEABODY ESSEX MUSEUM

East India Square
Salem, MA 01970
978 745 9500

A HISTORY OF FRENCH EXPLORATION, COLONIZATION AND ORNAMENTATION.

THE ENGLISH
WERE AWED BY THE ARTISTRY
of FRENCH SHIPS.

THE FRENCH
WERE AWED BY THE THUNDER
of ENGLISH CANNONS.

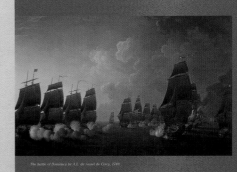

The Brits treated the French navy the same way they will treat their cuisine. They battered and fried it. French vessels were more an expression of embellishment than conquest. You can have experience that strong through the renowned works of French painters on exclusive loan from the 17th century and The Musée national de la Marine in Paris.

The battle of Dominica by A.L. de rossel de Cercy, 1789.

July 12 - Oct 14
For details, visit
www.pem.org

RENDEZ-VOUS with THE SEA
THE GLORY OF THE FRENCH MARITIME TRADITION
AT THE PEABODY ESSEX MUSEUM

East India Square
Salem, MA 01970
978 745 9500

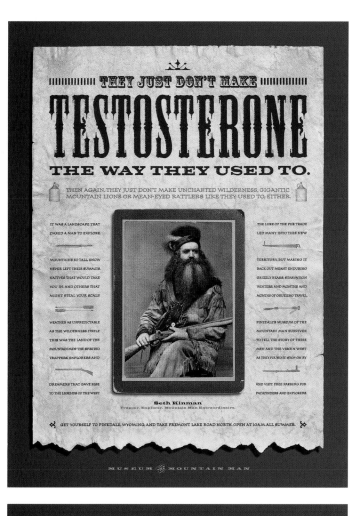

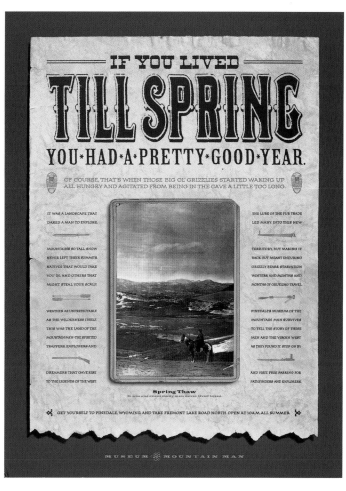

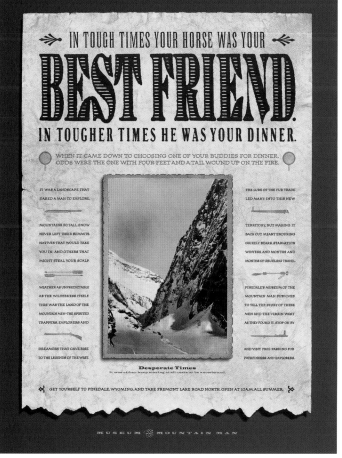

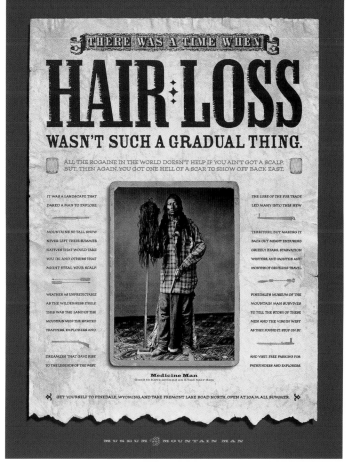

Agency: Howard, Merrell & Partners Creative Director: Scott Crawford Art Director: Scott Ballew Photographers: Bruce Deboer and Dan Abernathy Illustrator: Scotty Cherryholmes Copywriter: Charlie Sims Client: The Museum of the Mountain Man

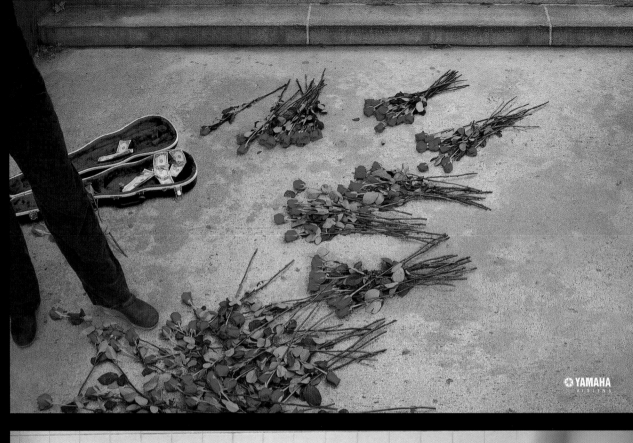

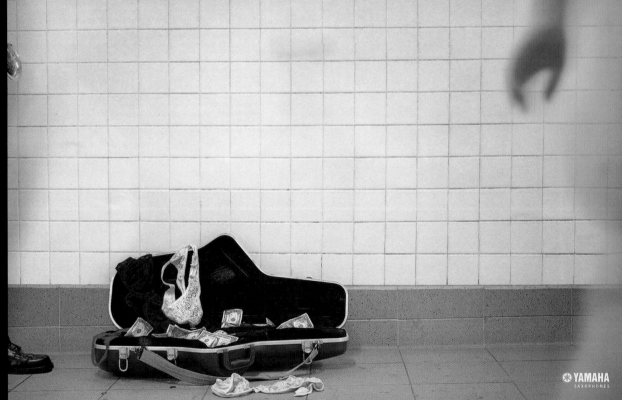

Agency: Bozell NY Creative Director: Tony Granger Art Director: Steve Mitsch Photographer: Richard Wallace Copywriter: Shannon Fagan Art Producer: Hillary Frileck Group CD: David Nobars Client: Woodwind & Brasswind NY

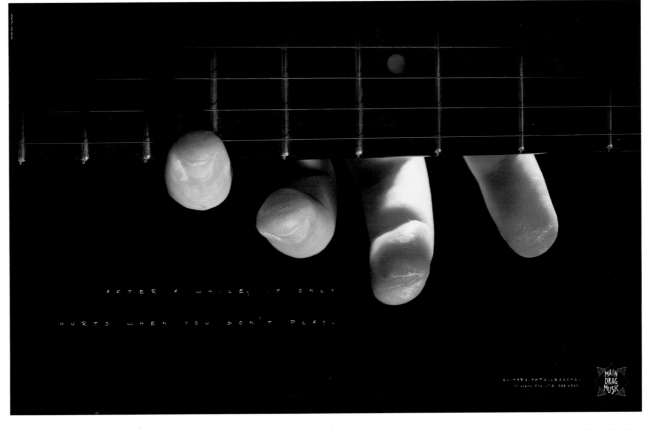

Agency: Young & Rubicam Art Director: Kleber Menezes Photographer: Luciano Filleti Copywriter: Corey Rakowsky Client: Main Drag Music

For healthy, flexible joints.

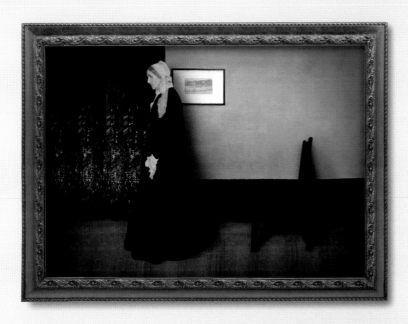

For healthy, flexible joints.

Unlike other vacuums, the suction power of a Dyson doesn't decline.

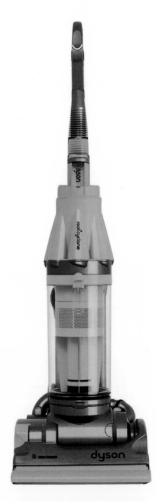

Although manufacturers are reluctant to admit it, other vacuums on the market today quickly get clogged and lose suction. Not Dyson. In fact, after picking up just ten ounces of dust, a Dyson has double the suction power of other vacuums. And now, it's here in America. So, come see a Dyson today. It's the vacuum. Reinvented. For more, visit www.dyson.com. **Available now at Best Buy.**

Unlike other vacuums that clog, the suction power of a Dyson doesn't fade. Unlike other vacuums that clog, the suction power of a Dyson doesn't fade. Unlike other vacuums that clog, the suction power of a Dyson doesn't fade. Unlike other vacuums that clog, the suction power of a Dyson doesn't fade. Unlike other vacuums that clog, the suction power of a Dyson doesn't fade. Unlike other vacuums that clog, the suction power of a Dyson doesn't fade. Unlike other vacuums that clog, the suction power of a Dyson doesn't fade. Unlike other vacuums that clog, the suction power of a Dyson doesn't fade. Unlike other vacuums that clog, the suction power of a Dyson doesn't fade. Unlike other vacuums that clog, the suction power of a Dyson doesn't fade. Unlike other vacuums that clog, the suction power of a Dyson doesn't fade. Unlike other vacuums that clog, the suction power of a Dyson doesn't fade. Unlike other vacuums that clog, the suction power of a Dyson doesn't fade. Unlike other vacuums that clog, the suction power of a Dyson doesn't fade. Unlike other vacuums that clog, the suction power of a Dyson doesn't fade. Unlike other vacuums that clog, the suction power of a Dyson doesn't fade. Unlike other vacuums that clog, the suction power of a Dyson doesn't fade. Unlike other vacuums that clog, the suction power of a Dyson doesn't fade. Unlike other vacuums that clog, the suction power of a Dyson doesn't fade. Unlike other vacuums that clog, the suction power of a Dyson doesn't fade. Unlike other vacuums that clog, the suction power of a Dyson doesn't fade. Unlike other vacuums that clog, the suction power of a Dyson doesn't fade. Unlike other vacuums that clog, the suction power of a Dyson doesn't fade. Unlike other vacuums that clog, the suction power of a Dyson doesn't fade. Unlike other vacuums that clog, the suction power of a Dyson doesn't fade. Unlike other vacuums that clog, the suction power of a Dyson doesn't fade. Unlike other vacuums that clog, the suction power of a Dyson doesn't fade. Unlike other vacuums that clog, the suction power of a Dyson doesn't fade. Unlike other vacuums that clog, the suction power of a Dyson doesn't fade. Unlike other vacuums that clog, the suction power of a Dyson doesn't fade. Unlike other vacuums that clog, the suction power of a Dyson doesn't fade. Unlike other vacuums that clog, the suction power of a Dyson doesn't fade. Unlike other vacuums that clog, the suction power of a Dyson doesn't fade. Unlike other vacuums that clog, the suction power of a Dyson doesn't fade. Unlike other vacuums that clog, the suction power of a Dyson doesn't fade. Unlike other vacuums that clog, the suction power of a Dyson doesn't fade. Unlike other vacuums that clog, the suction power of a Dyson doesn't fade. Unlike other vacuums that clog, the suction power of a Dyson doesn't fade. Unlike other vacuums that clog, the suction power of a Dyson doesn't fade. Unlike other vacuums that clog, the suction power of a Dyson doesn't fade. Unlike other vacuums that clog, the suction power of a Dyson doesn't fade. Unlike other vacuums that clog, the suction power of a Dyson doesn't fade. Unlike other vacuums that clog, the suction power of a Dyson doesn't fade. Unlike other vacuums that clog, the suction power of a Dyson doesn't fade. Unlike other vacuums that clog, the suction power of a Dyson doesn't fade. Unlike other vacuums that clog, the suction power of a Dyson doesn't fade. Unlike other vacuums that clog, the suction power of a Dyson doesn't fade. Unlike other vacuums that clog, the suction power of a Dyson doesn't fade. Unlike other vacuums that clog, the suction power of a Dyson doesn't fade. Unlike other vacuums that clog, the suction power of a Dyson doesn't fade. Unlike other vacuums that clog, the suction power of a Dyson doesn't fade. Unlike other vacuums that clog, the suction power of a Dyson doesn't fade. Unlike other vacuums that clog, the suction power of a Dyson doesn't fade. Unlike other vacuums that clog, the suction power of a Dyson doesn't fade. Unlike other vacuums that clog, the suction power of a Dyson doesn't fade. Unlike other vacuums that clog, the suction power of a Dyson doesn't fade. Unlike other vacuums that clog, the suction power of a Dyson doesn't fade. Unlike other vacuums that clog, the suction power of a Dyson doesn't fade. Unlike other vacuums that clog, the suction power of a Dyson doesn't fade. Unlike other vacuums that clog, the suction power of a Dyson doesn't fade. Unlike other vacuums that clog, the suction power of a Dyson doesn't fade. Unlike other vacuums that clog, the suction power of a Dyson doesn't fade. Unlike other vacuums that clog, the suction power of a Dyson doesn't fade. Unlike other vacuums that clog, the suction power of a Dyson doesn't fade. Unlike other vacuums that clog, the suction power of a Dyson doesn't fade. Unlike other vacuums that clog, the suction power of a Dyson doesn't fade. Unlike other vacuums that clog, the suction power of a Dyson doesn't fade. Unlike other vacuums that clog, the suction power of a Dyson doesn't fade. Unlike other vacuums that clog, the suction power of a Dyson doesn't fade.

dyson

Available at Best Buy and Sears.

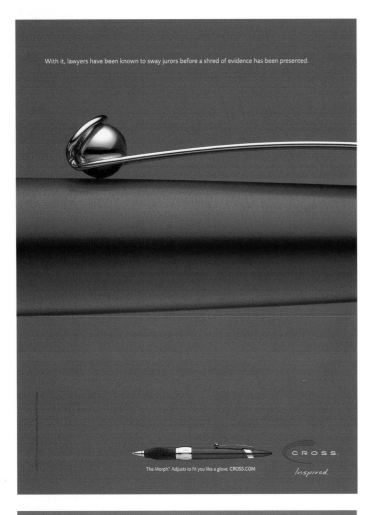

With it, lawyers have been known to sway jurors before a shred of evidence has been presented.

The Morph.™ Adjusts to fit you like a glove. CROSS.COM

CROSS

Inspired.

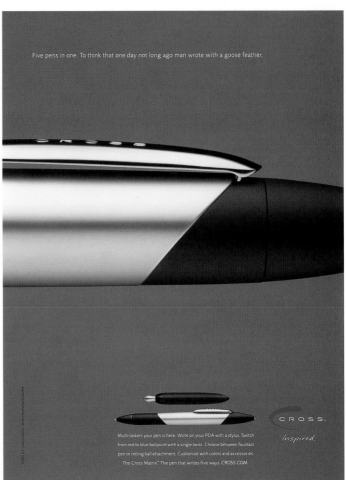

Five pens in one. To think that one day not long ago man wrote with a goose feather.

Multi-taskers your pen is here. Write on your PDA with a stylus. Switch from red to blue ballpoint with a single twist. Choose between fountain pen or rolling ball attachment. Customize with colors and accessories. The Cross Matrix.™ The pen that writes five ways. CROSS.COM

CROSS

Inspired.

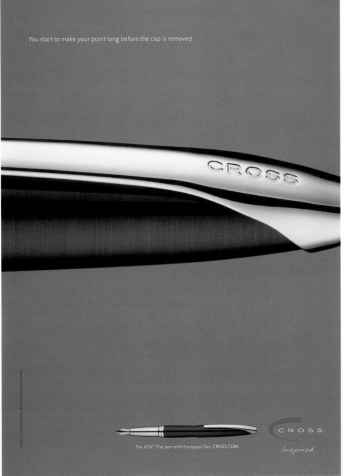

You start to make your point long before the cap is removed.

The ATX® The pen with European flair. CROSS.COM

CROSS

Inspired.

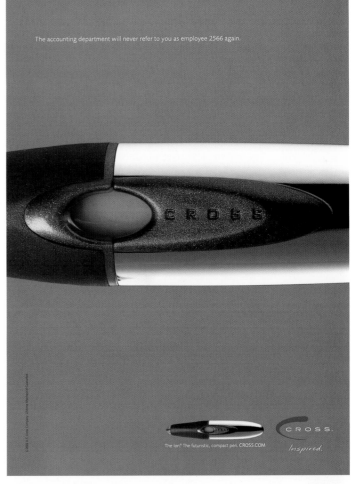

The accounting department will never refer to you as employee 2566 again.

The Ion® The futuristic, compact pen. CROSS.COM

CROSS

Inspired.

(this spread) Agency: Carmichael Lynch Creative Director: Jim Nelson Art Director: Libby Brockhoff Photographer: Norman Copywriter: Tom Camp Client: ATCross

Even if you don't leave any important writing behind, the pen alone makes an excellent legacy.

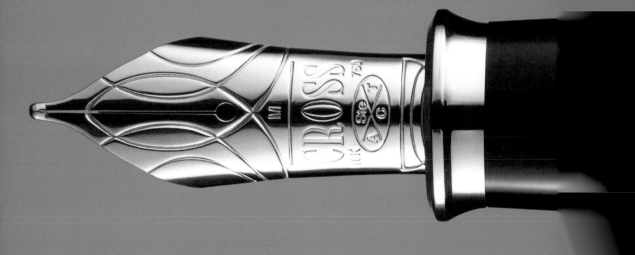

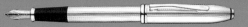

The Cross Townsend.® The pen of distinction. CROSS.COM

CROSS.

Inspired.

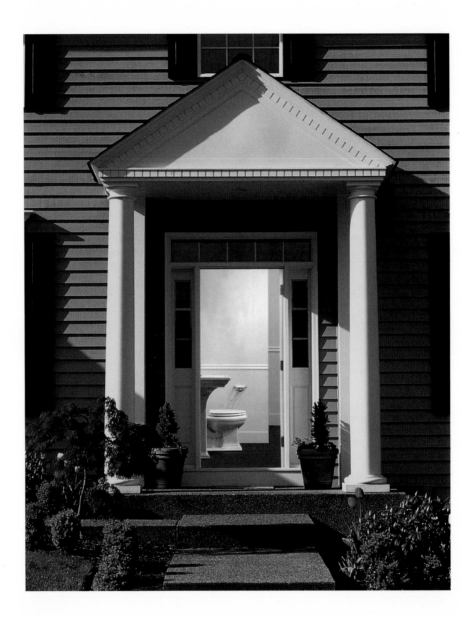

 Made to show off.

NATE PROPERTIES
BATHROOMS

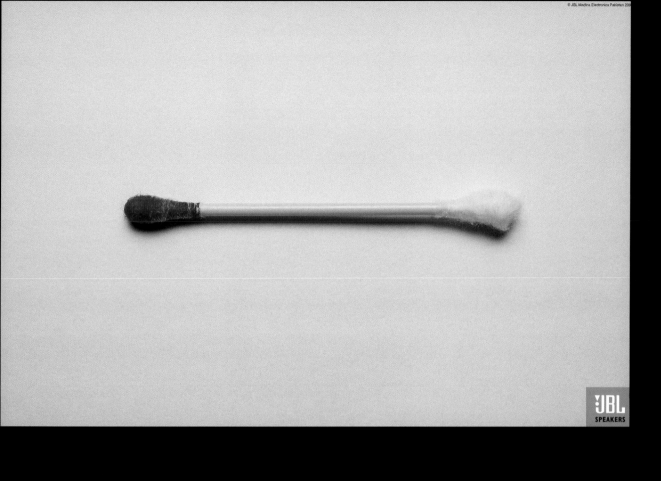

JBL
SPEAKERS

Advertising Art Director: Ali Mumtaz Photographer: Amean J. Mohammed Copywriter: Ali Mumtaz Client: Madina Electronics

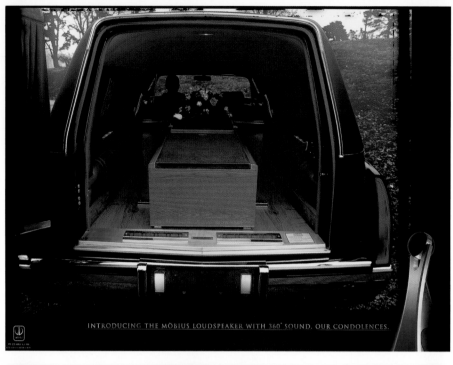

INTRODUCING THE MÖBIUS LOUDSPEAKER WITH 360° SOUND. OUR CONDOLENCES.

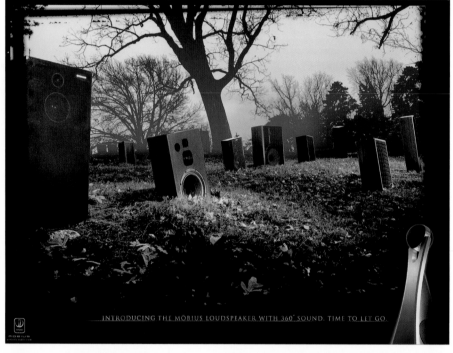

INTRODUCING THE MÖBIUS LOUDSPEAKER WITH 360° SOUND. TIME TO LET GO.

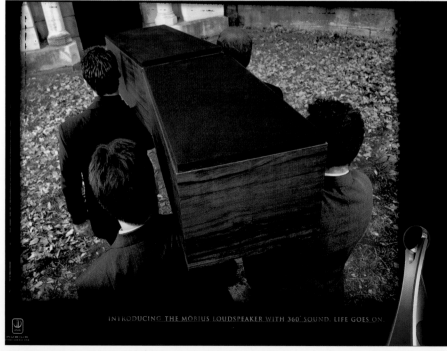

INTRODUCING THE MÖBIUS LOUDSPEAKER WITH 360° SOUND. LIFE GOES ON.

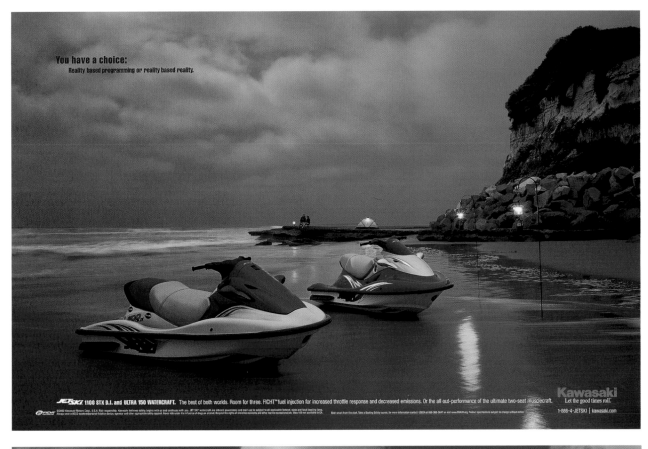

You have a choice:
Reality based programming or reality based reality.

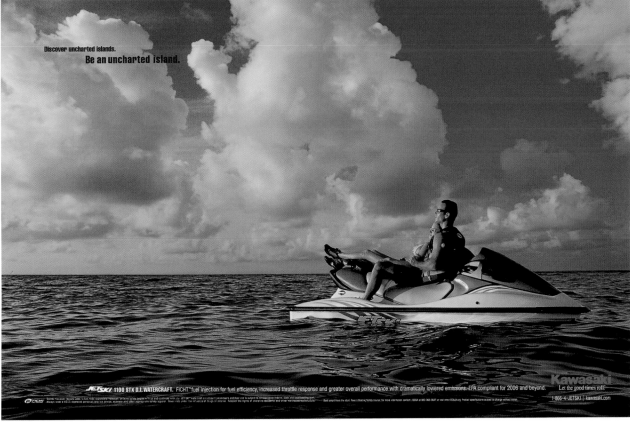

Discover uncharted islands.
Be an uncharted island.

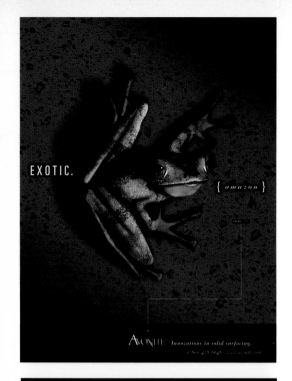

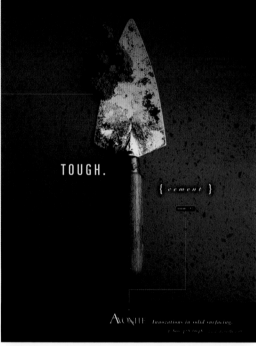

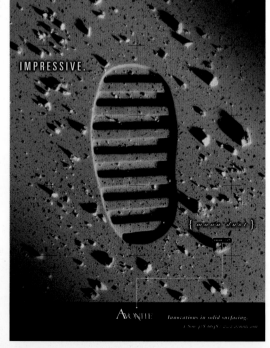

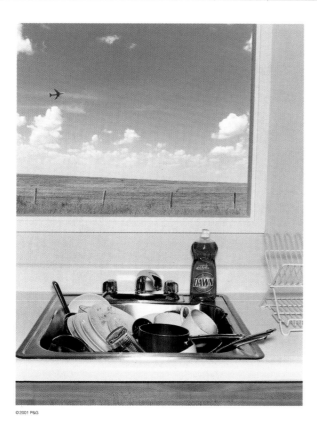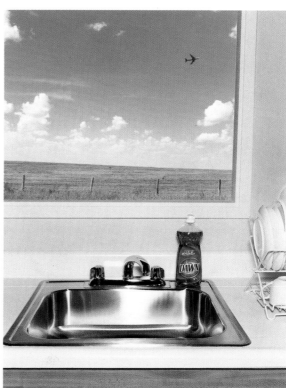

©2001 P&G

INTRODUCING *FASTER ACTING* DAWN.®

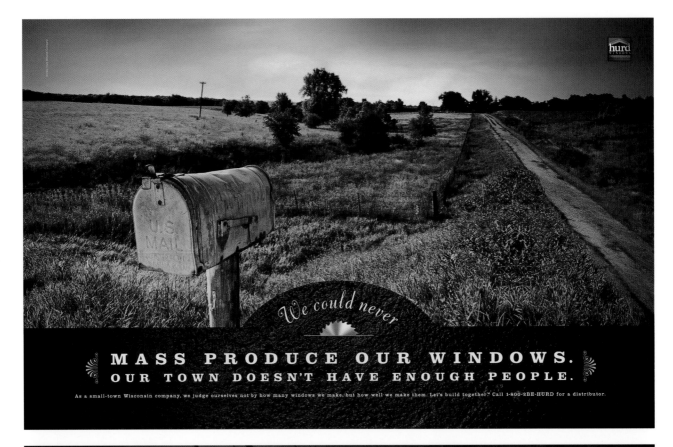

We could never

MASS PRODUCE OUR WINDOWS.
OUR TOWN DOESN'T HAVE ENOUGH PEOPLE.

As a small-town Wisconsin company, we judge ourselves not by how many windows we make, but how well we make them. Let's build together." Call 1-800-2BE-HURD for a distributor.

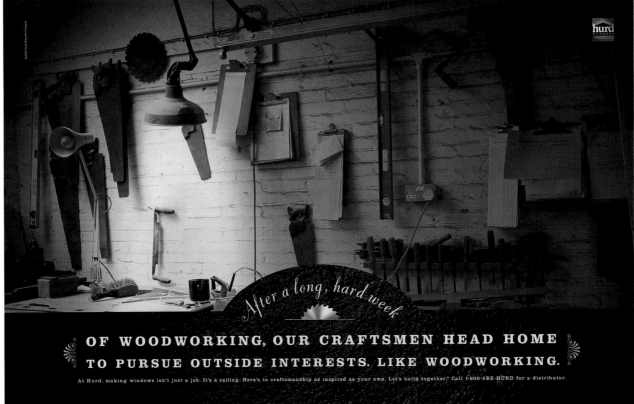

After a long, hard week

OF WOODWORKING, OUR CRAFTSMEN HEAD HOME
TO PURSUE OUTSIDE INTERESTS. LIKE WOODWORKING.

At Hurd, making windows isn't just a job. It's a calling. Here's to craftsmanship as inspired as your own. Let's build together." Call 1-800-2BE-HURD for a distributor.

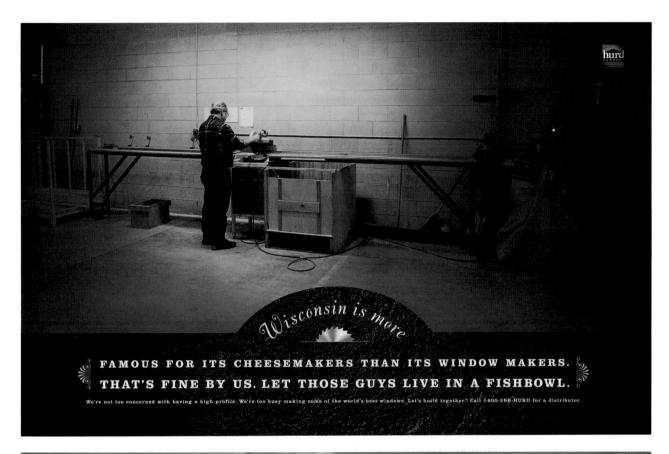

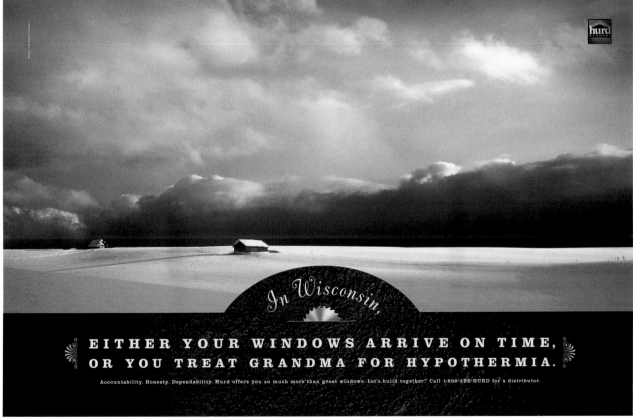

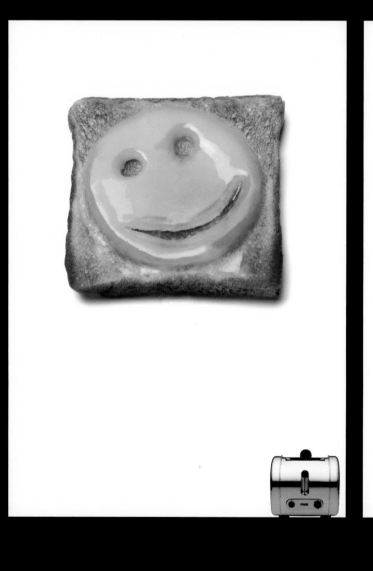
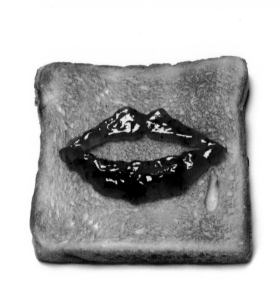

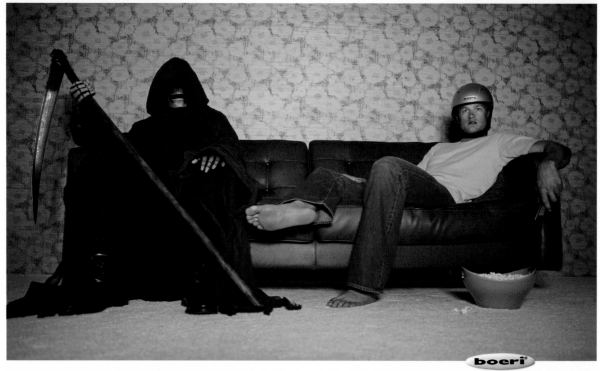

boeri
it's your head

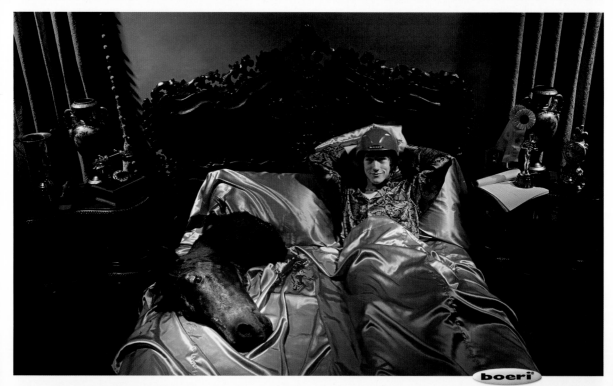

boeri
it's your head

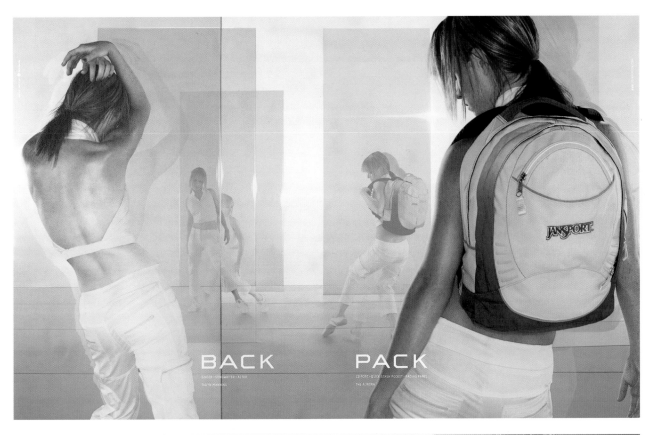

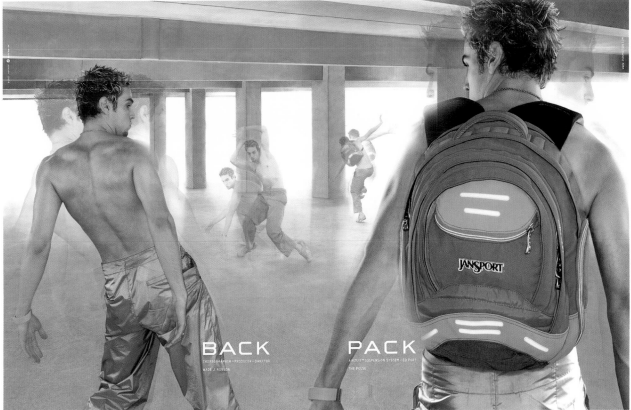

Agency: DDB Seattle Creative Director: Fred Hammerquist Art Director: Larry Olson Designers: Marisa Powell and Tracy Guza Photographer: Tim Simmons Copywriter: Angela Reid Client: Jan Sport

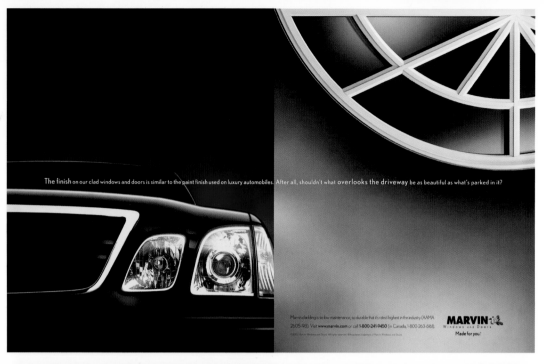

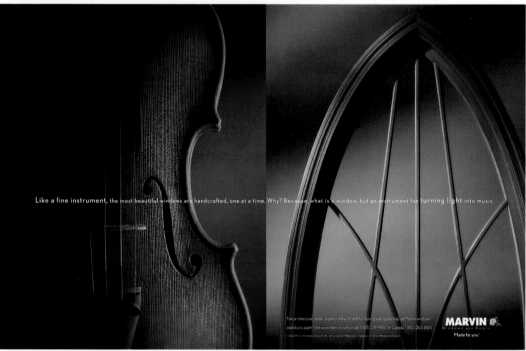

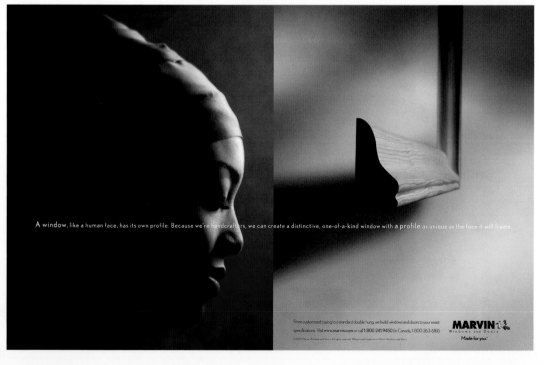

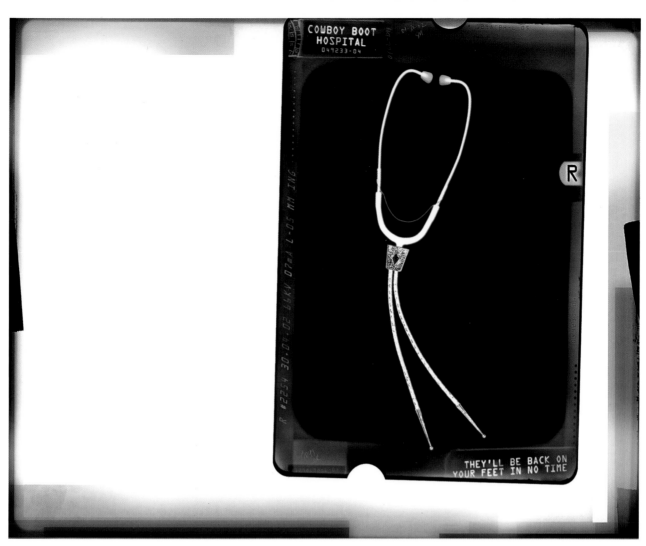

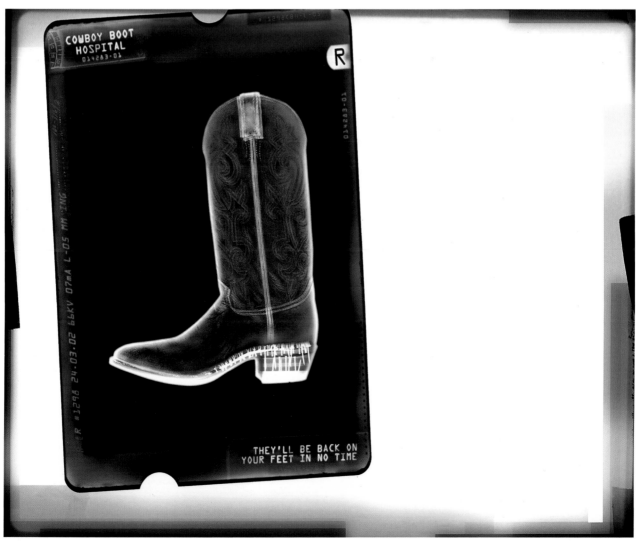

Art Director: Mark Moffett Designer: Scott Harwood Products 140,141

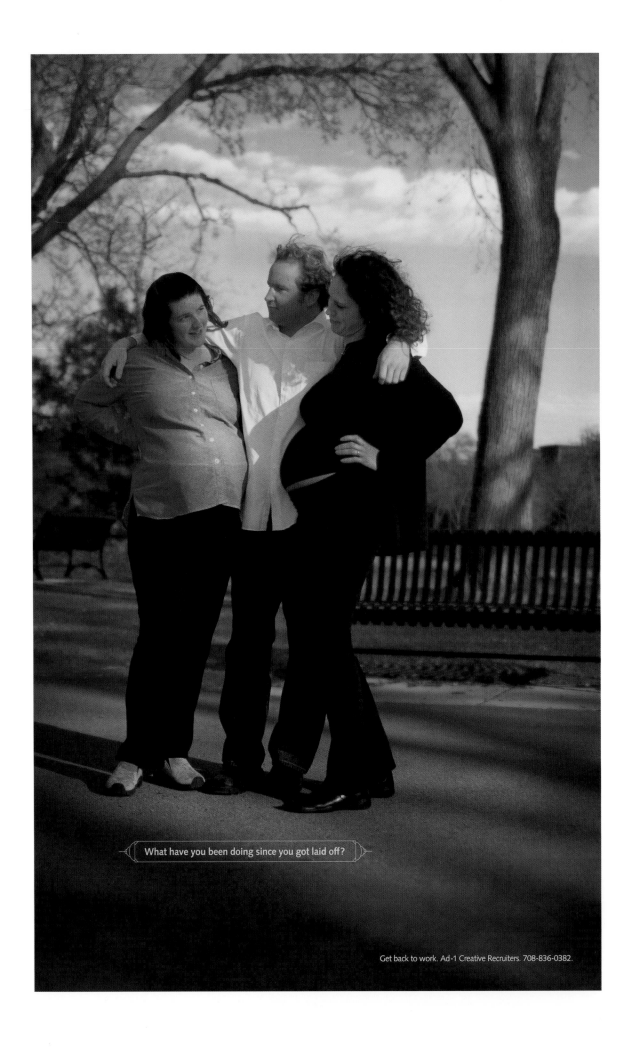

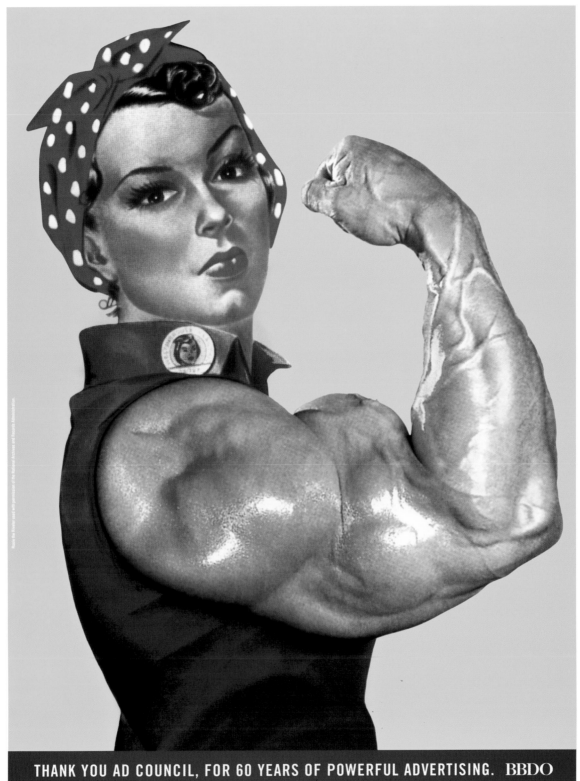

THANK YOU AD COUNCIL, FOR 60 YEARS OF POWERFUL ADVERTISING. BBDO

'Rosie the Riveter' Agency: BBDO New York Creative Director: Ted Sann Art Directors: Frank Anselmo and Jayson Atienza
Designers: Frank Anselmo and Jayson Atienza Copywriters: Jayson Atienza and Frank Anselmo Retouching: Joan Wood Client: Ad Council
Professional Services 142, 143

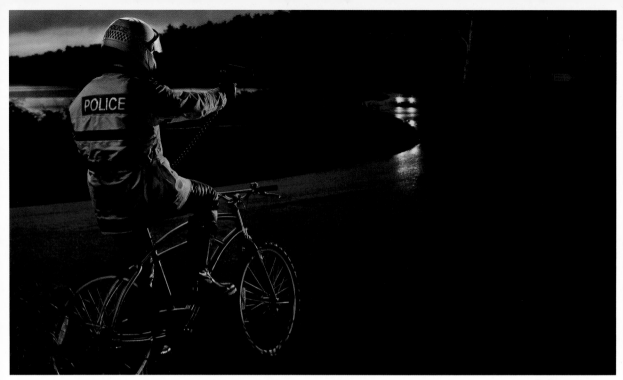

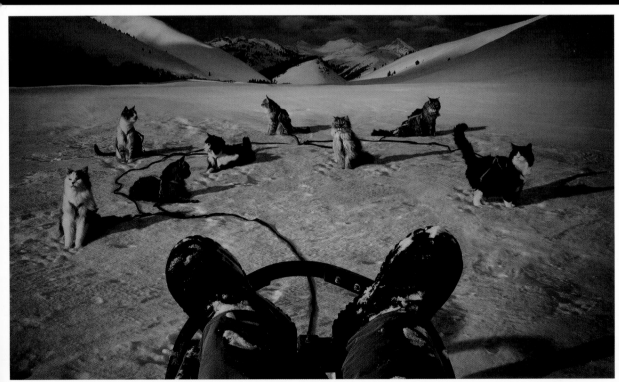

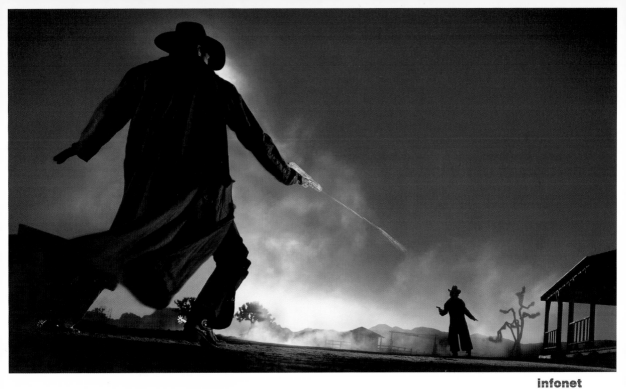

Without the right tools, you won't get far. At Infonet, we really get to know your business needs. That way you can be sure you're getting the right communication solutions for your company. For more information, visit www.infonet.com.

infonet
INSIGHT MATTERS

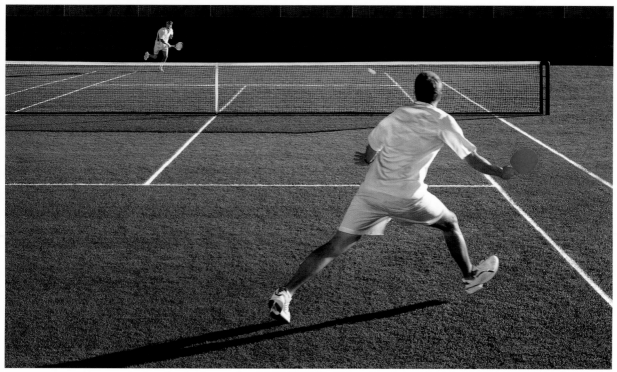

Without the right tools, you won't get far. At Infonet, we really get to know your business needs. That way you can be sure you're getting the right communication solutions for your company. For more information, visit www.infonet.com.

Infonet®
INSIGHT MATTERS™

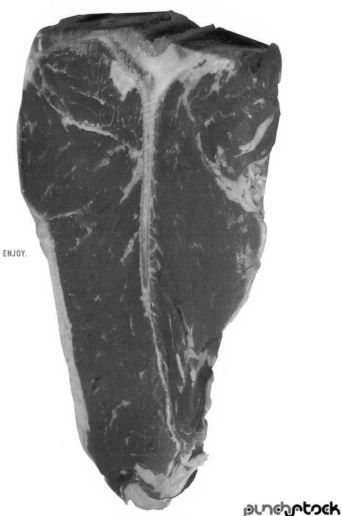

>>> YOU WANT PRIME? WE GOT PRIME. **EVERY BRAND THAT MATTERS: ARIDI, ARTVILLE, BANANA STOCK, BRAND X PICTURES, CORBIS, DIGITAL VISION, EYEWIRE, GOODSHOOT, IMAGE100, IMAGESTATE, IMAGESOURCE, MAP RESOURCES, PHOTODISC, RUBBERBALL, STOCKBYTE, AND VISUAL LANGUAGE. NO NEED TO GO ELSEWHERE. IT'S ALL AT PUNCHSTOCK. YOUR FIRST-STOP SHOP. YOUR ONLY-STOP SHOP.** >>> YOU WANT CHOICE? WE GOT CHOICE. **MORE THAN 185,000 IMAGES. MORE THAN 1,750 CD TITLES. IT ALL ADDS UP TO THE LARGEST AND MOST DIVERSE COLLECTION OF ROYALTY-FREE IMAGERY ANYWHERE. WHAT'S MORE, EVERY FRESH MONTH BRINGS FRESH NEW STUFF.** >>> YOU WANT FAST? WE GOT FAST. **OUR INTUITIVE NAVIGATION MAKES IT EASY TO SEARCH, PURCHASE, AND DOWNLOAD WHATEVER YOU'RE LOOKING FOR. AND WITH OUR NEW INSTANT PURCHASE ORDER (IPO), YOU CAN BUY AND DOWNLOAD IMAGES 24/7, WITHOUT A CREDIT CARD.** >>> YOU WANT STEAK? WE GOT STEAK. **IMAGE# 11408423.**

ENJOY.

punchstock
WWW.PUNCHSTOCK.COM
800.390.0461

© 2002 PUNCHSTOCK

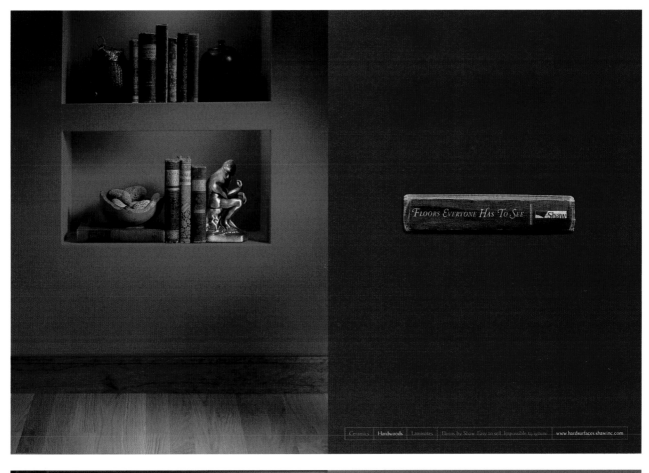

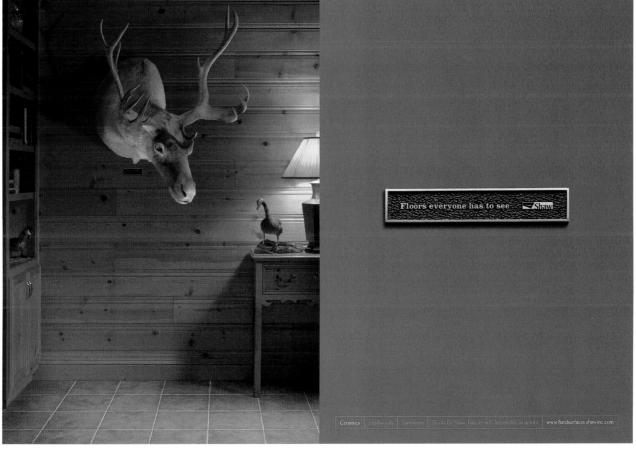

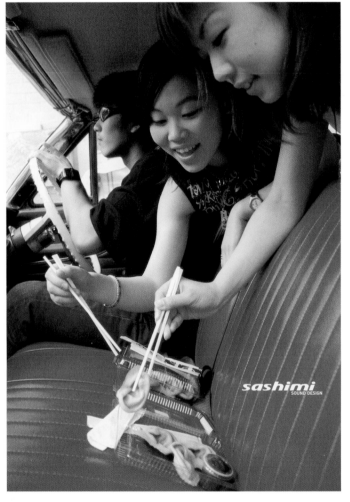
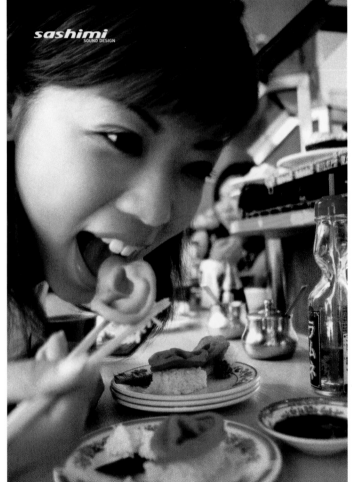

(this spread) Agency: De Pascuale Creative Director: Nic Harman Art Director: Grant Johnson Photographer: Vincent Long Copywriter: Grant Johnson Client: Sashimi Sound Design

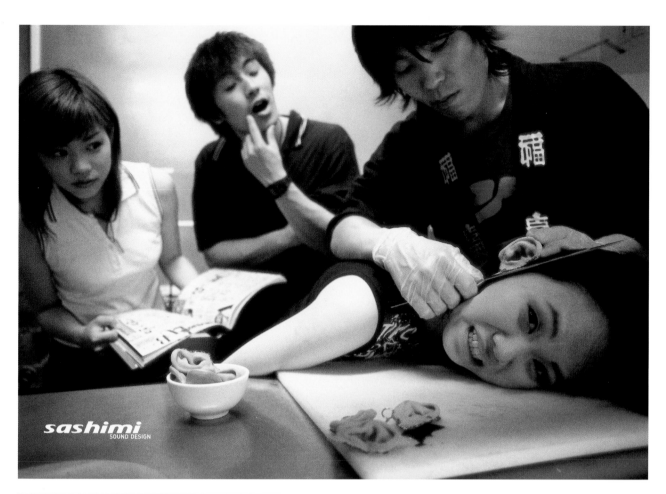

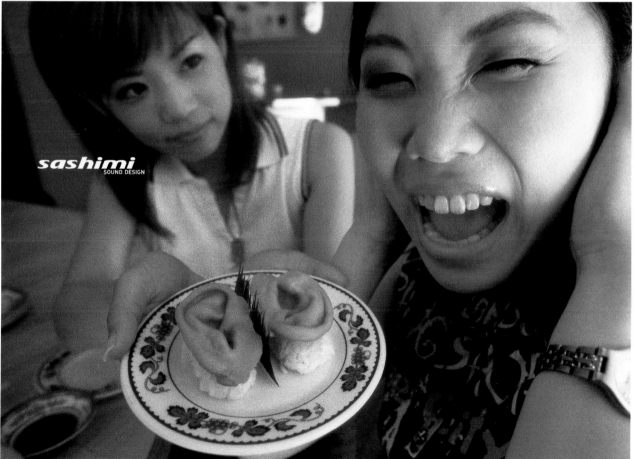

Sinbad started and looked fixedly at him, as he replied: "What makes you suppose so?"

"Everything!" answered Franz; "your voice, your look, your pallid complexion, and even the life you lead."

"I! I live the happiest life possible, the real life of a pasha. I am king of all creation. I am pleased with one place and stay there; I get tired of it and leave it; I am free as a bird, and have wings like one; my attendants obey me at a signal. Sometimes I amuse myself by carrying off from human justice some bandit it is in quest of, some criminal whom it pursues. Then I have my mode of dispensing justice, silent and sure, without respite or appeal, which condemns or pardons, and which no one sees. Ah! if you had tasted my life, you would not desire any other, and would never return to the world unless you had some great project to accomplish there."

"A vengeance, for instance," observed Franz.

The unknown fixed on the young man one of those looks which penetrate into the depth of the heart and thoughts.

"And why a vengeance?" he asked.

"Because," replied Franz, "you seem to me like a man who, persecuted by society, has a fearful account to settle with it."

"Ah!" responded Sinbad, laughing with his singular laugh, which displayed his white and sharp teeth. "You have not guessed rightly! Such as you see me I am, a sort of philosopher, and one day, perhaps, I shall go to Paris to rival M. Appert, and the little man in the blue cloak."

"And will that be the first time you ever took that journey?"

"Yes, it will! I must seem to you by no means curious, but I assure you that it is not my fault I have delayed it so long—it will happen one day or the other."

"And do you propose to make this journey very shortly?"

"I do not know; it depends on circumstances which depend on certain arrangements!"

"I should like to be there at the time you come and I will endeavor to repay you, as far as lies in my power, for your liberal hospitality, displayed to me at Monte Cristo."

"I should avail myself of your offer with pleasure," re-

The Count of Monte Cristo — pages 304–305

"And for pirates?"

"And for pirates," returned Gaetano, repeating Franz's words. "It is for that reason I have given orders to pass the isle, for, as you see, the fire is behind us."

"But this fire?" continued Franz. "It seems to me rather to assure than alarm us; men who did not wish to be seen would not light a fire."

"Oh, that goes for nothing," said Gaetano. "If you can guess the position of the isle in the darkness, you will see that the fire cannot be seen from the side, or from Pianosa, but only from the sea."

"You think, then, that this fire announces unwelcome neighbors?"

"That is what we must ascertain," returned Gaetano, fixing his eyes on this terrestrial star.

"How can you ascertain?"

"You shall see."

Gaetano consulted with his companions, and after five minutes' discussion a manoeuvre was executed which caused the vessel to tack about, they returned the way they had come, and in a few minutes the fire disappeared, hidden by a rise in the land. The pilot again changed the course of the little bark, which rapidly approached the isle, and was soon within fifty paces of it. Gaetano lowered the sail, and the bark remained stationary. All this was done in silence, and since their course had been changed, not a word was spoken.

Gaetano, who had proposed the expedition, had taken all the responsibility on himself; the four sailors fixed their eyes on him, while they prepared their oars and held themselves in readiness to row away, which, thanks to the darkness, would not be difficult. As for Franz, he examined his arms with the utmost coolness; he had two double-barrelled guns and a rifle; he loaded them, looked at the locks, and waited quietly. During this time the captain had thrown off his vest and shirt, and secured his trousers round his waist; his feet were naked, so he had no shoes and stockings to take off; after these preparations he placed his fingers on his lips, and lowering himself noiselessly into the sea, swam toward the shore with such precaution that it was impossible to hear the slightest sound; he could only be traced by the phosphorescent line in his wake. This track soon disappeared; it was evident that

he had touched the shore. Every one on board remained motionless during half an hour, when the same luminous track was again observed, and in two strokes he had regained the bark.

"Well!" exclaimed Franz and the sailors all together.

"They are Spanish smugglers," said he; "they have with them two Corsican bandits."

"And what are these Corsican bandits doing here with Spanish smugglers?"

"Alas!" returned the captain, with an accent of the most profound pity, "we ought always to help one another. Very often the bandits are hard pressed by gendarmes or carabineers; well, they see a bark, and good fellows like us on board, they come and demand hospitality of us; you can't refuse help to a poor hunted devil; we receive them, and for greater security we stand out to sea. This costs us nothing, and saves the life, or at least the liberty, of a fellow-creature, who on the first occasion returns the service by pointing out some safe spot where we can land our goods without interruption."

"Ah!" said Franz, "then you are a smuggler occasionally, Gaetano?"

"Your excellency, we must live somehow," returned the other, smiling in a way impossible to describe.

"Then you know the men who are on Monte Cristo?"

"Oh, yes, we sailors are like freemasons, and recognize each other by signs."

"And do you think we have nothing to fear if we land?"

"Nothing at all; smugglers are not thieves."

"But these two Corsican bandits?" said Franz, calculating the chances of peril.

"It is not their faults that they are bandits, but that of the authorities."

"How so?"

"Because they are pursued for having made a peau, as if it was not in a Corsican's nature to revenge himself."

"What do you mean by having made a peau?—having assassinated a man?" said Franz, continuing his investigation.

"I mean that they have killed an enemy, which is a very different thing," returned the captain.

"Well," said the young man, "let us demand hospitality

A Tree Grows in Brooklyn — pages 126–127

"Gladly!" Miss Tynmore sat down in relief.

Katie rushed out to the kitchen and heated the coffee which was always standing on the stove. While it was warming, she put a sugar bun and a spoon on a round tin tray.

In the meantime, Neeley had fallen asleep on the sofa. Miss Tynmore and Francie sat exchanging stares. Finally Miss Tynmore asked,

"What are you thinking about, little girl?"

"Just thinking," Francie said.

"Sometimes I see you sitting on the gutter curb for hours. What do you think of then?"

"Nothing. I just tell myself stories."

Miss Tynmore pointed at her sternly. "Little girl, you'll be a story writer when you grow up." It was a command rather than a statement.

"Yes ma'am," agreed Francie out of politeness.

Katie came in with the tray. "This may not be as refined as you're used to," she apologized, "but it's what we have in the house."

"It's very good," stated Miss Tynmore dainty. Then she concentrated on trying not to wolf it down.

To tell the truth, the Tynmores lived on the "tea" they got from their pupils. A few lessons a day at a quarter a lesson did not make for prosperity. After paying their rent, there was little left to eat on. Most of the ladies served them weak tea and soda crackers. The ladies knew what was polite and would come through with a cup of tea but they had no intention of supplying a meal and paying a quarter, too. So Miss Tynmore came to look forward to the hour at the Nolans. The coffee was heartening and there was always a bun or a bologna sandwich to sustain her.

After each lesson, Katie taught the children what she had been taught. She made them practice half an hour each day. In time, all three of them learned to play the piano.

When Johnny heard that Maggie Tynmore gave voice lessons, he figured that he could do no less than Katie. He offered to repair a broken sash cord in one of the Tynmore windows in exchange for two voice lessons for Francie. Johnny, who had never even seen a sash cord in all his life, got a hammer and screw driver and took the whole window frame out of its case. He looked at the broken rope and that was as far as he could go. He experimented and got nowhere. His

heart was willing but his skill was nil. In attempting to get the window back in to keep out the cold winter rain that was blowing into the room while he was figuring out about the sash cord, he broke a pane of glass. The deal fell through. The Tynmores had to get a regular window man in to fix it. Katie had to do two washings free for the girls to make up for it and Francie's voice lessons were abandoned forever.

To Kill a Mocking Bird — pages 102–103

10

Atticus was feeble: he was nearly fifty. When Jem and I asked him why he was so old, he said he got started late, which we felt reflected upon his abilities and manliness. He was much older than the parents of our school contemporaries, and there was nothing Jem or I could say about him when our classmates said, "My father—"

Jem was football crazy. Atticus was never too tired to play keep-away, but when Jem wanted to tackle him Atticus would say, "I'm too old for that, son."

Our father didn't do anything. He worked in an office, not in a drugstore. Atticus did not drive a dump-truck for the county, he was not the sheriff, he did not farm, work in a garage, or do anything that could possibly arouse the admiration of anyone.

Besides that, he wore glasses. He was nearly blind in his left eye, and said left eyes were the tribal curse of the Finches. Whenever he wanted to see something well, he turned his head and looked from his right eye.

He did not do the things our schoolmates' fathers did: he never went hunting, he did not play poker or fish or drink or smoke. He sat in the livingroom and read.

With these attributes, however, he would not remain as inconspicuous as we wished him to: that year, the school buzzed with talk about him defending Tom Robinson, none of which was complimentary. After my bout with Cecil Jacobs when I committed myself to a policy of cowardice, word got around that Scout Finch wouldn't fight any more,

her daddy wouldn't let her. This was not entirely correct: I wouldn't fight publicly for Atticus, but the family was private ground. I would fight anyone from a third cousin upwards tooth and nail. Francis Hancock, for example, knew that.

When he gave us our air-rifles Atticus wouldn't teach us to shoot. Uncle Jack instructed us in the rudiments thereof; he said Atticus wasn't interested in guns. Atticus said to Jem one day, "I'd rather you shot at tin cans in the back yard, but I know you'll go after birds. Shoot all the bluejays you want, if you can hit 'em, but remember it's a sin to kill a mockingbird."

That was the only time I ever heard Atticus say it was a sin to do something, and I asked Miss Maudie about it.

"Your father's right," she said. "Mockingbirds don't do one thing but make music for us to enjoy. They don't eat up people's gardens, don't nest in corncribs, they don't do one thing but sing their hearts out for us. That's why it's a sin to kill a mockingbird."

"Miss Maudie, this is an old neighborhood, ain't it?"

"Been here longer than the town."

"Nome, I mean the folks on our street are all old. Jem and me's the only children around here. Mrs. Dubose is close on to a hundred and Miss Rachel's old and so are you and Atticus."

"I don't call fifty very old," said Miss Maudie tartly. "Not being wheeled around yet, am I? Neither's your father. But I must say Providence was kind enough to burn down that old mausoleum of mine, I'm too old to keep it up—maybe you're right, Jean Louise, this is a settled neighborhood. You've never been around young folks much, have you?"

"Yessum, at school."

"I mean young grown-ups. You're lucky, you know. You and Jem have the benefit of your father's age. If your father was thirty you'd find life quite different."

"I sure would. Atticus can't do anything."

"You'd be surprised," said Miss Maudie. "There's life in him yet."

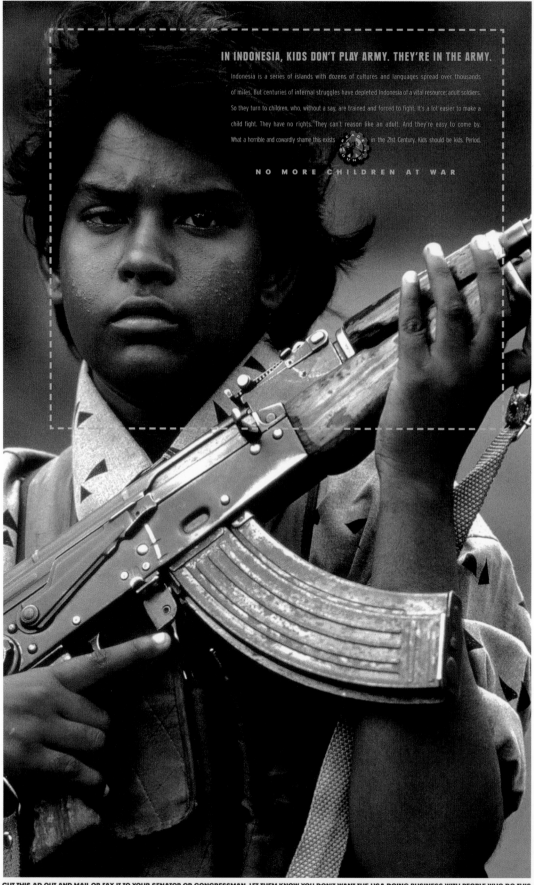

IN INDONESIA, KIDS DON'T PLAY ARMY. THEY'RE IN THE ARMY.

Indonesia is a series of islands with dozens of cultures and languages spread over thousands of miles. But centuries of internal struggles have depleted Indonesia of a vital resource: adult soldiers. So they turn to children, who, without a say, are trained and forced to fight. It's a lot easier to make a child fight. They have no rights. They can't reason like an adult. And they're easy to come by. What a horrible and cowardly shame this exists in the 21st Century. Kids should be kids. Period.

NO MORE CHILDREN AT WAR

VERY FEW CRIME REPORTS START WITH "THE SUSPECT, A FORMER CUB SCOUT, WAS LAST SEEN..."

CUB SCOUT ENROLLMENT IS HERE. WWW.JOINCUBS.COM

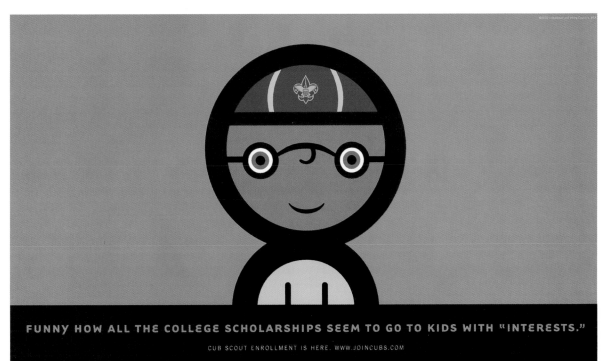

FUNNY HOW ALL THE COLLEGE SCHOLARSHIPS SEEM TO GO TO KIDS WITH "INTERESTS."

CUB SCOUT ENROLLMENT IS HERE. WWW.JOINCUBS.COM

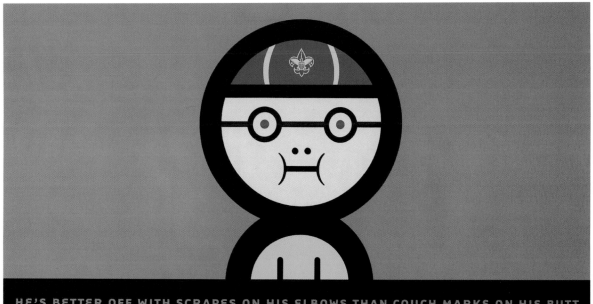

HE'S BETTER OFF WITH SCRAPES ON HIS ELBOWS THAN COUCH MARKS ON HIS BUTT.

CUB SCOUT ENROLLMENT IS HERE. WWW.JOINCUBS.COM

Agency: Carmichael Lynch Art Director: James Clunie Illustrator: James Clunie Copywriter: Tim Cawley Client: Cub Scouts

Public Service 152, 153

OUR ENTIRE STATE IS KINDLING.

STOP PLAYING WITH FIRE, COLORADO.

© 2002 HATCH SHOW PRINT · NASHVILLE, TENNESSEE

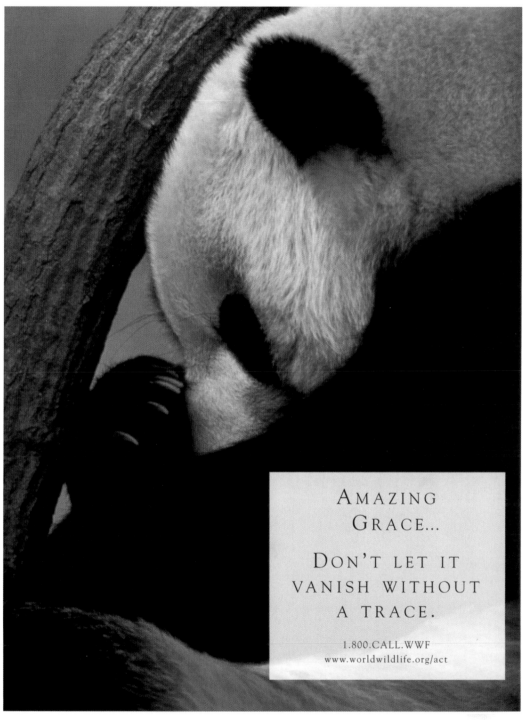

AMAZING
GRACE...

DON'T LET IT
VANISH WITHOUT
A TRACE.

1.800.CALL.WWF
www.worldwildlife.org/act

Get your free World Wildlife Fund Action Kit and help leave our children a living planet.

WWF

Agency: Crispin, Porter & Bogusky Creative Directors: Alex Bogusky and Pete Favat Art Directors: Rob Baird, Alex Bernard and Mike Delmarmol Photographers: Rob Baird, Alex Burnard and Mike Del Marmol Illustrator: Roger Baldacci, Rob Strasberg and Tom Adams Client: American Legacy Foundation Copywriters: Jasper Goodall

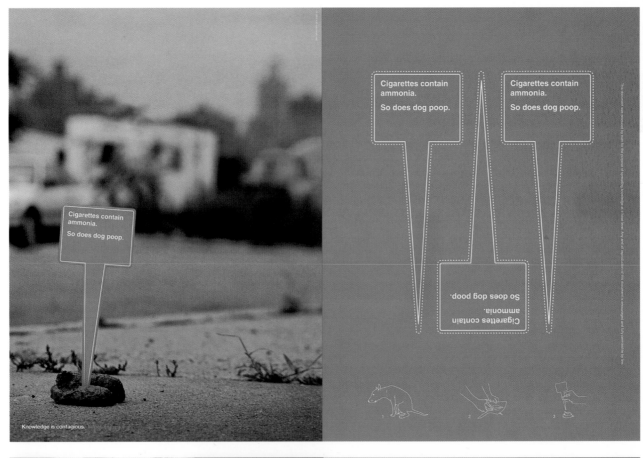

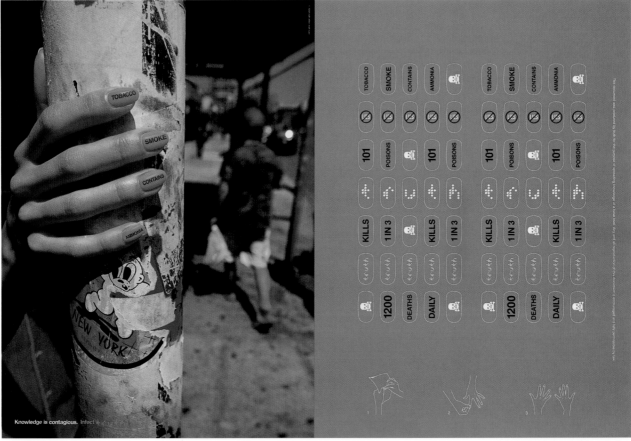

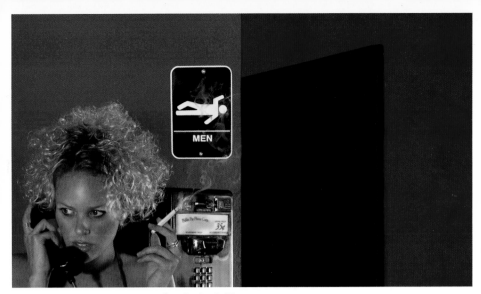

Secondhand smoke kills. A single puff of smoke unleashes more than 200 deadly poisons on anyone caught in its path. For more information, call 385-5520 or 395-8272.

TOBACCO FREE HALL COUNTY
Copyright 2001 Tobacco Free Hall County

Special thanks to Bailey Lauerman, RushWade2, Scott Graphic, and Burnham Press

Secondhand smoke kills. Smoke breathed by a nonsmoker contains higher concentrations of some cancer-causing substances than smoke inhaled by the actual smoker. For more information, call 385-5520 or 395-8272.

TOBACCO FREE HALL COUNTY
Copyright 2001 Tobacco Free Hall County

Special thanks to Bailey Lauerman, RushWade2, Scott Graphic, and Burnham Press

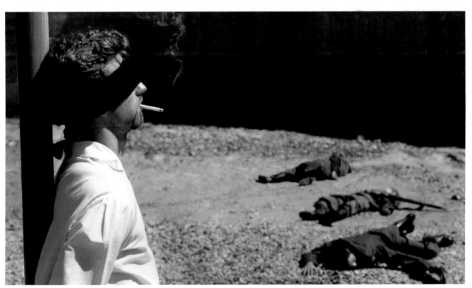

Secondhand smoke kills. More than 53,000 Americans in the last year alone. Sentenced to die for a crime they didn't commit. For more information, call 385-5520 or 395-8272.

TOBACCO FREE HALL COUNTY
Copyright 2001 Tobacco Free Hall County

Special thanks to Bailey Lauerman, RushWade2, Scott Graphic, and Burnham Press

Public Service 159

Bailey Lauerman Creative Director: Carter Weitz Art Directors: Ron Sack, David Thornhill and David Steinke Photographer: RushWade2 Illustrator: Joe McDermott Account Executive: Rich Clausen Client: Tobacco Free Hall County

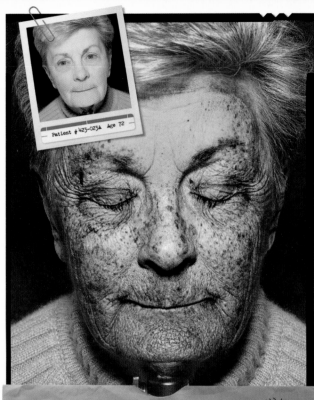

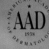

THE FATE OF SUN WORSHIPPERS – REVEALED

With a special ultraviolet camera, one picture exposes just how much sun damage lies beneath the skin's surface. And since 1 in 5 Americans will develop skin cancer in their lifetime, make sure to examine your skin regularly and report any unusual changes to your dermatologist.

AMERICAN ACADEMY OF DERMATOLOGY | 1.888.462.DERM | www.aad.org

AMERICAN ACADEMY OF DERMATOLOGY
1938

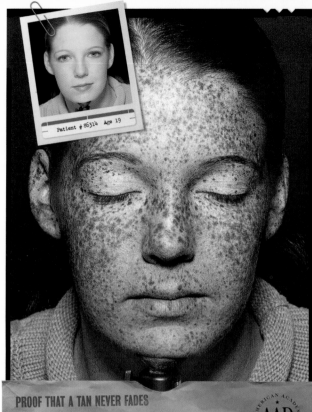

PROOF THAT A TAN NEVER FADES

A special ultraviolet camera makes it possible to see the underlying skin damage done by the sun. And since 1 in 5 Americans will develop skin cancer in their lifetime, what better reason to always use sunscreen, wear protective clothing and use common sense.

AMERICAN ACADEMY OF DERMATOLOGY | 1.888.462.DERM | www.aad.org

AMERICAN ACADEMY OF DERMATOLOGY
1938

UV Camera Agency: Publicis Creative Director: Richard Coad Art Director: Michelle Litos Photographer: Ken Farraghan Copywriter: Ann Biderbost Client: American Academy of Dermatology

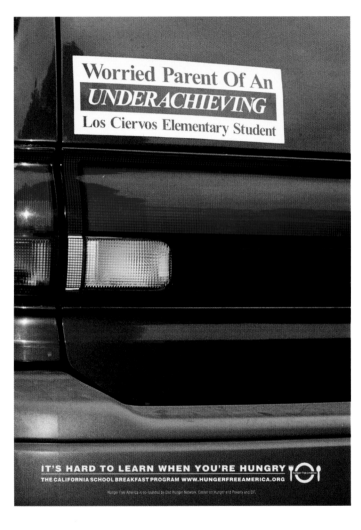

Worried Parent Of An
UNDERACHIEVING
Los Ciervos Elementary Student

IT'S HARD TO LEARN WHEN YOU'RE HUNGRY
THE CALIFORNIA SCHOOL BREAKFAST PROGRAM WWW.HUNGERFREEAMERICA.ORG

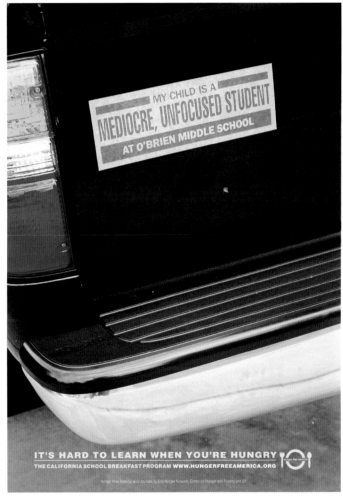

MY CHILD IS A
MEDIOCRE, UNFOCUSED STUDENT
AT O'BRIEN MIDDLE SCHOOL

IT'S HARD TO LEARN WHEN YOU'RE HUNGRY
THE CALIFORNIA SCHOOL BREAKFAST PROGRAM WWW.HUNGERFREEAMERICA.ORG

Agency: Agenda Marketing Partners Creative Directors: Luis Camano and Roger Poirier Art Director: Carlos Musquez Photographers: Enrique Ahumada and Tony Musquez Copywriter: Cameron Young Client: Hunger Free America Public Service 158,159

They won the war, only to be forced to surrender
their seats to Nazi POWs on the train ride home.

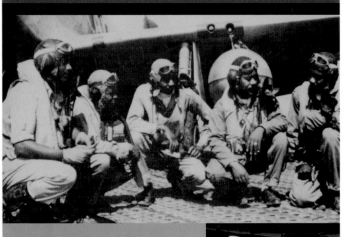

There was a time in this country's history when being black was more of a crime than being the enemy.

World War II was winding down. The Tuskegee Airmen, a group of African American pilots and crew, were returning home victorious after helping defeat Hitler's German Luftwaffe. They had proven themselves as the most successful escort fighter group in the European theatre. And yet in the eyes of their own countrymen, their skin color made them less deserving of a train seat than white enemy prisoners. And so, despite their distinguished wartime record, they returned to an America still unwilling to serve the men

who served their country so courageously.

Their mission is far from over. These brave men, their crews, and their planes are poised to speak louder than bombs. With a message of courage, patriotism, and persistence in the face of overwhelming odds.

The Red Tail Project has restored a living symbol that recognizes the contributions of the Tuskegee Airmen: a P51C Mustang with the airmen's signature red-painted tail. It will serve as a museum without walls and enable

millions of children and adults to celebrate the role of African Americans in World War II. The Red Tail Project will also preserve this history through an aviation education program that holds up the Tuskegee Airmen as role models and exposes youth to careers in aviation, science, and technology.

We can't win this battle alone. To make a donation or to learn more, please contact us at (651)457-6000 or www.redtail.org. Or write to us at Red Tail Project, 310 Airport Road, South Saint Paul, MN 55075.

American AirPower Heritage Foundation
Commemorative Air Force

They destroyed enemy aircraft, radar installations, and the
belief that a man could be judged by
the color of his skin.

It began as a War Department experiment. Thirteen men carrying the hopes of thirteen million African American countrymen.

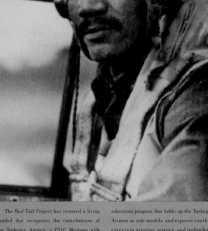

At a base just outside Tuskegee, Alabama, thirteen African American men underwent training to become World War II fighter pilots. It came at a time in our nation's history when African Americans were believed fit only for military positions such as cooks, drivers, and laborers. And in the face of ignorance, bigotry, and incredible odds, these men rose above. Over time, thirteen aviators grew to over nine hundred. And the Tuskegee Airmen went on to become our country's most successful World War II escort pilots. By the war's end they had flown over 15,000 combat missions, earned more than 800 service medals, and helped forge a path for all African Americans.

But their mission is far from over. These brave men, their crews, and their planes are now poised to speak louder than bombs. With a message of courage, patriotism, and persistence in the face of overwhelming odds.

The Red Tail Project has restored a living symbol that recognizes the contributions of the Tuskegee Airmen: a P51C Mustang with the airmen's signature red-painted tail. It will serve as a museum without walls and enable millions of children and adults to celebrate the role of African Americans in World War II. The Red Tail Project will also preserve this history through an aviation

education program that holds up the Tuskegee Airmen as role models and exposes youth to careers in aviation, science, and technology.

We can't win this battle alone. To make a donation or to learn more about the Red Tail Project, please contact us at (651)457-6000 or www.redtail.org. Or you can write to us at Red Tail Project, 310 Airport Road South Saint Paul, MN 55075.

American AirPower Heritage Foundation
Commemorative Air Force

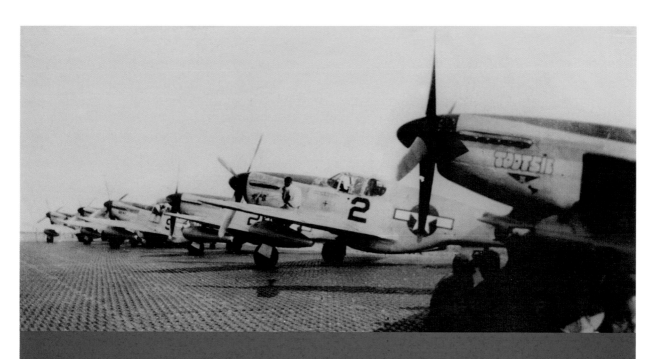

15,533 combat missions.
864 service medals.
0 pages in American history books.

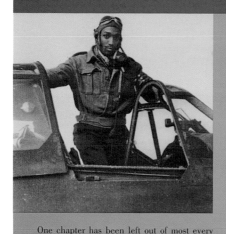

They were more than a part of Black history.
They helped change the course of American history.

One chapter has been left out of most every history textbook. It is the story of the Tuskegee Airmen. The story of how a group of African American aviators fought and won a battle on two fronts. Against the Nazis in Europe. And against racism at home.

It began as a War Department experiment. At a military base outside Tuskegee, Alabama, thirteen men trained to become fighter pilots at a time when African Americans were believed only capable of holding military positions such as cooks and laborers. But in the face of ignorance and bigotry, these men

rose above. And their numbers grew. Eventually, 952 pilots and over 10,000 crew were trained. And from their ranks came the most successful escort fighter group in the European theatre. Yet despite their distinguished record, the Tuskegee Airmen returned home to an America still unwilling to serve the men who served their country so courageously.

Their mission is far from over. These brave men, their crews, and their planes are poised to speak louder than bombs. With a message of courage, patriotism, and persistence in the face of overwhelming odds.

The Red Tail Project has restored a living symbol that recognizes the contributions of the Tuskegee Airmen: a P51C Mustang fighter plane with the Tuskegee Airmen's signature red-painted tail. The plane will serve as a museum without walls and enable millions of children and adults to celebrate

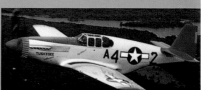

the crucial role of African Americans in World War II. The Red Tail Project will also preserve this important piece of history through an aviation education program that holds up the Tuskegee Airmen as role models and exposes youth to careers in aviation, science, and technology.

We can't win this battle alone. To make a donation or to learn more about the Red Tail Project, please contact us at (651)457-6000 or www.redtail.org. Or you can write us at Red Tail Project, 310 Airport Road, South Saint Paul, MN 55075.

American AirPower Heritage Foundation
Commemorative Air Force

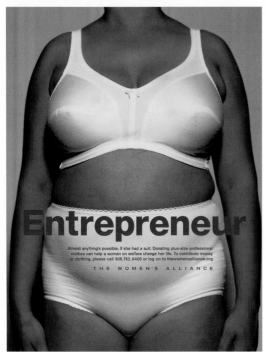

Entrepreneur

Almost anything's possible, if she had a suit. Donating plus-size professional clothes can help a woman on welfare change her life. To contribute money or clothing, please call 305.762.6400 or log on to thewomensalliance.org.

THE WOMEN'S ALLIANCE

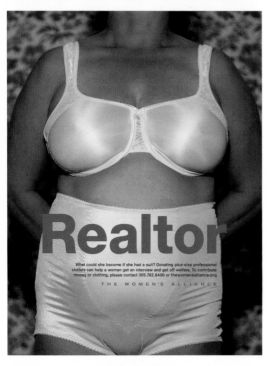

Realtor

What could she become if she had a suit? Donating plus-size professional clothes can help a woman get an interview and get off welfare. To contribute money or clothing, please contact 305.762.6400 or thewomensalliance.org.

THE WOMEN'S ALLIANCE

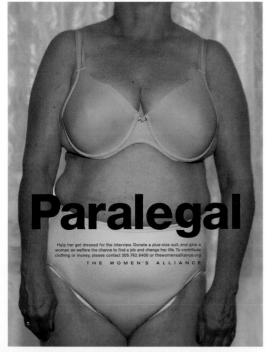

Paralegal

Help her get dressed for the interview. Donate a plus-size suit, and give a woman on welfare the chance to find a job and change her life. To contribute clothing or money, please contact 305.762.6400 or thewomensalliance.org.

THE WOMEN'S ALLIANCE

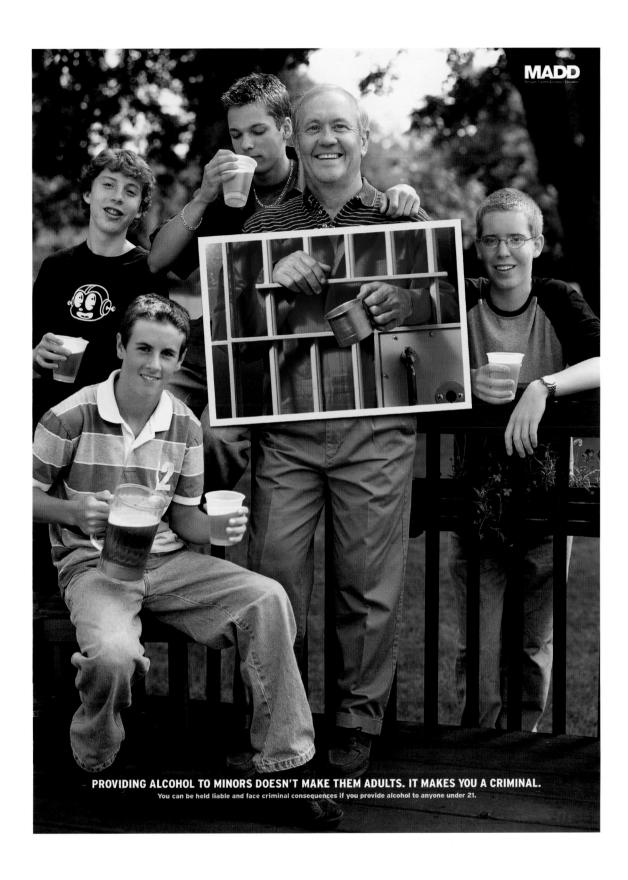

PROVIDING ALCOHOL TO MINORS DOESN'T MAKE THEM ADULTS. IT MAKES YOU A CRIMINAL.
You can be held liable and face criminal consequences if you provide alcohol to anyone under 21.

Agency: Clarity Coverdale Fury Creative Director: Jac Coverdale Art Director: Glenn Gary Photographer: Jen Stocksmith Client: Mothers Against Drunk Driving (MADD)

THE WHITE HOUSE ★ WASHINGTON, D.C. 20003
PAID FOR BY SPECIAL INTEREST GROUPS.

I am proud to support my party. I would like my contribution to go towards:

☐ Deforestation
☐ Shifting the tax burden from the wealthy to the middle class
☐ Decreasing funding for public schools
☐ Eliminating basic civil liberties
☐ Stacking the Supreme Court with extremist judges
☐ Military aid to countries that torture and kill their own citizens
☐ Other _____

★ ★ ★ ★ ★

I have enclosed my special contribution* of:

☐ $1,000,000 ☐ $500,000 ☐ $250,000
☐ $100,000 ☐ $50,000 ☐ $10,000
☐ Other $_____

*Unlike individuals, there is no limit to the amount that corporations can donate to political parties.

 ☑ None of the above.

 ✳ | GREEN PARTY
www.greenparty.org

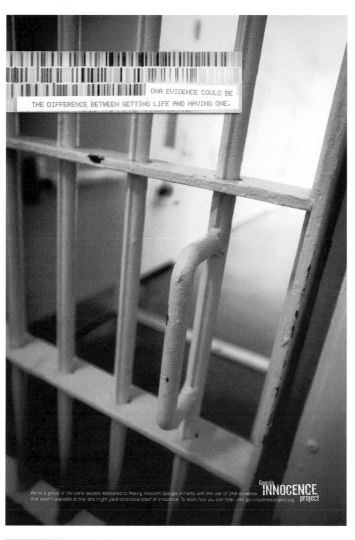

DNA EVIDENCE COULD BE
THE DIFFERENCE BETWEEN GETTING LIFE AND HAVING ONE.

We're a group of pro-bono lawyers dedicated to freeing innocent Georgia inmates with the use of DNA evidence that wasn't available at trial and might yield conclusive proof of innocence. To learn how you can help, visit ga-innocenceproject.org.

Georgia INNOCENCE project

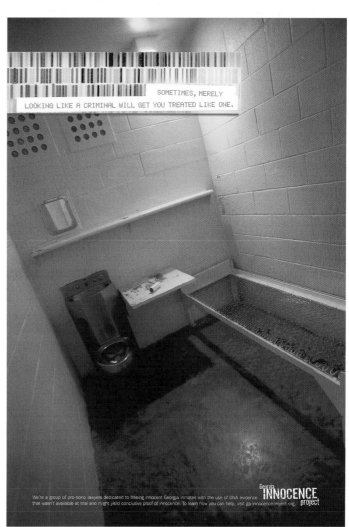

SOMETIMES, MERELY
LOOKING LIKE A CRIMINAL WILL GET YOU TREATED LIKE ONE.

We're a group of pro-bono lawyers dedicated to freeing innocent Georgia inmates with the use of DNA evidence that wasn't available at trial and might yield conclusive proof of innocence. To learn how you can help, visit ga-innocenceproject.org.

Georgia INNOCENCE project

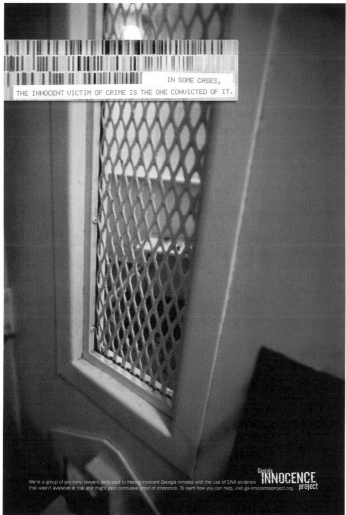

IN SOME CASES,
THE INNOCENT VICTIM OF CRIME IS THE ONE CONVICTED OF IT.

We're a group of pro-bono lawyers dedicated to freeing innocent Georgia inmates with the use of DNA evidence that wasn't available at trial and might yield conclusive proof of innocence. To learn how you can help, visit ga-innocenceproject.org.

Georgia INNOCENCE project

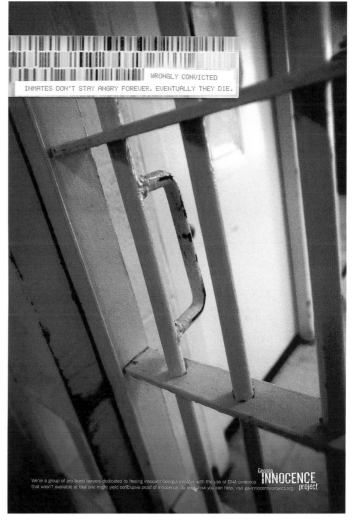

WRONGLY CONVICTED
INMATES DON'T STAY ANGRY FOREVER. EVENTUALLY THEY DIE.

We're a group of pro-bono lawyers dedicated to freeing innocent Georgia inmates with the use of DNA evidence that wasn't available at trial and might yield conclusive proof of innocence. To learn how you can help, visit ga-innocenceproject.org.

Georgia INNOCENCE project

Agency: McKinney & Silver Art Director: Keith Greenstein Photographer: Tony Pearce Copywriter: Keith Greenstein Client: Georgia Innocence Project

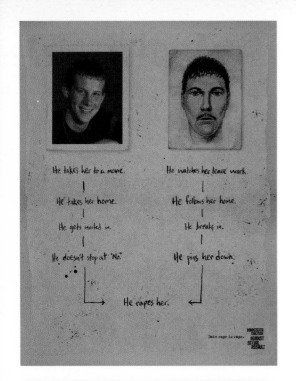

He takes her to a movie. He watches her leave work.

He takes her home. He follows her home.

He gets invited in. He breaks in.

He doesn't stop at "No." He pins her down.

He rapes her.

Date rape is rape. MINNESOTA COALITION AGAINST SEXUAL ASSAULT

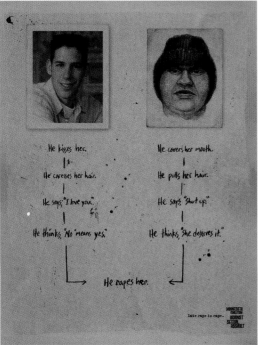

He kisses her. He covers her mouth.

He caresses her hair. He pulls her hair.

He says, "I love you." He says, "Shut up."

He thinks, "No means yes." He thinks, "She deserves it."

He rapes her.

Date rape is rape. MINNESOTA COALITION AGAINST SEXUAL ASSAULT

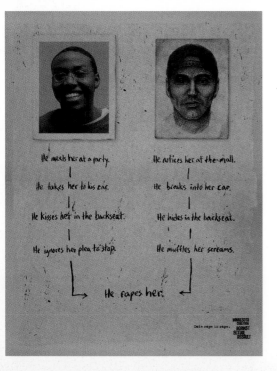

He meets her at a party. He notices her at the mall.

He takes her to his car. He breaks into her car.

He kisses her in the backseat. He hides in the backseat.

He ignores her plea to stop. He muffles her screams.

He rapes her.

Date rape is rape. MINNESOTA COALITION AGAINST SEXUAL ASSAULT

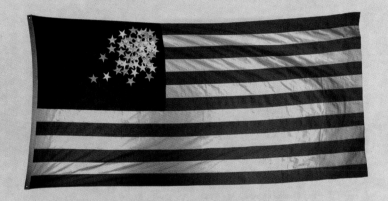

On September 11, America came together like no other time in our history. And Texans came
through in record numbers by sending food, money, blood and prayers to our friends up north.
So for the thousands of people you helped, 1700 miles away, we'd like to say thanks. They needed it.

**American
Red Cross**
of Central Texas

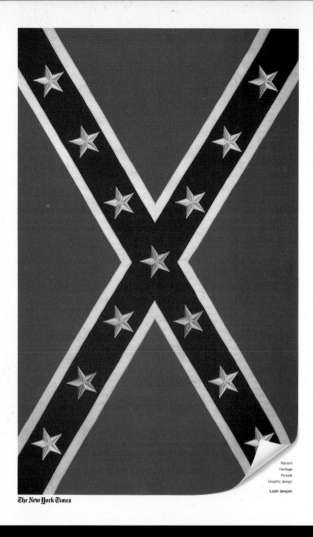

Racism
Heritage
Protest
Graphic design

Look deeper

The New York Times

War
Movies
Foreign policy
Fashion

Look deeper

The New York Times

Gaming
Addictions
Revenue
Magic

Look deeper

The New York Times

Cabaret
Feminism
Censorship
Style

Look deeper

The New York Times

Religion
Oil
Women's rights
Travel

Look deeper

The New York Times

Can you find:

- ☐ Fireman
- ☐ Bug
- ☐ Rabbit
- ☐ Surf
- ☐ Orange
- ☐ Baseball player
- ☐ Bell
- ☐ Merry-go-round
- ☐ '93 Saab 900 S, red with tan leather, one owner, garaged, 5-speed, AM-FM w/cassette, only driven by a cute light-footed young lady to church on Sundays.

Where to look when you want to find it. THE ORANGE COUNTY REGISTER

OC CarFinder. In The Orange County Register and on OCRegister.com daily.

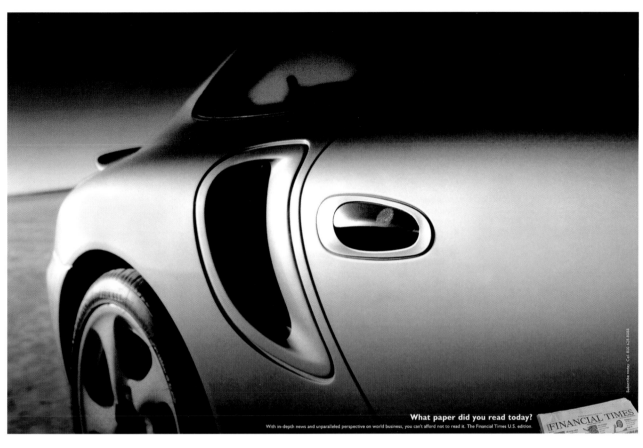

What paper did you read today?

With in-depth news and unparalleled perspective on world business, you can't afford not to read it. The Financial Times U.S. edition.

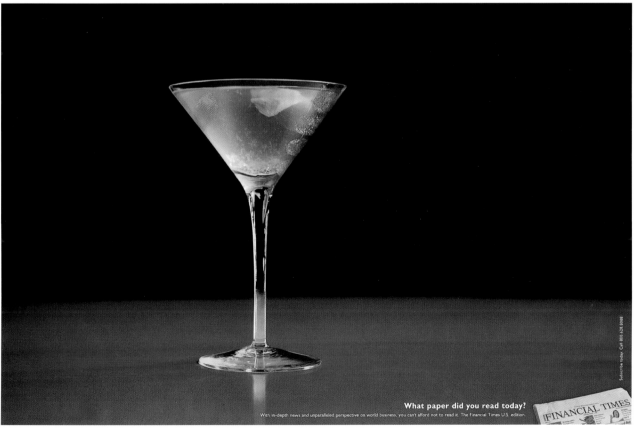

What paper did you read today?

With in-depth news and unparalleled perspective on world business, you can't afford not to read it. The Financial Times U.S. edition.

Agency: BBDO New York Creative Director: Donna Weinheim Art Directors: Frank Anselmo, Jayson Atienza and Chris Curry Designers: Frank Anselmo, Jayson Atienza and Chris Curry Copywriters: Heather Parke, Justin Racz and Eric Van Skyhawk Retouching: Rubber Fish Client: Financial Times

Design proposal No. 4

Please note we didn't carry the re-design thing too far [see exhibit at left].
Our idea was simpler. We're introducing a new section three days a week, Personal Journal,
featuring articles on personal finance, health and family, travel, cars and gadgets.
We've also tweaked the layout for easier navigation and readability —
and, oh yes, we've added just the most judicious hint of color.
Otherwise, it's the same old brilliant rigorous shrewd witty authoritative Journal.

Coming April 9.

Design proposal No. 7

Please note we didn't carry the re-design thing too far [see exhibit at left].
Our idea was simpler. We're introducing a new section three days a week, Personal Journal,
featuring articles on personal finance, health and family, travel, cars and gadgets.
We've also tweaked the layout for easier navigation and readability —
and, oh yes, we've added just the most judicious hint of color.
Otherwise, it's the same old brilliant rigorous shrewd witty authoritative Journal.

Coming April 9.

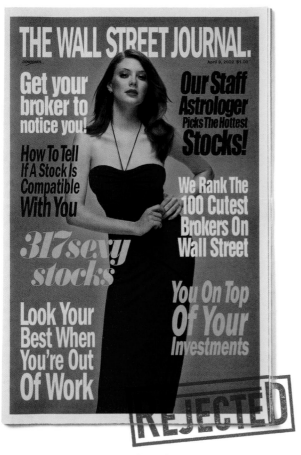

(Details TBD)

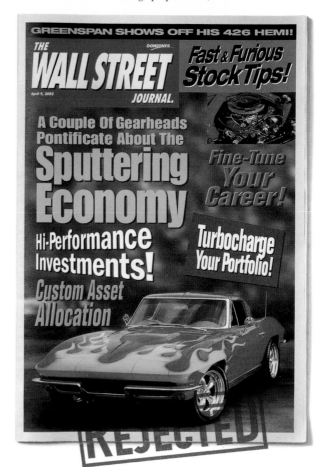

(Interesting, but.)

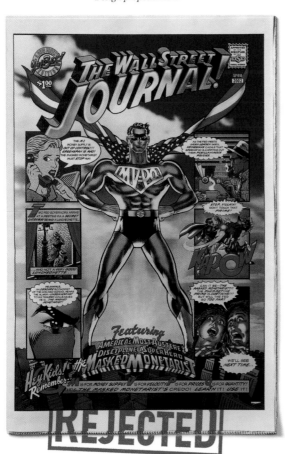

(Nice, but is it us?)

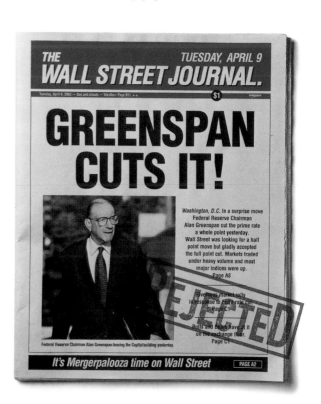

(Still working on it.)

Have the networks finally bitten the head off
family values?

Join the conversation.

Remember when only environmentalists
would have been alarmed by this photo?

Join the conversation.

(this spread) Agency: Fallon Creative Directors: David Lubars and Kevin Roddy Art Director: Bob Barrie Copywriter: Dean Buckhorn Client: Time

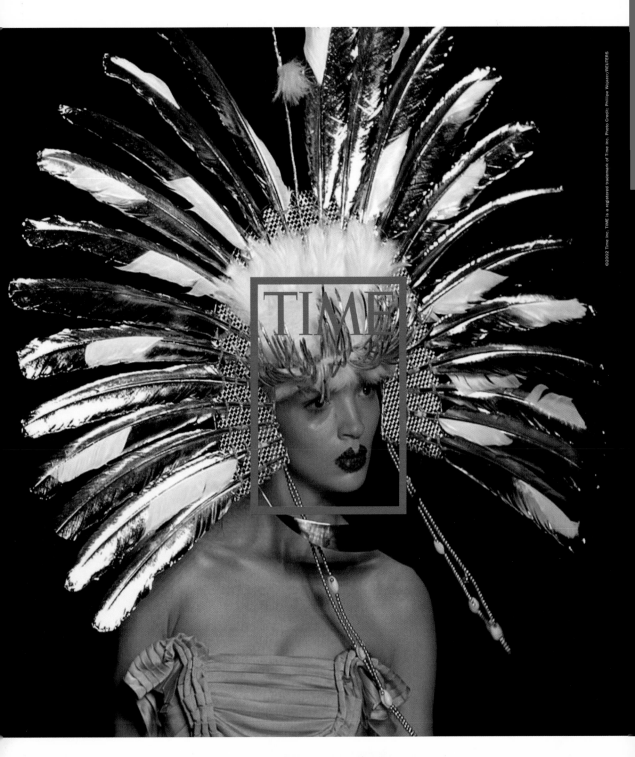

©2002 Time Inc. TIME is a registered trademark of Time Inc. Photo Credit: Philippe Wojazer/REUTERS

TIME

Fashion's impact on design,

architecture and, occasionally,

waterfowl.

TIME Style & Design Issue, closing January 13th. Join the conversation.

Coolest Inventions · Person of the Year · Best Pictures of the Year · Your Body, Your Mind · 80 Days that Changed the World

The Economist

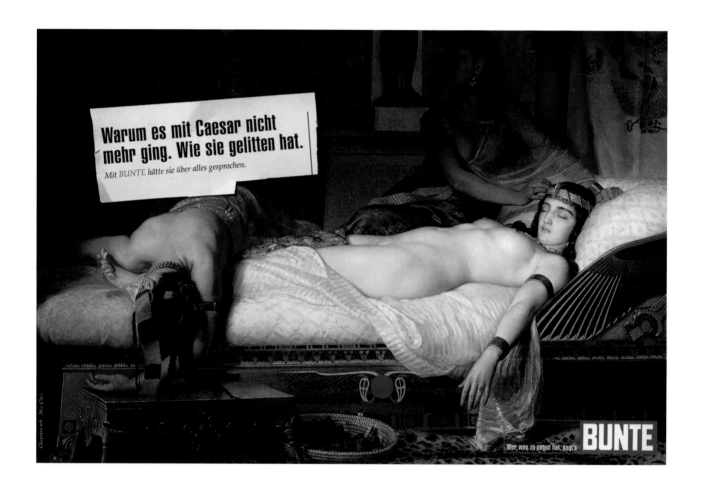

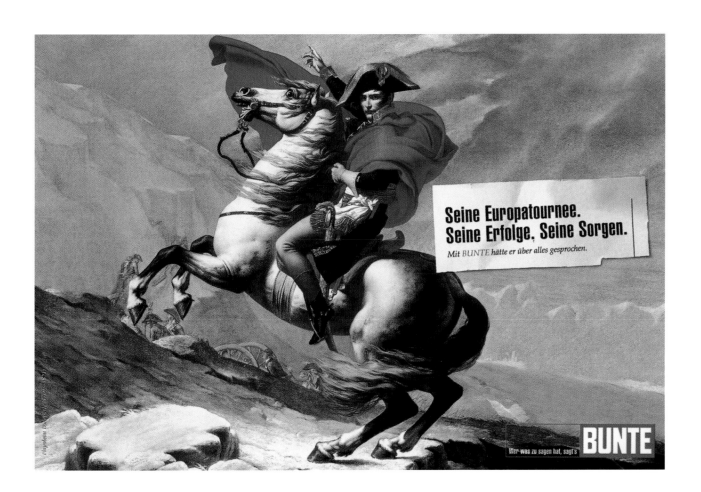

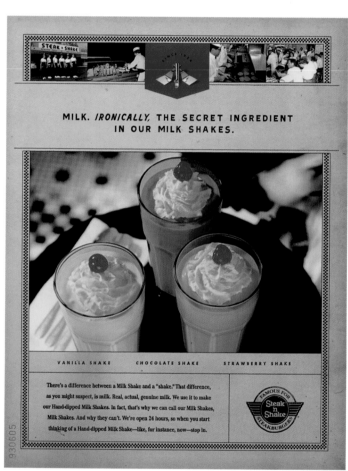

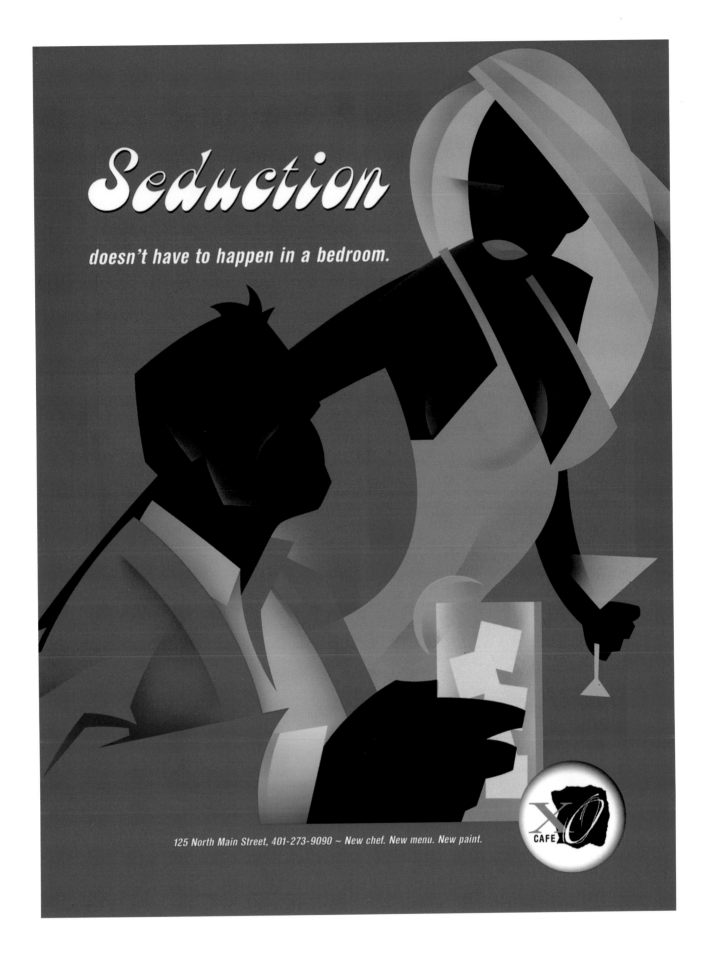

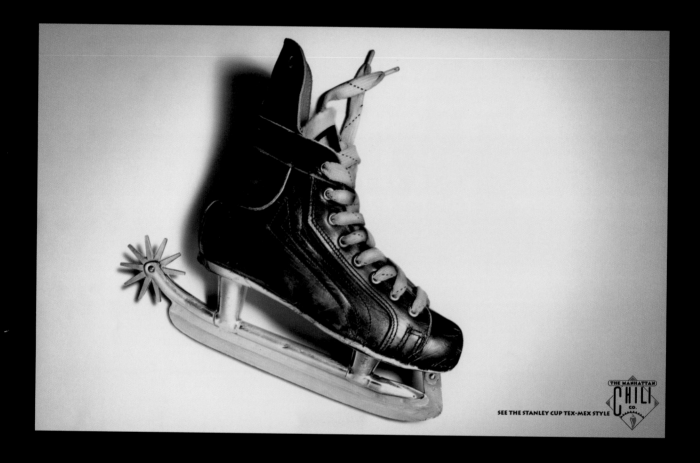

SEE THE STANLEY CUP TEX-MEX STYLE

THE MANHATTAN
CHILI
CO.

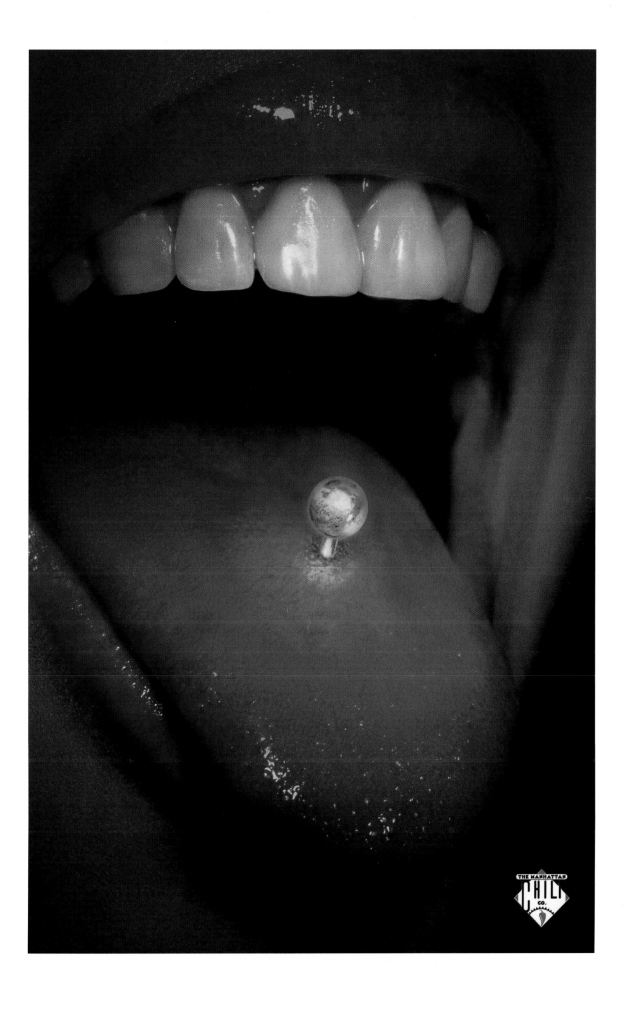

'Tongue Pierce' Agency: Bozell NY Creative Director: Tony Granger Art Director: Judy Robinson Photographer: Chris Triblehorn Copywriter: Josh Schildkraut Group CDs: Jan Jacobs and: Porky Hefer Client: Manhattan Chili Co. Restaurants 186,187

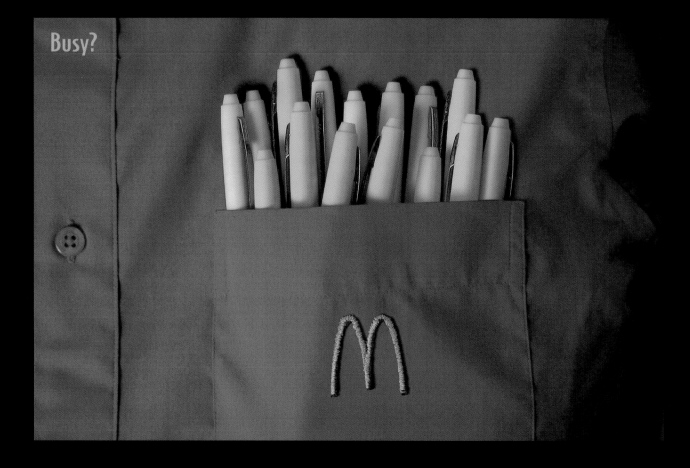

Busy?

'Fries' Agency: Lopito, Ileana and Howie Creative Director: Lili Madera Art Directors: Francisco Fernandez and Victor Lleras Designers: Victor Lleras and Francisco Fernandez Photographer: Concepto Uno Fotografia Copywriters: Victor Lleras and Francisco Fernandez Client: McDonald's

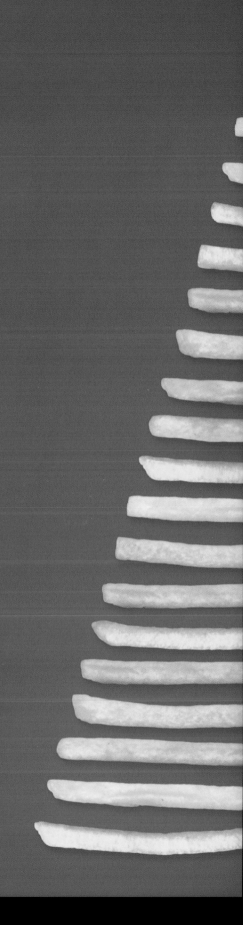

McDonald's Merry Christmas

'Turkey' Agency: Lopito, Ileana and Howie Creative Director: Lili Madera Art Director: Javier O'Neill Designer: Javier O'Neill Photographer: Javier O'Neill Copywriter: Adolfo Valdes Client: McDonald's

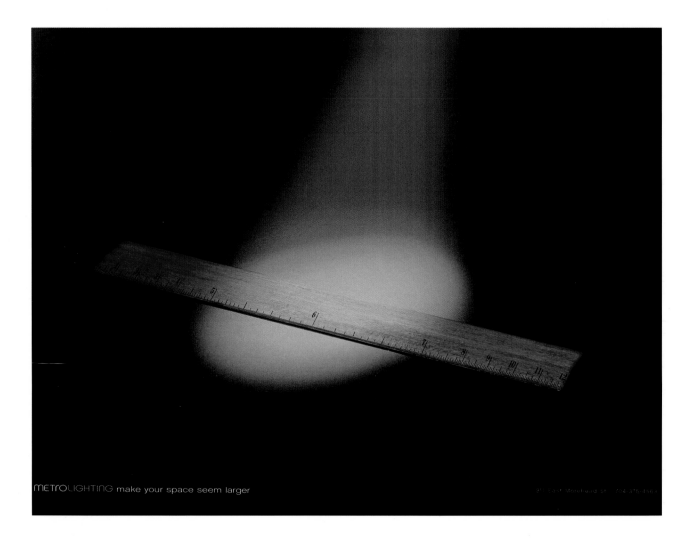

METROLIGHTING make your space seem larger

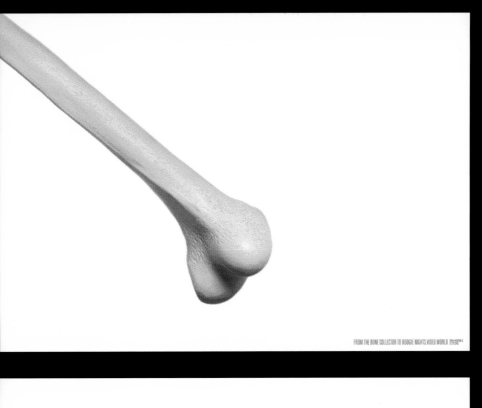

FROM THE BONE COLLECTOR TO BOOGIE NIGHTS.VIDEO WORLD

FROM PEARL HARBOR TO NOSFERATU.VIDEO WORLD

FROM CABARET TO JAWS.VIDEO WORLD

Agency: Bozell NY Creative Director: Tony Granger Art Directors: Eric Venroegen and Soo Mean Chang Photographer: Andy Spreitzer Copywriter: Kerry Keenan Group CD: Kerry Keenan and: Eric Venroegen Client: Video World Retail 190,19

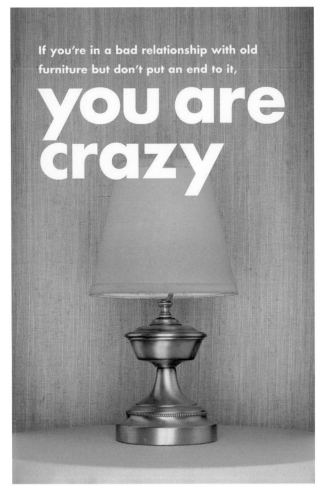

If you're in a bad relationship with old furniture but don't put an end to it,

you are crazy

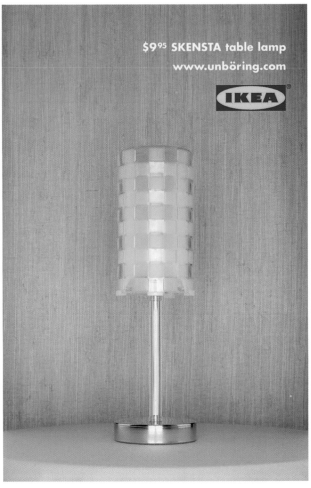

$9⁹⁵ SKENSTA table lamp
www.unböring.com

IKEA®

YOU CAN FREEZE YOUR SPERM. YOU CAN FREEZE

YOUR EMBRYOS. BUT LAST WE CHECKED IT WAS

STILL ILLEGAL TO FREEZE YOUR CHILDREN.

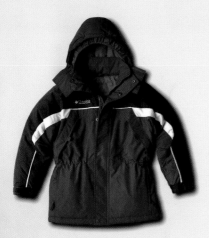

Jr. Fire Ridge Parka™: Detachable hood · Security zip pockets
inside and out · Articulated elbow · Adjustable cuffs. For a dealer
near you, call 1-800-MA BOYLE or visit www.columbia.com.

"Early signs of hypothermia include poor coordination
and confusion. Two things best saved for puberty."
— Chairman Gert Boyle

THERE'S NOTHING MOTHERLY ABOUT

MOTHER NATURE. EXCEPT MAYBE HER

BIG MOUNTAINOUS BREASTS.

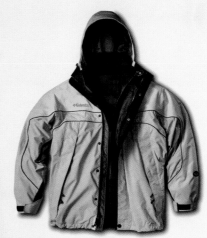

Boundary Peak Parka™: Waterproof/breathable Omni-Tech® Storm Dry TN
fabric w/Omni-Shield™ seam sealing · Removable non-pilling MTR Fleece™
liner · Oversized mesh vented pockets · Attached, visored, full-feature hood.
For a dealer near you, call 1-800-MA BOYLE or visit www.columbia.com.

"I've got hot flashes to keep me warm. You'll
need something that zips."
— Chairman Gert Boyle

IF IT WALKS LIKE A DUCK

AND IT QUACKS LIKE A DUCK,

IT'S A GONER.

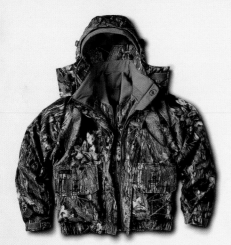

Silent Hunter Widgeon Parka™: Waterproof/breathable Omni-
Tech® Silent Rain Plus™ fabric · Interchange System™ w/zip-out
reversible liner & detachable hood · Drawcord waist. For a dealer
near you, call 1-800-MA BOYLE or visit www.columbia.com.

"Migratory waterfowl see nothing. Taxidermists
see dollar signs."
— Chairman Gert Boyle

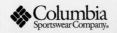

HOODS ARE ALL THE RAGE

ON PARIS RUNWAYS.

LIKE WE GIVE A CRAP.

Sunrise Peak Parka™: Removable MTR Fleece™ liner · Stowable
hood with visor · Mesh venting pockets. For a dealer near
you, call 1-800-MA BOYLE or visit www.columbia.com.

"It's about time those fashion people had a
halfway decent idea."
— Chairman Gert Boyle

Agency: Borders Perrin Norrander Creative Director: Terry Schneider Art Director: Kent Suter Photographer: Michael Jones Copywriters: Mike Ward and Ginger Robinson Client: Columbia Sportswear

Tulip Chairs by Eero Saarinen. Realistically available at 1/6 scale. **Vitra Design Museum**
MINIATURE COLLECTION

Panton Chair by Verner Panton. Realistically available at 1/6 scale. **Vitra Design Museum** MINIATURE COLLECTION

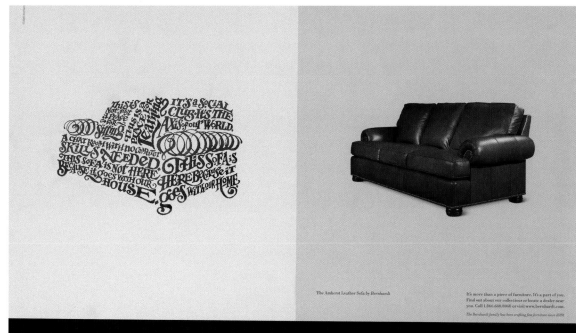

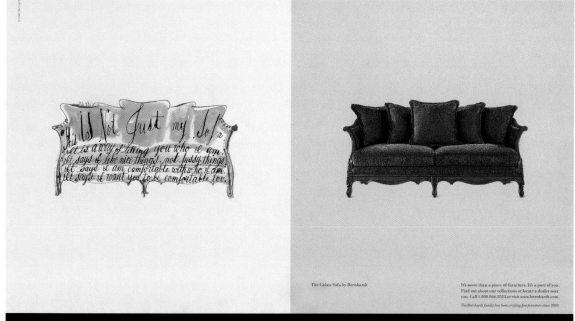

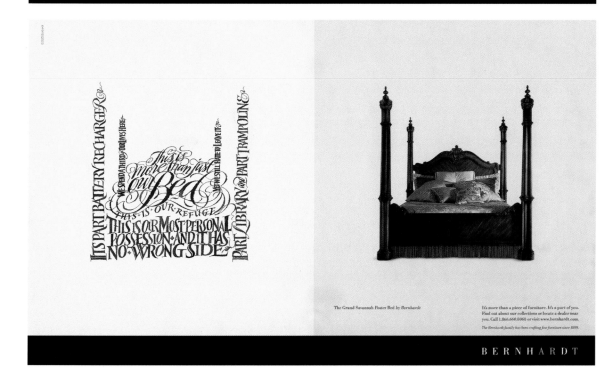

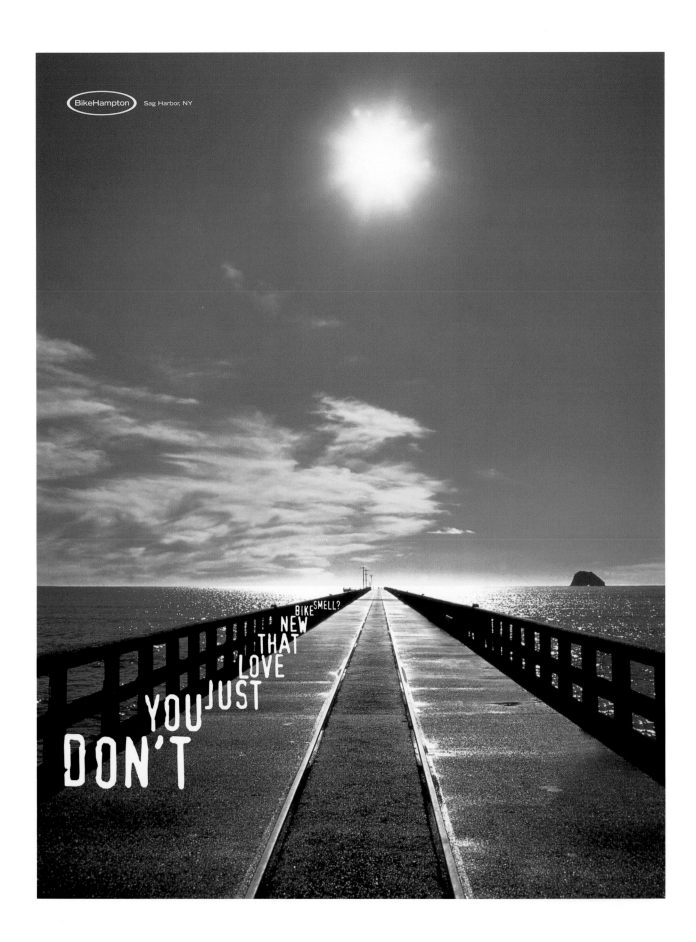

(this spread) 'Morning Trees' Agency: Hill Holliday, NY Creative Directors: Rob Reilly and Melanie Foster Art Directors: Melanie Foster and Charles Chang Photographer: Rob Reilly and Lewis McVey Sr. Production Manager: Jeanne Martin Client: Bike Hampton Copywriters: Klaus Lucka

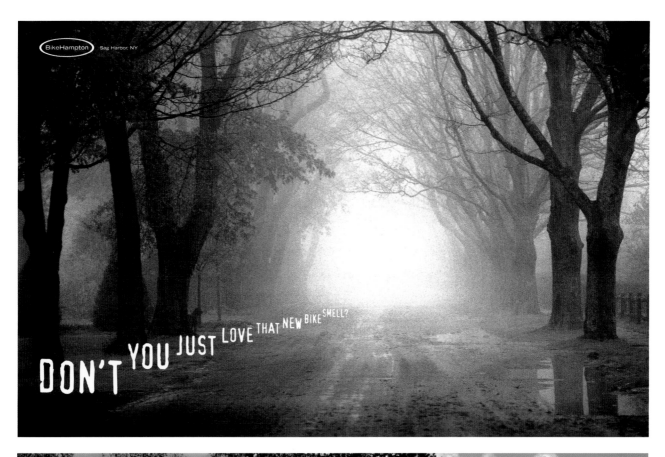

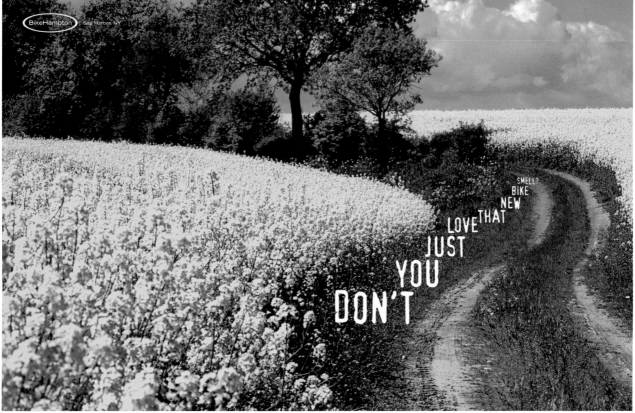

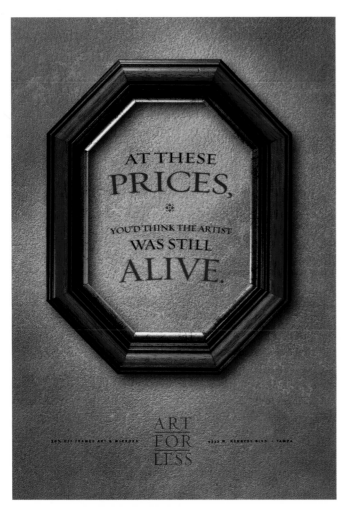

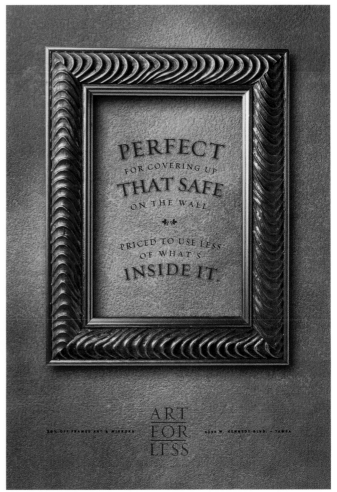

'TV Snow' Agency: Borders Perrin Norrander Creative Director: Terry Schneider Art Director: Kent Suter Photographer: Michael Prince Copywriter: Mike Ward Client: Columbia Sportwear

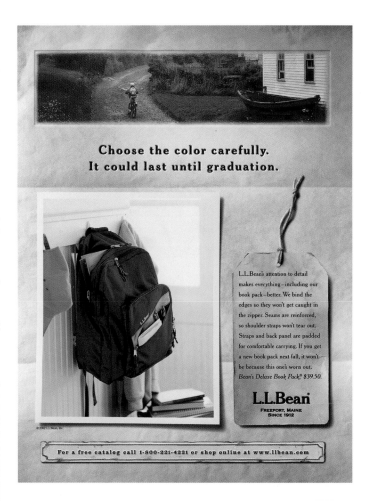

Choose the color carefully.
It could last until graduation.

L.L.Bean's attention to detail makes everything–including our book pack–better. We bind the edges so they won't get caught in the zipper. Seams are reinforced, so shoulder straps won't tear out. Straps and back panel are padded for comfortable carrying. If you get a new book pack next fall, it won't be because this one's worn out. *Bean's Deluxe Book Pack,* $39.50.

L.L.Bean
FREEPORT, MAINE
SINCE 1912

For a free catalog call 1-800-221-4221 or shop online at www.llbean.com

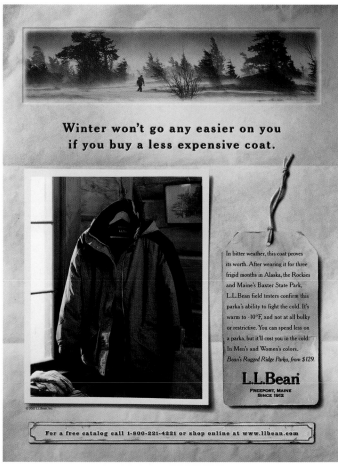

Winter won't go any easier on you
if you buy a less expensive coat.

In bitter weather, this coat proves its worth. After wearing it for three frigid months in Alaska, the Rockies and Maine's Baxter State Park, L.L.Bean field testers confirm this parka's ability to fight the cold. It's warm to -10°F, and not at all bulky or restrictive. You can spend less on a parka, but it'll cost you in the cold. In Men's and Women's colors. *Bean's Rugged Ridge Parka, from $129.*

L.L.Bean
FREEPORT, MAINE
SINCE 1912

For a free catalog call 1-800-221-4221 or shop online at www.llbean.com

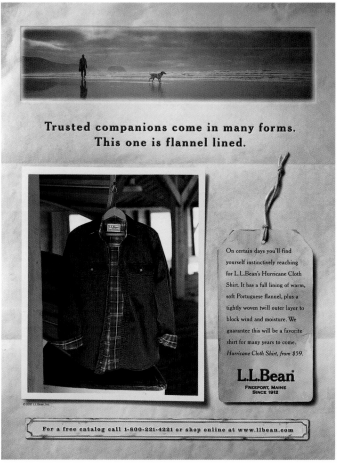

Trusted companions come in many forms.
This one is flannel lined.

On certain days you'll find yourself instinctively reaching for L.L.Bean's Hurricane Cloth Shirt. It has a full lining of warm, soft Portuguese flannel, plus a tightly woven twill outer layer to block wind and moisture. We guarantee this will be a favorite shirt for many years to come. *Hurricane Cloth Shirt, from $59.*

L.L.Bean
FREEPORT, MAINE
SINCE 1912

For a free catalog call 1-800-221-4221 or shop online at www.llbean.com

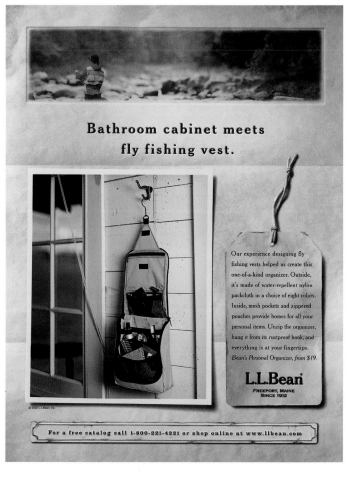

Bathroom cabinet meets
fly fishing vest.

Our experience designing fly fishing vests helped us create this one-of-a-kind organizer. Outside, it's made of water-repellent nylon packcloth in a choice of eight colors. Inside, mesh pockets and zippered pouches provide homes for all your personal items. Unzip the organizer, hang it from its rustproof hook, and everything is at your fingertips. *Bean's Personal Organizer, from $19.*

L.L.Bean
FREEPORT, MAINE
SINCE 1912

For a free catalog call 1-800-221-4221 or shop online at www.llbean.com

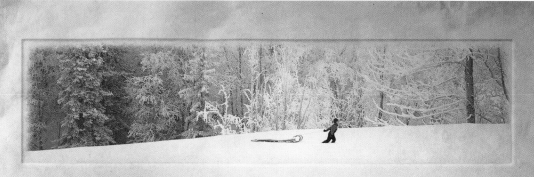

If not completely satisfied, your grandchildren can return it to our grandchildren.

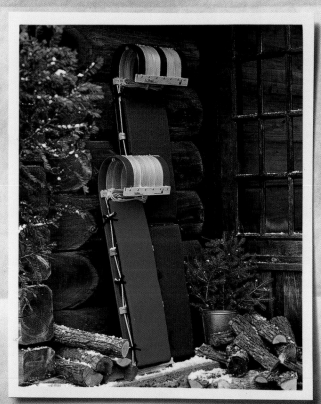

© 2002 L.L.Bean, Inc.

Each generation will appreciate this classic toboggan as much as the last. It's made the old-fashioned way, custom-built in Canada from steambent northern hardwood slats, to stand up to years of fun. Even the cushion is made with a long-lasting, nonslip woven polyester shell. Unlike plastic sleds, you'll buy this once—and pass it on when you're done with it. *Toboggan and Cushion Set, from $85.*

L.L.Bean

FREEPORT, MAINE
SINCE 1912

For a free catalog call 1-800-221-4221 or shop online at www.llbean.com

Cannes' 3rd most awarded agency overall and most awarded U.S. agency for print. **Bozell New York**

The Bozell & Jacobs Summer Internship Program.
Positions available in Account Service, Art Direction, Copywriting, Interactive, Media, and Public Relations. For more information or to download an application, log on to www.bozelljacobs.com/Summerintern.

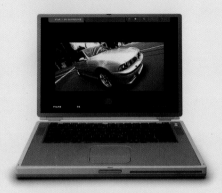

The Cannes Cyber Jury awarded us the Grand Prix.
The Cannes Television Jury disqualified us because we broke the rules.

We're still not sure which one makes us more proud.

Fallon

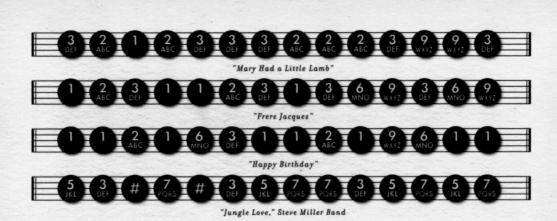

"Mary Had a Little Lamb"

"Frere Jacques"

"Happy Birthday"

"Jungle Love," Steve Miller Band

Seeing possibilities in everyday things : www.bamads.com.

BRADLEY AND MONTGOMERY ADVERTISING

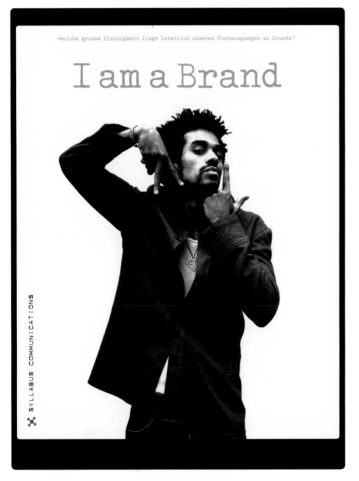

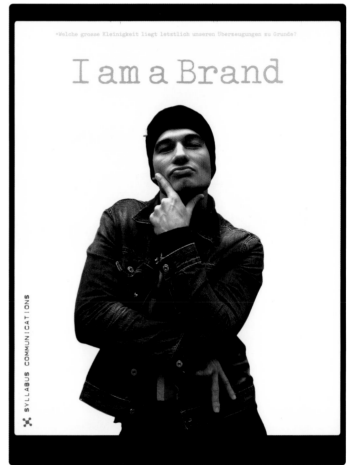

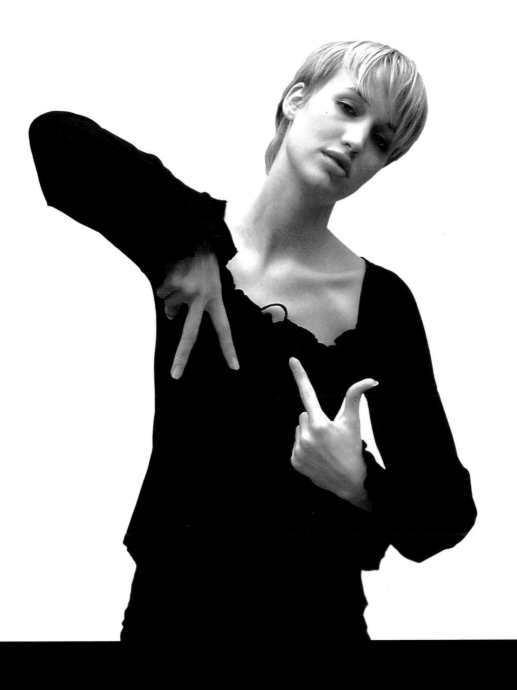

*Welche grosse Kleinigkeit liegt letztlich unseren Überzeugungen zu Grunde?

I am a Brand

SYLLABUS COMMUNICATIONS

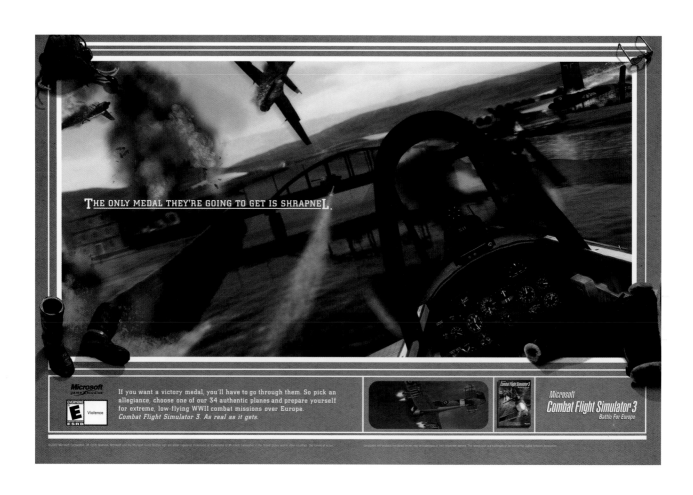

How do you get
feedback from
52 busy partners
over 4th of July
weekend?

{Digital Review and Comment}

Get feedback on a document from multiple people
wherever and whenever with digital sticky notes. It's the revolutionary
way to keep all of your comments in one place.
Adobe Acrobat. Create an Adobe PDF and do more with your documents.

Adobe Acrobat 5.0 | Tools for the New Work

Keep
privileged
information
from the
unprivileged.

{Document Security}

Keep control of your documents even after they leave your desktop.
You say who can view them, who can alter them, even who can print them.
Adobe Acrobat. Create an Adobe PDF and do more with your documents.

Adobe Acrobat 5.0 | Tools for the New Work

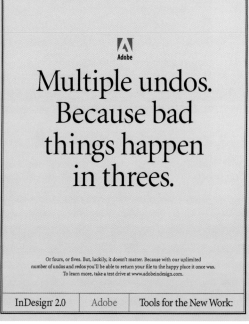

Multiple undos.
Because bad
things happen
in threes.

Or fours, or fives. But, luckily, it doesn't matter. Because with our unlimited
number of undos and redos you'll be able to return your file to the happy place it once was.
To learn more, take a test drive at www.adobeindesign.com.

InDesign 2.0 | Adobe | Tools for the New Work:

Agency: Goodby, Silverstein & Partners Creative Directors: Jeffrey Goodby and Rich Silverstein Art Directors: Keith Anderson Photographers: Terry Heffernan and Claude Shade Copywriter: Chris Ford Client: Adobe

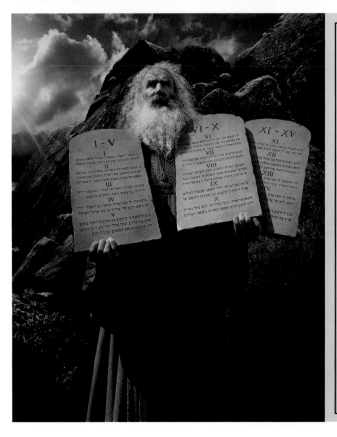

Agency: Goodby, Silverstein & Partners Creative Directors: Jeffrey Goodby and Rich Silverstein Art Directors: Keith Anderson and Claude Shade Photographer: Terry Heffernan Copywriter: Chris Ford Client: Adobe

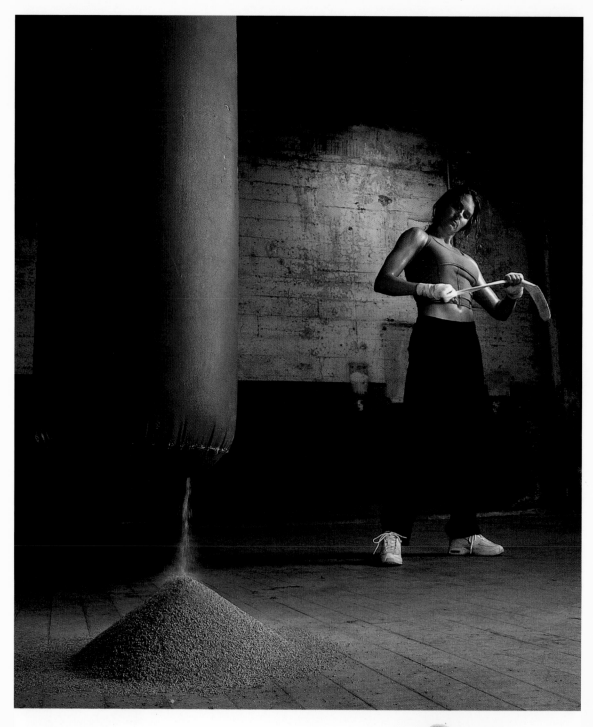

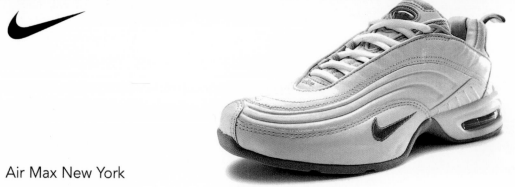

Air Max New York

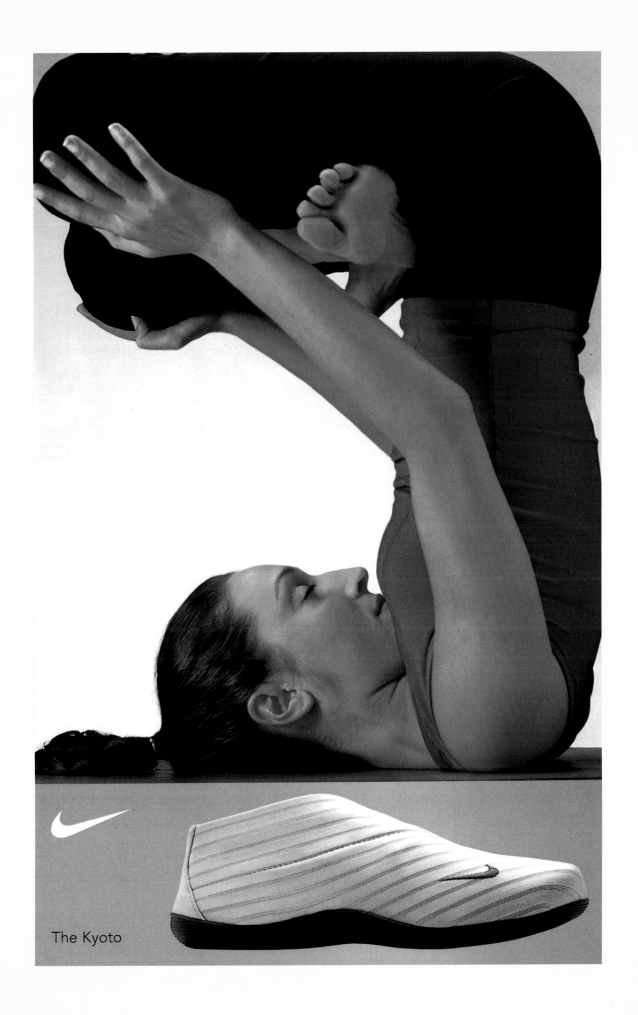

The Kyoto

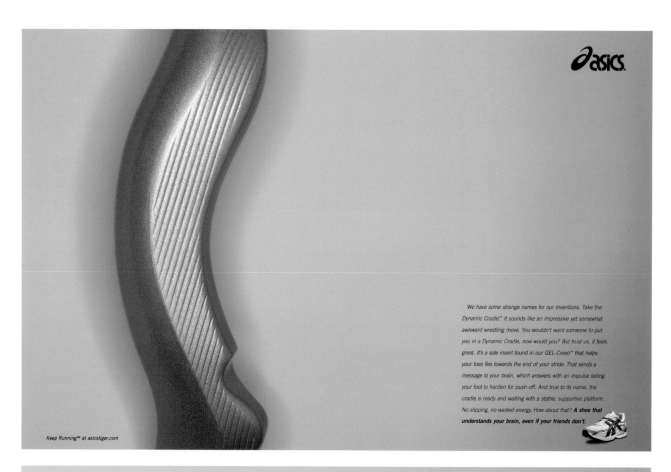

Keep Running™ at asicstiger.com

We have some strange names for our inventions. Take the
Dynamic Cradle.™ It sounds like an impressive yet somewhat
awkward wrestling move. You wouldn't want someone to put
you in a Dynamic Cradle, now would you? But trust us, it feels
great. It's a sole insert found in our GEL-Creed™ that helps
your toes flex towards the end of your stride. That sends a
message to your brain, which answers with an impulse telling
your foot to harden for push-off. And true to its name, the
cradle is ready and waiting with a stable, supportive platform.
No slipping, no wasted energy. How about that? **A shoe that
understands your brain, even if your friends don't.**

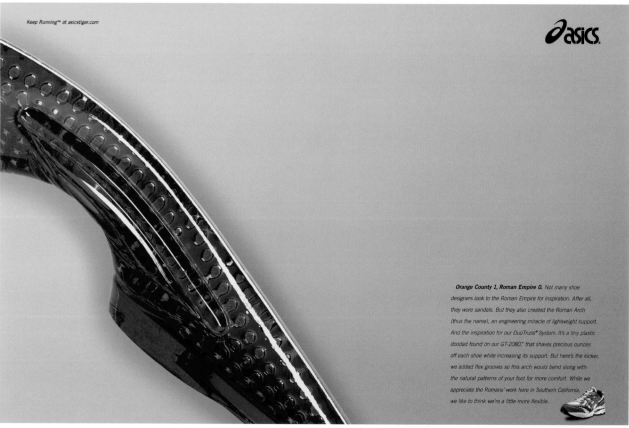

Keep Running™ at asicstiger.com

Orange County 1, Roman Empire 0. Not many shoe
designers look to the Roman Empire for inspiration. After all,
they wore sandals. But they also created the Roman Arch
(thus the name), an engineering miracle of lightweight support.
And the inspiration for our DuoTruss® System. It's a tiny plastic
doodad found on our GT-2080,™ that shaves precious ounces
off each shoe while increasing its support. But here's the kicker,
we added flex grooves so this arch would bend along with
the natural patterns of your foot for more comfort. While we
appreciate the Romans' work here in Southern California,
we like to think we're a little more flexible.

(this spread) Agency: Craig Cutler Studio Art Director: Mark Chila Photographer: Craig Cutler Client: Asics

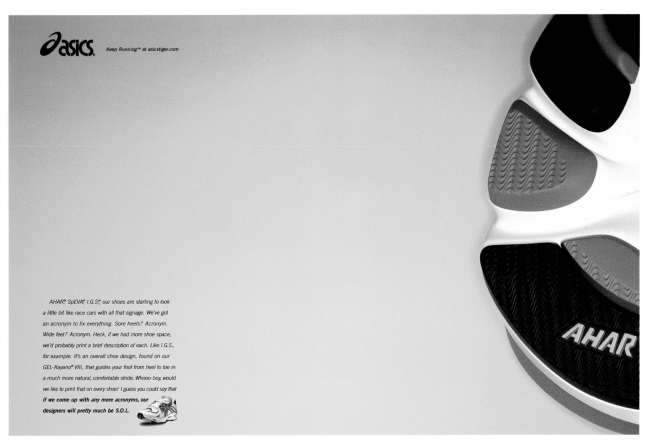

asics. *Keep Running™ at asicstiger.com*

*AHAR,® SpEVA,® I.G.S.,™ our shoes are starting to look
a little bit like race cars with all that signage. We've got
an acronym to fix everything. Sore heels? Acronym.
Wide feet? Acronym. Heck, if we had more shoe space,
we'd probably print a brief description of each. Like I.G.S.,
for example. It's an overall shoe design, found on our
GEL-Kayano® VIII, that guides your foot from heel to toe in
a much more natural, comfortable stride. Whooo-boy, would
we like to print that on every shoe! I guess you could say that
**if we come up with any more acronyms, our
designers will pretty much be S.O.L.***

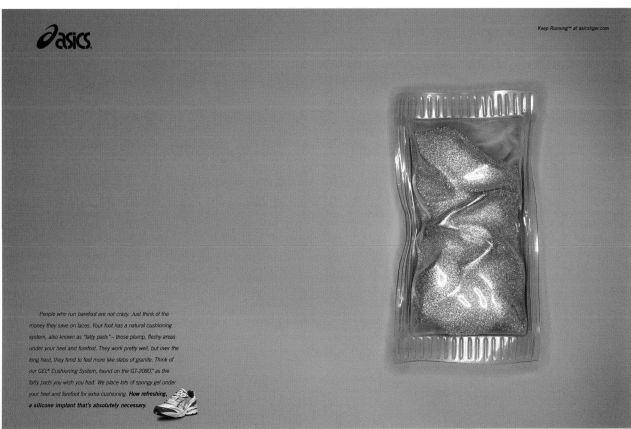

asics. *Keep Running™ at asicstiger.com*

*People who run barefoot are not crazy. Just think of the
money they save on laces. Your foot has a natural cushioning
system, also known as "fatty pads" – those plump, fleshy areas
under your heel and forefoot. They work pretty well, but over the
long haul, they tend to feel more like slabs of granite. Think of
our GEL® Cushioning System, found on the GT-2080,™ as the
fatty pads you wish you had. We place lots of spongy gel under
your heel and forefoot for extra cushioning. **How refreshing,
a silicone implant that's absolutely necessary.***

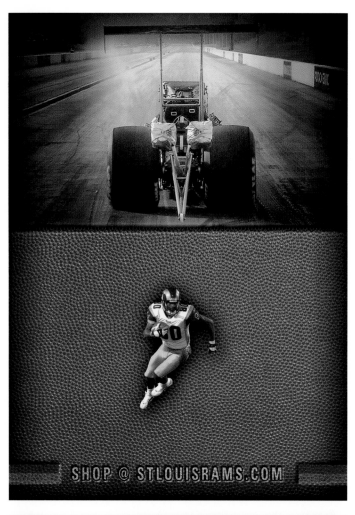

SHOP @ STLOUISRAMS.COM

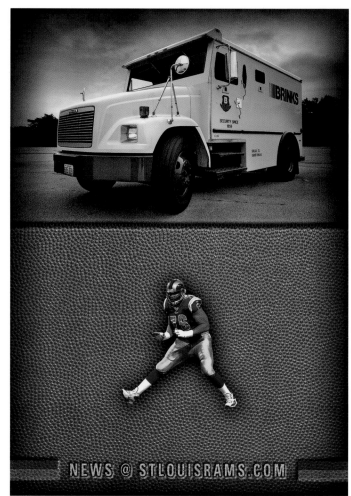

NEWS @ STLOUISRAMS.COM

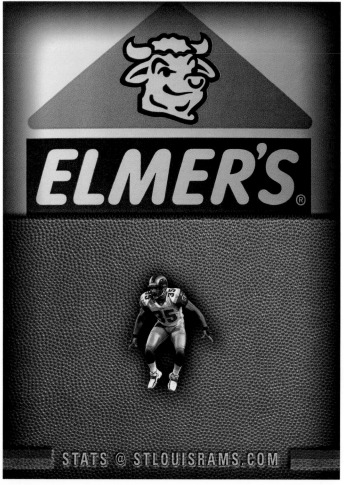

STATS @ STLOUISRAMS.COM

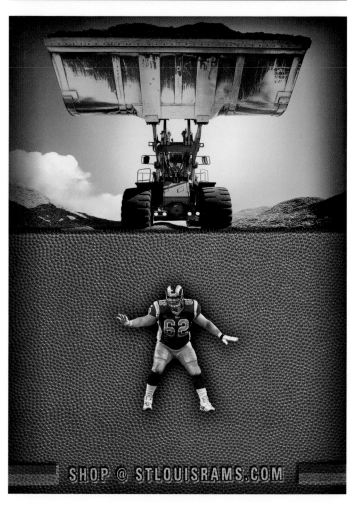

SHOP @ STLOUISRAMS.COM

(this spread) 'Rams Bus Shelter Campaign' Agency: Rodgers Townsend Art Director: Tom Hudder Photographer: Todd Davis Copywriter: Tom Townsend Client: Saint Louis Rams

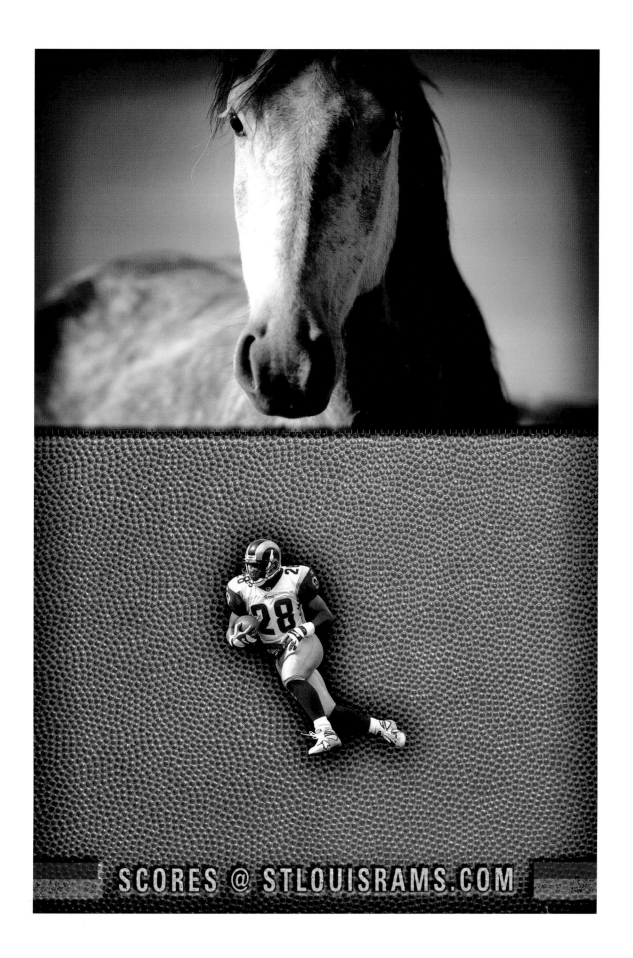

SCORES @ STLOUISRAMS.COM

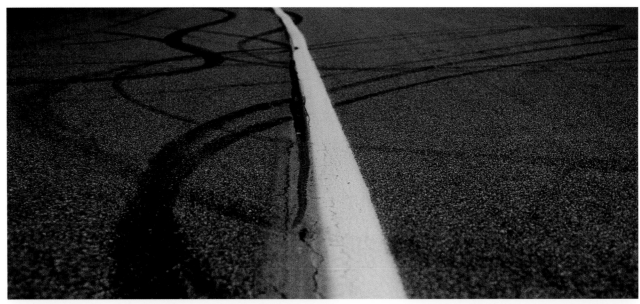

Real athletes don't get grass stains.

Some UFOs never leave the ground.

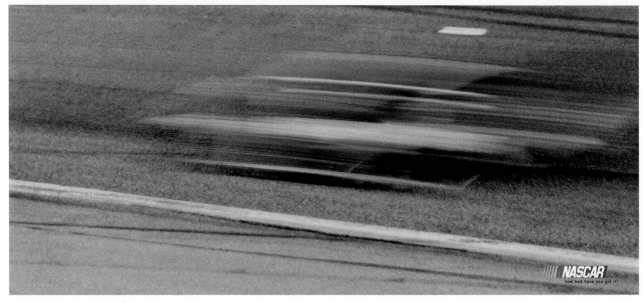

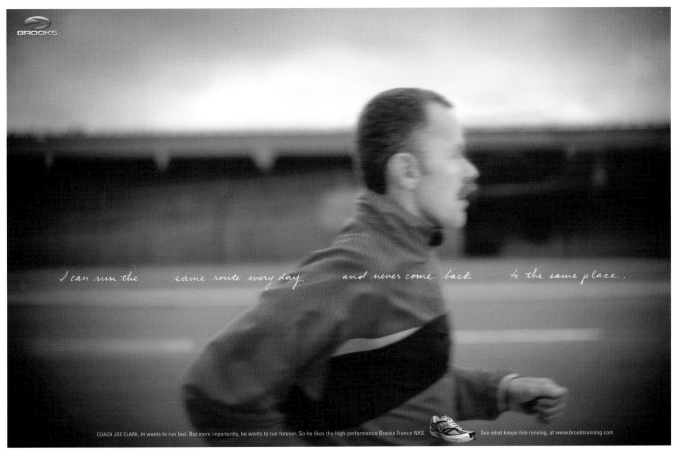

I can run the same route every day and never come back to the same place.

COACH JOE CLARK, 44 wants to run fast. But more importantly, he wants to run forever. So he likes the high-performance Brooks Trance NXS. See what keeps him running, at www.brooksrunning.com

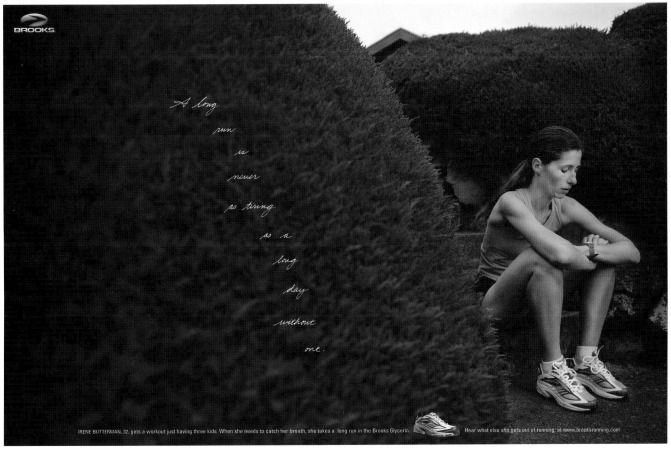

A long run is never so tiring as a long day without one.

IRENE BUTTERMAN, 32, gets a workout just having three kids. When she needs to catch her breath, she takes a long run in the Brooks Glycerin. Hear what else she gets out of running, at www.brooksrunning.com

Agency: DDB Seattle Creative Director: Fred Hammerquist Art Directors: Larry Olson and Carol Davidson Photographer: John Huet Copywriter: Angela Reid Client: Brooks

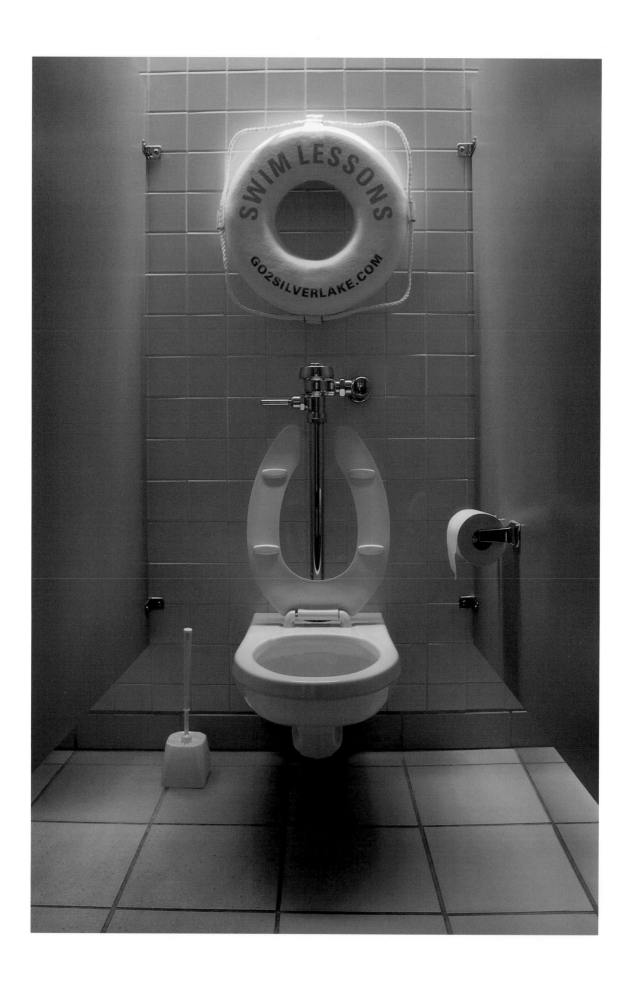

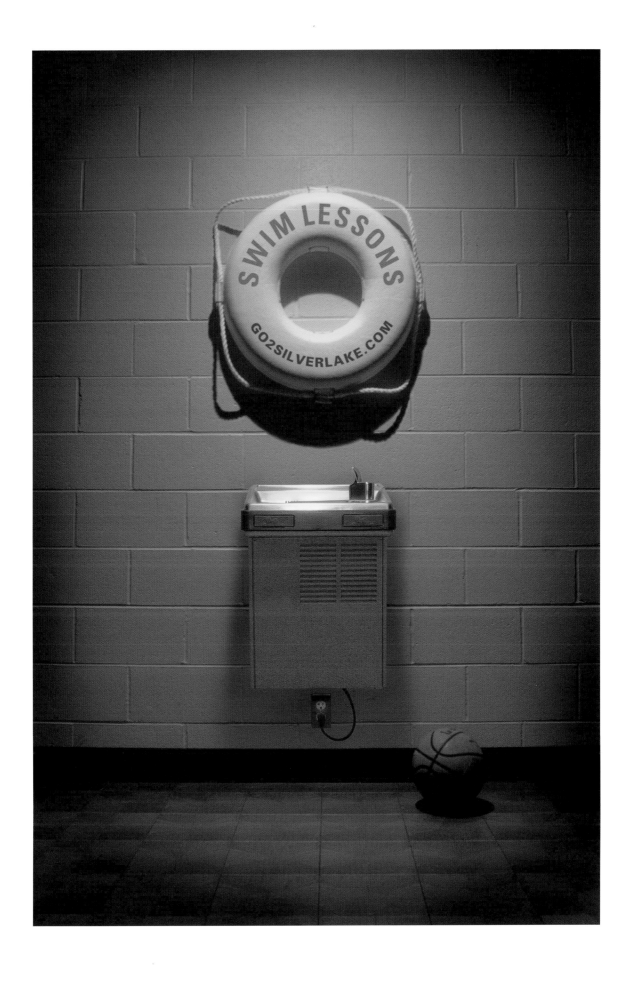

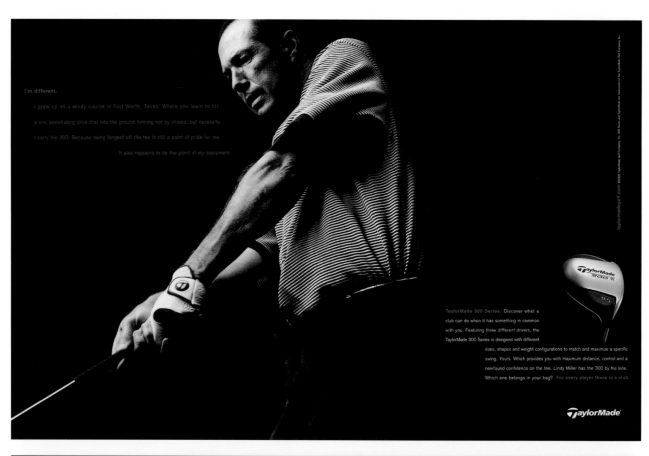

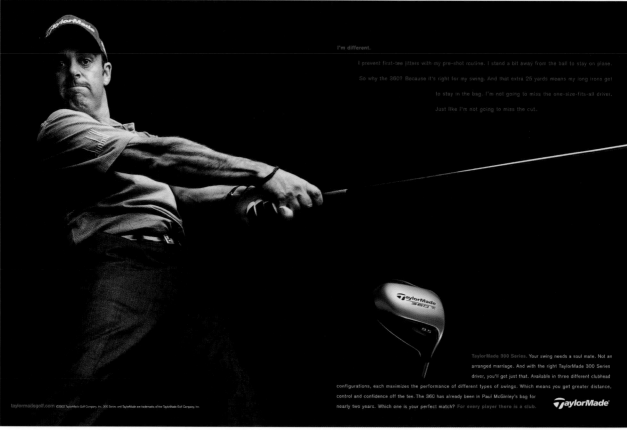

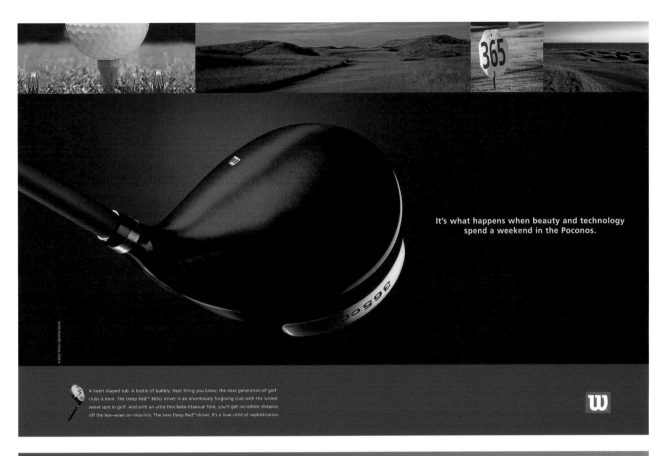

It's what happens when beauty and technology
spend a weekend in the Poconos.

A heart shaped tub. A bottle of bubbly. Next thing you know, the next generation of golf
clubs is born. The Deep Red™ 365cc driver is an enormously forgiving club with the widest
sweet spot in golf. And with an ultra thin beta-titanium face, you'll get incredible distance
off the tee—even on miss-hits. The new Deep Red™ driver. It's a love child of sophistication.

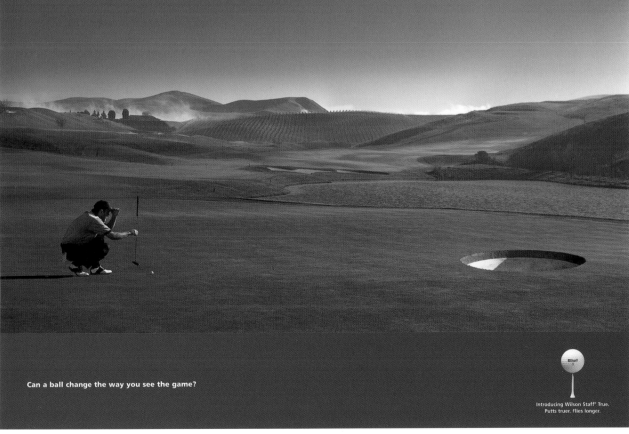

Can a ball change the way you see the game?

Introducing Wilson Staff® True.
Putts truer. Flies longer.

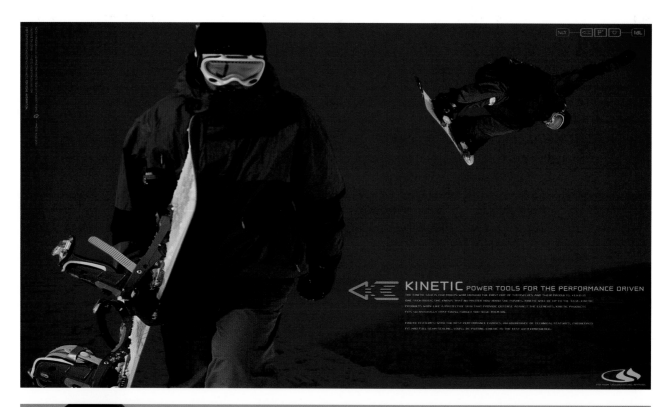

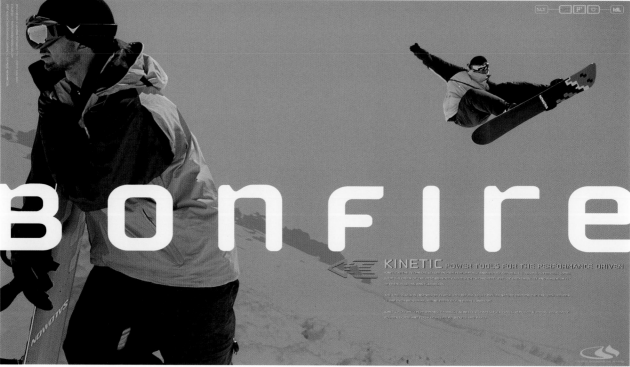

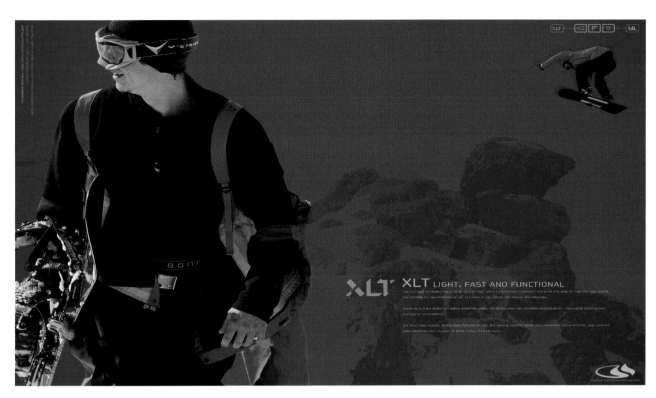

XLT LIGHT, FAST AND FUNCTIONAL

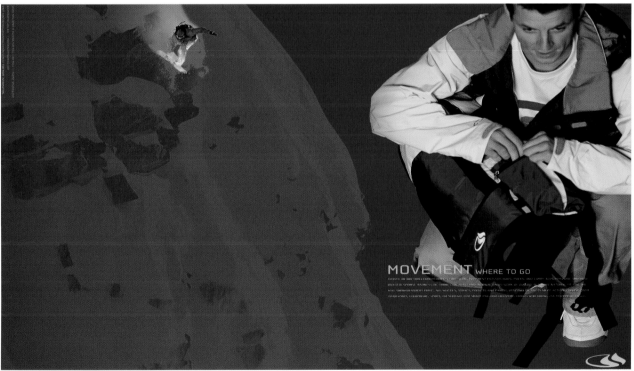

MOVEMENT WHERE TO GO

When crankbait fishing, are you doing too much cranking and not enough fishing?

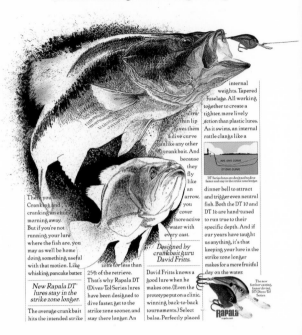

There you are. Cranking and cranking an entire morning, away. But if you're not running your lure where the fish are, you may as well be home doing something useful with that motion. Like whisking pancake batter.

New Rapala DT lures stay in the strike zone longer.

The average crankbait hits the intended strike zone for less than 25% of the retrieve. That's why Rapala DT (Dives-To) Series lures have been designed to dive faster, get to the strike zone sooner, and stay there longer. An

internal weights. Tapered fuselage. All working together to create a tighter, more lively action than plastic lures. As it swims, an internal rattle clangs like a

DT Series lures are designed to dive faster and stay in the strike zone longer.

dinner bell to attract and trigger even neutral fish. Both the DT 10 and DT 16 are hand-tuned to run true to their specific depth. And if our years have taught us anything, it's that keeping your lure in the strike zone longer makes for a more fruitful day on the water.

ultra-thin lip gives them a dive curve unlike any other crankbait. And because they fly like an arrow, you cover more active water with every cast.

Designed by crankbait guru David Fritts.

David Fritts knows a good lure when he makes one. (Even the prototype put on a clinic, winning back-to-back tournaments.) Select balsa. Perfectly placed

The new further-casting, faster-diving DT (Dives-To) Series.

Reaching suspended fish can be as easy as one-thousand-one... one-thousand-two... one-thousand-three.

You know where they are. The graph shows them plump and ready for the picking three feet off the bottom. So now what? Do you go the horseshoes and hand grenades route and just toss something out with the hopes of getting within

striking distance? Or do you want to drop one right on their noses?

The CountDown controlled-depth technique.

Whether fish are suspending at the weed tops or off bottom structure, nothing puts you on them like the slow-sinking depth control of a Rapala CountDown. Start by casting your CountDown

into shore lines, over rock reefs, or

along weed lines. Its heavy weight makes for long and pinpoint casts even in windy conditions. As soon as the lure hits the water,

The CountDown's slow-sinking depth control let's you drop in on the party.

it won't take long for the legendary wounded-minnow wiggle of your Rapala to close the deal. It's that simple. With a CountDown and a little technique, there's no easier way to put your lure where a fish's mouth is.

Remember the count at this point. (We promise this is as close to a math quiz as we'll ever give you.) Retrieve and cast out again. This time, reduce your count by three seconds. That will put your tasty little balsa snack right in front of those fatties you marked three feet off the bottom. From there, take up any slack and begin counting. The lure is designed to sink at one foot per second, so count it down at a uniform rate (one-thousand-one... one-thousand-two... one-thousand-three) until you feel it come to rest on the bottom. You'll know you're there when the line goes slack.

The new bright chartreuse Fire Minnow CountDown.

The difference between a day out fishing with your buddies and a day out-fishing your buddies.

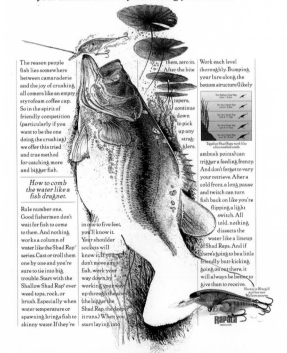

The reason people fish lies somewhere between camaraderie and the joy of crushing all comers like an empty styrofoam coffee cup. So in the spirit of friendly competition (particularly if you want to be the one doing the crushing) we offer this tried and true method for catching more and bigger fish.

How to comb the water like a fish dragnet.

Rule number one. Good fishermen don't wait for fish to come to them. And nothing works a column of water like the Shad Rap series. Cast or troll them one by one and you're sure to tie into big trouble. Start with the Shallow Shad Rap over weed tops, rock, or brush. Especially when water temperature or spawning brings fish to skinny water. If they're

in one to five feet, you'll know it. Your shoulder sockets will know it. If you don't move any fish, work your way down by working your way up through the sizes (the bigger the Shad Rap, the deeper it runs.) When you start laying into

them, zero in. After the bite

Work each level thoroughly. Bumping your lure along the bottom structure (likely

The Shallow Shad Rap runs 1-3 feet.
The No. 5 Shad Rap runs 5-9 feet.
The No. 7 Shad Rap runs 8-11 feet.
The No. 9 Shad Rap runs 11-18 feet.

Together, Shad Raps work like a fine-toothed comb.

ambush points) can trigger a feeding frenzy. And don't forget to vary your retrieve. After a cold front, a long pause and twitch can turn fish back on like you're flipping a light switch. All told, nothing dissects the water like a lineup of Shad Raps. And if there's going to be a little friendly butt-kicking going on out there, it will always be better to give than to receive.

tapers, continue down to pick up any stragglers.

Shown in Bluegill and hot new Walleye patterns.

Any floating lure can scratch the lake's surface. But what happens if you go down a little deeper?

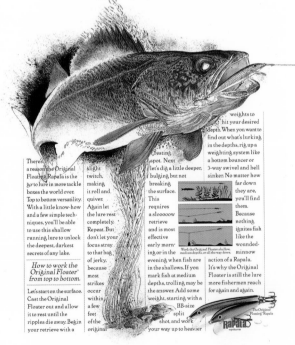

There's a reason the Original Floating Rapala is the go-to lure in more tackle boxes the world over. Top to bottom versatility. With a little know-how and a few simple techniques, you'll be able to use this shallow running lure to unlock the deepest, darkest secrets of any lake.

How to work the Original Floater from top to bottom.

Let's start on the surface. Cast the Original Floater out and allow it to rest until the ripples die away. Begin your retrieve with a

slight twitch, making it roll and quiver. Again let the lure rest completely. Repeat. But don't let your focus stray to that bag of jerky, because most strikes occur within a few feet of the original

resting spot. Next let's dig a little deeper, bulging but not breaking the surface. This requires a sloooooow retrieve and is most effective early morning or in the evening when fish are in the shallows. If you mark fish at medium depths, trolling may be the answer. Add some weight, starting with a BB-size split shot, and work your way up to heavier

Work the Original Floater shallow, medium depths, or all the way down.

weights to hit your desired depth. When you want to find out what's lurking in the depths, rig up a weighting system like a bottom bouncer or 3-way swivel and bell sinker. No matter how far down they are, you'll find them. Because nothing ignites fish like the wounded-minnow action of a Rapala. It's why the Original Floater is still the lure more fishermen reach for again and again.

The Original Floating Rapala.

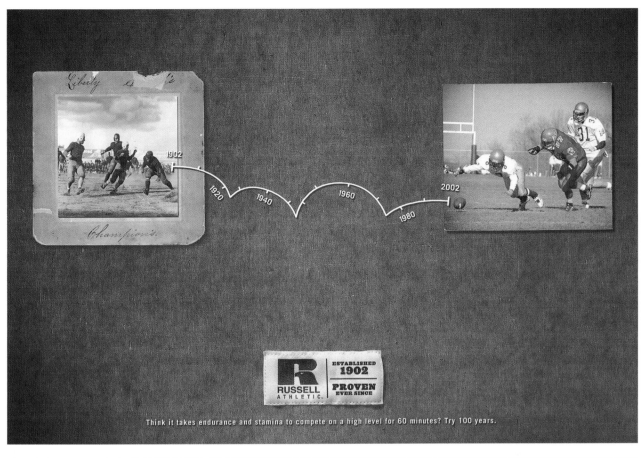

Think it takes endurance and stamina to compete on a high level for 60 minutes? Try 100 years.

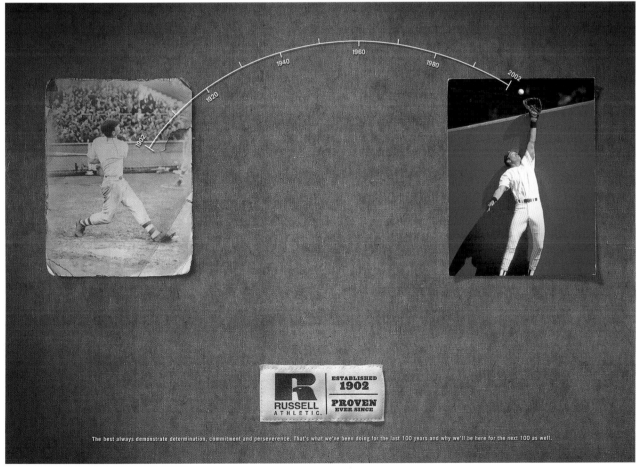

The best always demonstrate determination, commitment and perseverence. That's what we've been doing for the last 100 years and why we'll be here for the next 100 as well.

Agency: Westwayne Creative Director: Scott Sheinberg Art Director: John Stapleton Photographer: Dave Spataro Copywriter: James Rosene Client: Russell Athletic

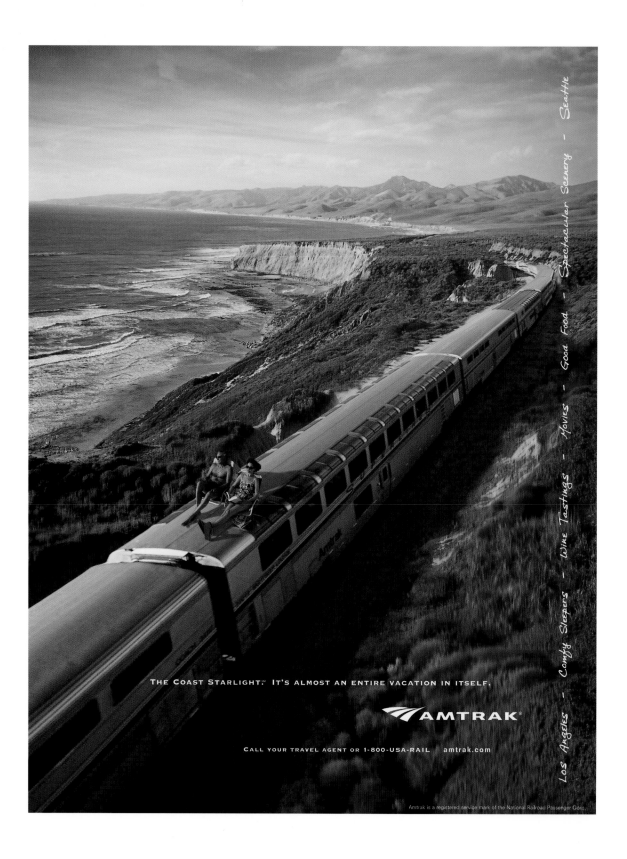

THE COAST STARLIGHT. IT'S ALMOST AN ENTIRE VACATION IN ITSELF.

AMTRAK®

CALL YOUR TRAVEL AGENT OR 1-800-USA-RAIL amtrak.com

Amtrak is a registered service mark of the National Railroad Passenger Corp.

Los Angeles — Comfy Sleepers — Wine Tastings — Movies — Good Food — Spectacular Scenery — Seattle

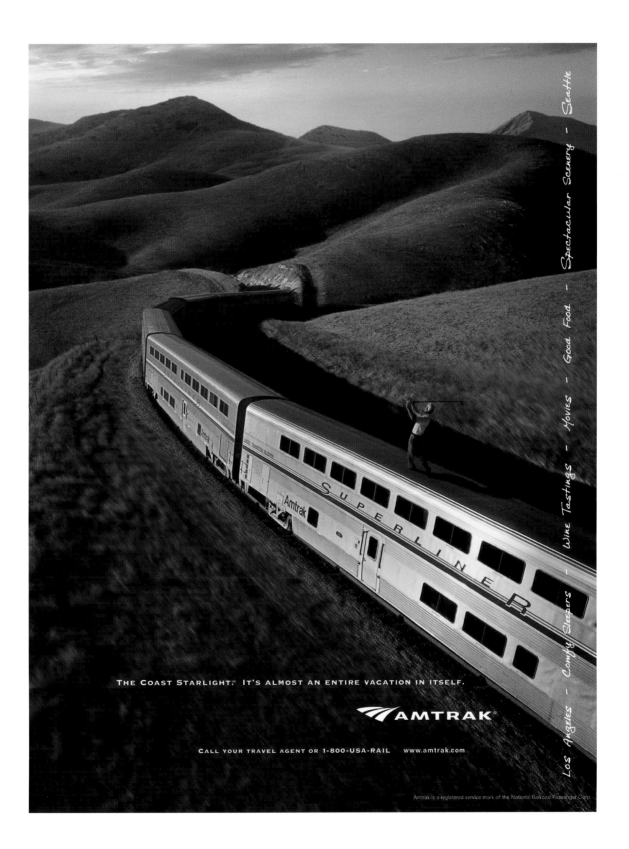

THE COAST STARLIGHT. IT'S ALMOST AN ENTIRE VACATION IN ITSELF.

AMTRAK®

CALL YOUR TRAVEL AGENT OR 1-800-USA-RAIL www.amtrak.com

Los Angeles – Comfy Sleepers – Wine Tastings – Movies – Good Food – Spectacular Scenery – Seattle

Amtrak is a registered service mark of the National Railroad Passenger Corp.

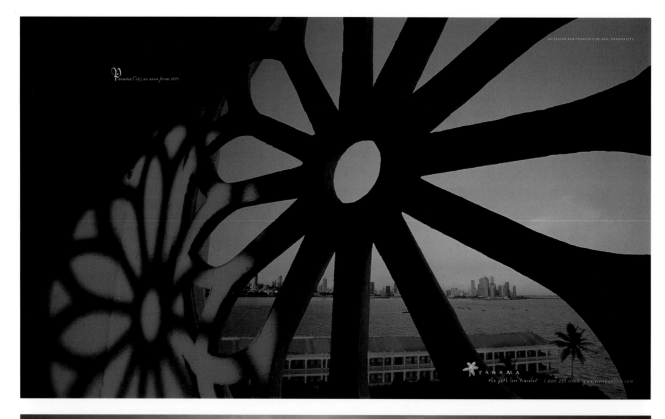

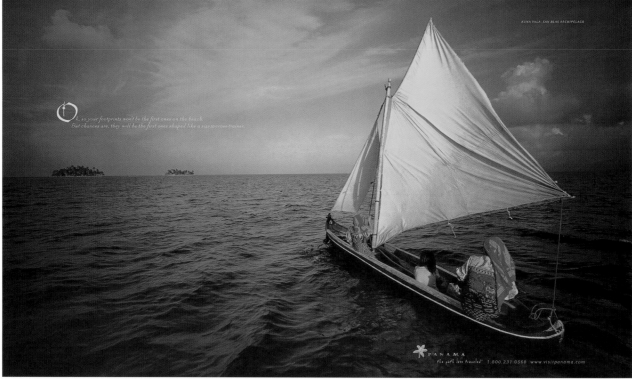

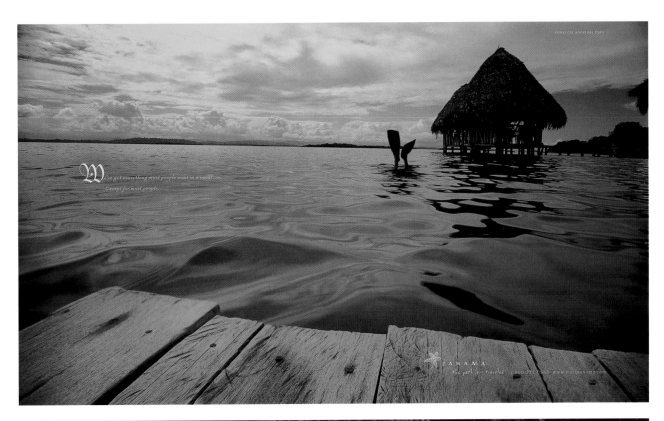

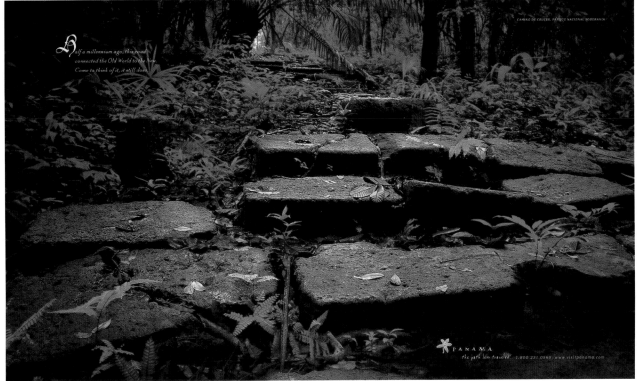

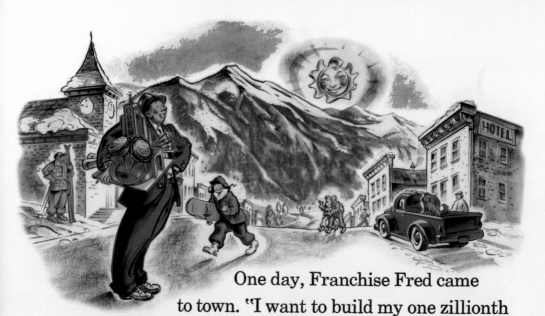

One day, Franchise Fred came
to town. "I want to build my one zillionth
Clone-A-Burger right here," he grinned. So all the
people held a meeting. Mr. Snowboarder was there.
Mrs. Hiker, Mr. Skier and Ms. Ski Instructor were
there too. "No, no," they told Franchise Fred. "Your idea
is not so good. We have come here to laugh and play
and ride and ski all the livelong day. Your eyesore
will ruin our happy mountain town." Franchise Fred
made a big fuss. Finally, everyone said, "Well, there
is some land above treeline." Then they took him way
up there and left him. Maybe Franchise Fred made
it home. But with 311 inches of annual snowfall, no
one will really know for sure until the spring thaw.
Telluride. A land where people come to play. The end.

TELLURIDE.

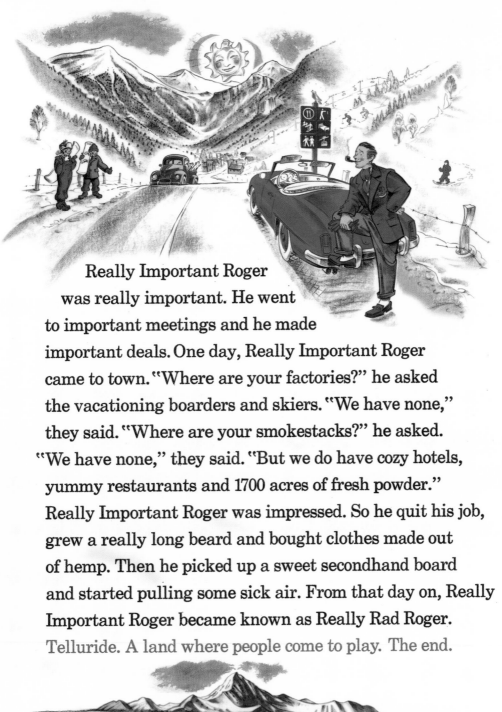

Really Important Roger
was really important. He went
to important meetings and he made
important deals. One day, Really Important Roger
came to town. "Where are your factories?" he asked
the vacationing boarders and skiers. "We have none,"
they said. "Where are your smokestacks?" he asked.
"We have none," they said. "But we do have cozy hotels,
yummy restaurants and 1700 acres of fresh powder."
Really Important Roger was impressed. So he quit his job,
grew a really long beard and bought clothes made out
of hemp. Then he picked up a sweet secondhand board
and started pulling some sick air. From that day on, Really
Important Roger became known as Really Rad Roger.
Telluride. A land where people come to play. The end.

TELLURIDE

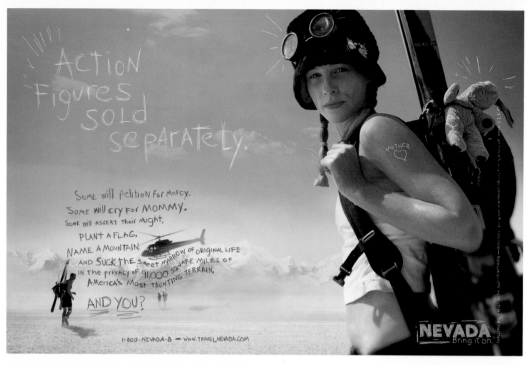

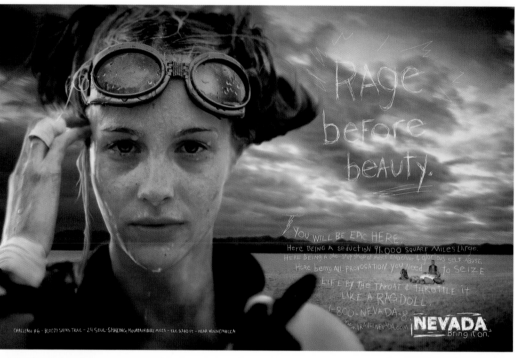

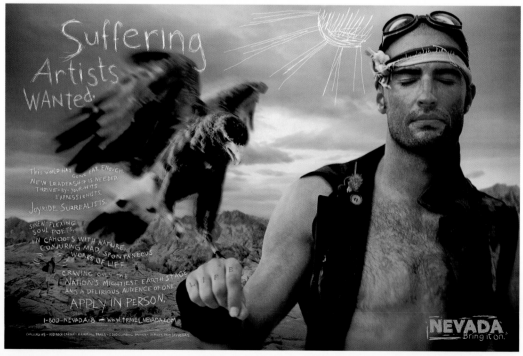

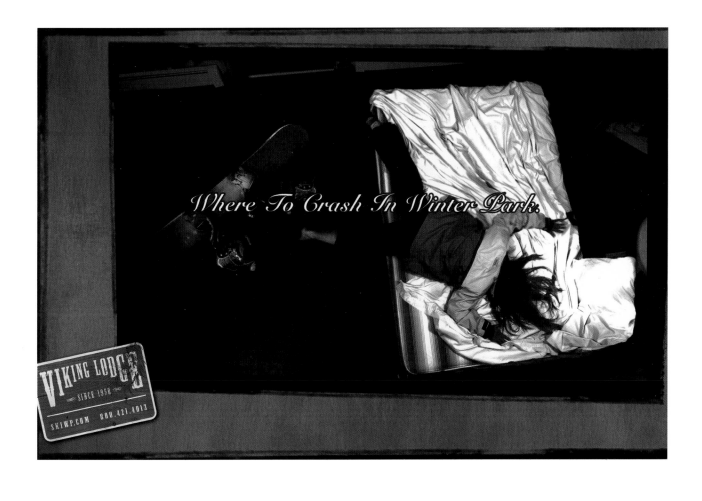

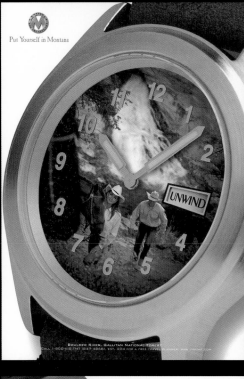
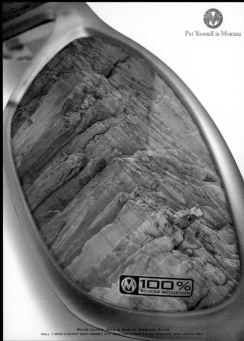

THE ROAD TO THE FUTURE ISN'T A ROAD AT ALL.

In the 1860s, we connected a nation—east to west and west to east. Today we carry America's way of life, from raw materials to finished goods, in a cost-efficient, environmentally friendly way. Though 140 years have passed, we're still connecting a nation—past to present, present to future.

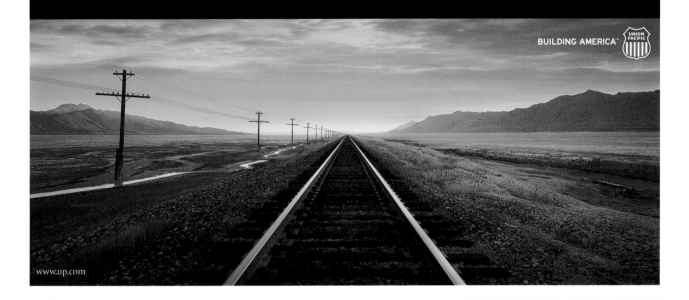

BUILDING AMERICA™ UNION PACIFIC

www.up.com

THE TIES THAT BIND A NATION.

It's 33,000 miles of timber and steel that connect America—from Portland to New Orleans, from Chicago to Los Angeles. It's the backbone of our economy and in turn, the backbone of our nation. Most importantly, it's 48,000 men and women who every day transport the raw materials and finished goods that keep our country moving.

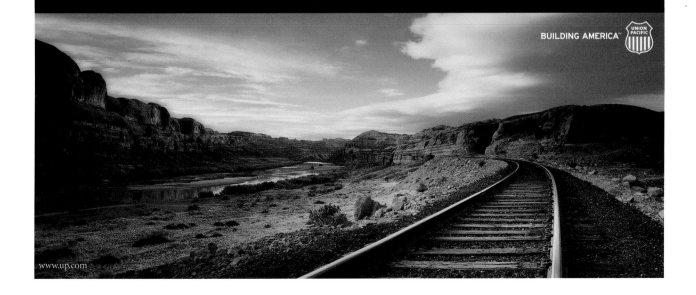

BUILDING AMERICA™ UNION PACIFIC

www.up.com

Agency: Bailey Lauerman Creative Directors: Carter Weitz and Marty Amsler Art Directors: David Steinke and Ron Sack
Designer: Ed McCollum Photographer: Olaf Veltman Retouch: Thomas Irvin Account Executive: Lance Koenig Client: Union Pacific

Information on any big city in India is now available online at www.timescity.com

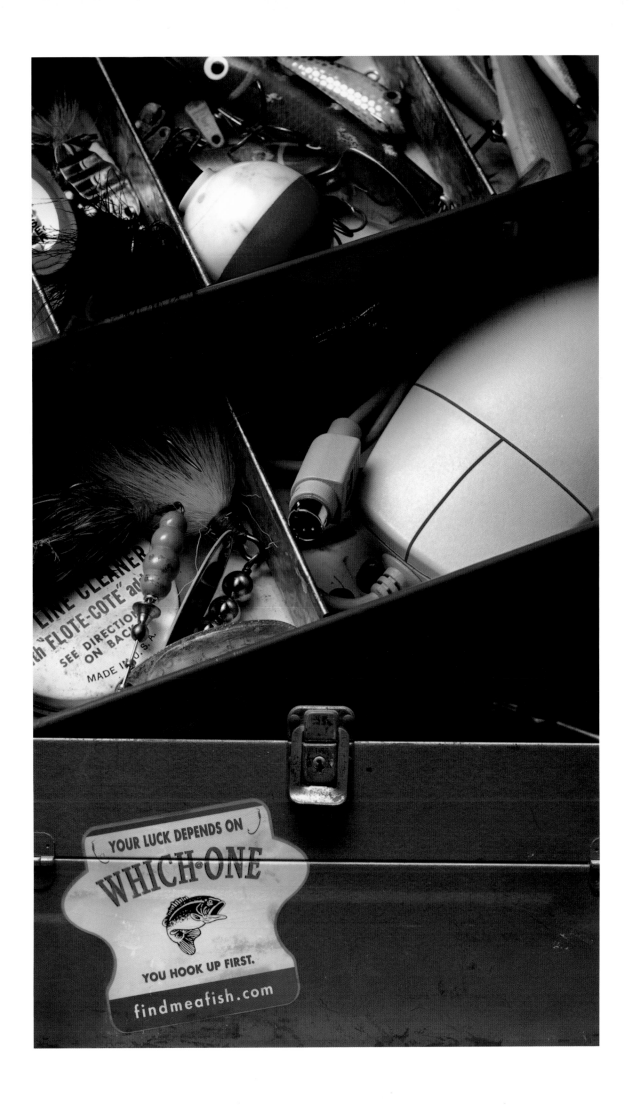

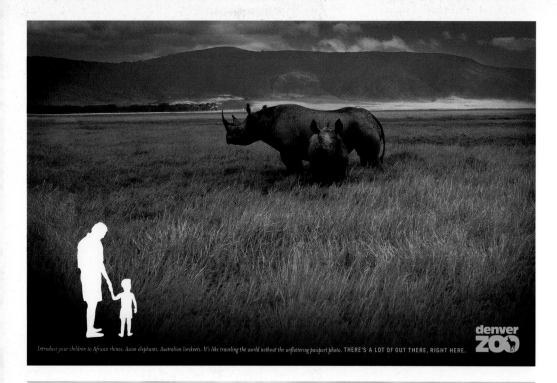

Introduce your children to African rhinos. Asian elephants. Australian lorikeets. It's like traveling the world without the unflattering passport photo. THERE'S A LOT OF OUT THERE, RIGHT HERE.

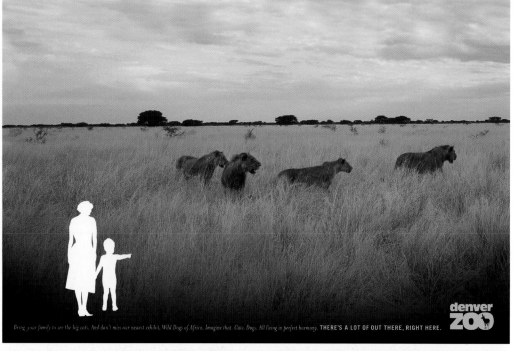

Bring your family to see the big cats. And don't miss our newest exhibit, Wild Dogs of Africa. Imagine that. Cats. Dogs. All living in perfect harmony. THERE'S A LOT OF OUT THERE, RIGHT HERE.

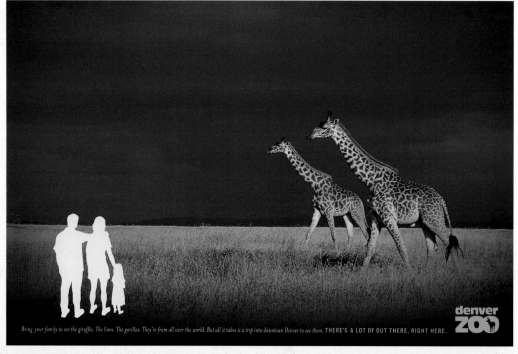

Bring your family to see the giraffes. The lions. The gorillas. They're from all over the world. But all it takes is a trip into downtown Denver to see them. THERE'S A LOT OF OUT THERE, RIGHT HERE.

Agency: McClain Finlon Advertising Creative Director: Tom Leydon Art Director: Jeff Martin Photographer: Nicholas Parfitt Copywriter: Gregg Bergan Client: Denver Zoo

CreativeDirectorsArtDirectorsDesigners

PhotographersIllustrators

Copywriters

Agencies

Clients

Directory of Ad Agencies

Abbott Mead Vickers, BBDO Ltd.
151 Marylebone Road
London NW1 5QE
England
Tel: 44 207 616 3500
Fax: 44 207 616 3600
www.amvbbdo.com

Acme Advertising
195 Portola Drive
San Francisco, CA 94131
Tel: 1 415 970 3385
Fax: 1 415 970 3386

Agenda Marketing Partners
200 McCormick Avenue
Costa Mesa, CA 92626
Tel: 1 714 689 9400
Fax: 1 714 689 9401
www.agendamarketing.com

Alok Nanda & Company
Great Western Building, 2nd Floor
130 132 SB Road Fort
Mumbai Maharashtra, India 400023
Tel: 91 22 2281 9395
Fax: 91 22 2281 7704

Arnold Worldwide
101 Huntington Avenue
Boston, MA 02199
Tel: 1 617 587 8000
Fax: 1 617 587 8070
www.arnoldworldwide.com

Bailey Lauerman
900 Wells Fargo Center
Lincoln, NE 68508
Tel: 1 402 475 2800
Fax: 1 402 475 5115
www.baileylauerman.com

BBDO New York
1285 Avenue of the Americas
New York, NY 10019
Tel: 1 212 459 5000
www.bbdo.com

Bbdo South
3500 Lenox Road 1900
Atlanta, GA 30326
Tel: 1 404 231 1700
Fax: 1 404 841 1667
www.bbdo.com

BBDO West
637 Commercial Street, 3rd Floor
San Francisco, CA 94111
Tel: 1 415 274 6231
Fax: 1 415 274 6221
www.bbdo.com

BBDS Communications
1110 North Old World Third Street,
Suite 500
Milwaukee, WI 53203
Tel: 1 414 223 4300
Fax: 1 414 223 4301
www.noble-bbds.com

Bonfire Snowboarding
525 SE 11th Street
Portland, OR 97274
Tel: 1 503 236 3473
Fax: 1 503 236 0989
www.bonfiresnowboarding.com

Borders Perrin Norrander
808 SW Third Avenue, 8th Floor
Portland, OR 97204
Tel: 1 503 227 2506
Fax: 1 503 227 4287
www.bpninc.com

Bozell And Jacobs
13801 FNB Parkway
Omaha, NE 68154
Tel: 1 402 965 4300
Fax: 1 402 965 4399
www.bozelljacobs.com

Bozell New York
40 West 23rd Street
New York, NY 10010
Tel: 1 212 727 5525
Fax: 1 212 727 5505

Bradley and Montgomery Advertising
720 North Park Avenue
Indianapolis, IN 46202
Tel: 1 317 423 1745
Fax: 1 317 423 1748
www.bamads.com

Brand Architecture International
488 Madison Avenue
New York, NY 10022
Tel: 1 212 804 1224
Fax: 1 212 804 1225
www.brandarch.com

Brave Heart
548 Merton Street
Toronto, Ontario M4S 1B3
Canada
Tel: 1 416 486 9597

Butler, Shine & Stern
10 Liberty Ship Way 300
Sausalito, CA 94965
Tel: 1 415 331 6049
Fax: 1 415 331 3524
www.bsands.com

Carmichael Lynch
800 Hennepin Avenue
Minneapolis, MN 55403
Tel: 1 612 334 6045
Fax: 1 612 334 6032
www.carmichaellynch.com

CHRW Advertising, Llc
106 West 11th Street Suite 2220
Kansas City, MO 64105
Tel: 1 816 472 4455
Fax: 1 816 472 8855
www.chrwadvertising.com

Clarity Coverdale Fury
120 South 6th Street, Suite 1300
Minneapolis, MO 55402
Tel: 1 612 359 4379
Fax: 1 612 359 4392
www.claritycoverdalefury.com

Cole & Weber/Red Cell
34 NW 1st Avenue Suite 100
Portland, OR 97209
Tel: 1 503 548 3314
Fax: 1 503 226 6059
www.coleweber.com

Colle & McVoy
8500 Normandale Lake Boulevard 2400
Minneapolis, MN 55437
Tel: 1 952 852 7500
Fax: 1 952 852 8100
www.collemcvoy.com

Craig Cutler Studio
15 East 32nd Street
New York, NY 10016
Tel: 1 212 779 9755
Fax: 1 212 799 9780
www.craigcutler.com

Crispin Porter Bogusky
2699 South Bayshore Drive
Miami, FL 33133
Tel: 1 305 859 2070
Fax: 1 305 854 3419
www.cpbmiami.com

Cultivator Advertising Design
1708 Walnut Street
Boulder, CO 80302
Tel: 1 303 444 4134
Fax: 1 800 783 4152
www.cultivatoradvertising.com

DDB Seattle
1000 Second Avenue Suite 1000
Seattle, WA 98101
Tel: 1 206 464 0190
Fax: 1 206 447 1201
www.sea.ddb.com

De Pascuale
1/358 Wickham Street
Brisbane, Queensland
Australia 4006
Tel: 61 7 38524588
Fax: 61 7 38524577
www.depascuale.com.au

Di Zinno Thompson
2215 India Street
San Diego, CA 92101
Tel: 1 619 237 5011
Fax: 1 619 237 0532
www.dzt.com

Eisner Underground
509 South Exeter Street
Baltimore, MD 21202
Tel: 1 410 843 3255
Fax: 1 410 385 8386
www.undergroundadvertising.com
Euro RSCG Tatham Partners
36 East Grand Avenue
Chicago, IL 60611
Tel: 1 312 640 3059
Fax: 1 312 640 3180
www.eurorscg-tathampartners.com

Fallon
50 South 6th Street
Minneapolis, MN 55402
Tel: 1 612 758 2363
Fax: 1 612 758 2346
www.fallon.com

FCB Southern California
17600 Gillette Avenue
Irvine, CA 92614
Tel: 1 949 567 9166
Fax: 1 949 567 9465
www.fcb.com

Flea Communications
Fairfeilds 204 VS Road Mahim
Mumbai, 400016
india
Tel: 91 22 2445 4056
Fax: 91 22 2446 0465

G Whiz
825 Third Avenue
New York, NY 10022
Tel: 1 212 537 8485
Fax: 1 212 537 8413
www.thinkgwhiz.com

Giovanni FCB
SCN, Quadra 1, Bloco B-no.100
Ctro Empresarial Varig, Sala 503-Parte A
Cep: 70710-500,
Brasília/DF, Brazil
Tel: 55 61 328 9900
Fax: 55 61 328 9898
www.fcb.com

Goodby, Silverstein & Partners
720 California Street
San Francisco, CA 94108
Tel: 1 415 392 0669
Fax: 1 415 788 4303
www.gspsf.com

GSD&M
828 West 6th Street
Austin, TX 78703
Tel: 1 512 242 5800
Fax: 1 512 242 8800
www.gsdm.com

Heye & Partner
Ottobrunnerstrasse 28
Unterhaching Bavaria 82008
Germany
Tel: 49 89 6653 2340
Fax: 49 89 6653 2380
www.heye.de

Hill Holliday, NY
345 Hudson Street
New York, NY 10014
Tel: 1 212 830 7648
Fax: 1 212 830 7600
www.hillholliday.com

Hoffman York, Inc.
1000 North Water Street, 16th Floor
Milwaukee, WI 53202
Tel: 1 414 225 9511
Fax: 1 414 289 0417
www.hoffmanyork.com

Howard, Merrell & Partners
8521 Six Forks Road
Raleigh, NC 27615
Tel: 1 919 848 2400
Fax: 1 919 845 9845
www.merrellgroup.com

HSR Business To Business
300 East Business Way
Cincinnati, OH 45241
Tel: 1 513 346 3465
Fax: 1 513 671 3811
www.hsr.com

J. Walter Thompson
500 Woodward Avenue
Detroit, MI 48073
Tel: 1 313 964 3800
Fax: 1 313 964 2311
www.jwtworld.com

J. Walter Thompson/Denver
1401 17th Street Suite 1500
Denver, CO 80202
Tel: 1 303 382 2423
Fax: 1 303 296 9816
www.jwtworld.com

Kilmer & Kilmer
125 Truman Street NE Suite 200
Albuquerque, NM 87108
Tel: 1 505 260 1175
Fax: 1 505 260 1155
www.kilmer2.com

Kinetic Singapore
2 Leng Kee Road #04–03A
Thye Hong Centre
Singapore 159086
Tel: 65 6 379 5320
Fax: 65 6 472 5440
www.kinetic.com.sg

Loeffler Ketchum Mountjoy
2101 Rexford Road Suite 200E
Charlotte, NC 28211
Tel: 1 704 364 8969
Fax: 1 704 364 8470
www.lkmads.com

Lopito, Ileana and Howie
Metro Office Park N13 1st Street
Guaynabo, Puerto Rico 00968
Tel: 1 787 783 1160
Fax: 1 787 783 2272

Martin Williams, Inc.
60 South 6th Street, Suite 2800
Minneapolis, MN 55402
Tel: 1 612 342 9844
Fax: 1 612 342 9700
www.martinwilliams.com

McCann Erickson
622 Third Avenue
New York, NY 10017
Tel: 1 646 865 3203
Fax: 1 646 865 3995
www.mccann.com

Mccann-Erickson SF
135 Main Street
San Francisco, CA 94105
Tel: 1 415 348 5100
Fax: 1 415 357 1088
www.mccann.com

McClain Finlon Advertising
2340 Blake Street
Denver, CO 80205
Tel: 1 303 436 9400
Fax: 1 303 436 9600
www.mcclainfinlon.com

McGarrah Jessee
205 Brazos
Austin, TX 78701
Tel: 1 512 225 2000
Fax: 1 512 225 2020
www.mcgarrahjessee.com

McKinney & Silver
333 Corporate Plaza
Raleigh, NC 27601
Tel: 1 919 828 0691
www.mckinney-silver.com

Moses Media
584 Broadway 607
New York, NY 10012
Tel: 1 212 625 0331
Fax: 1 212 626 0332

Mullen
36 Essex Street
Wenham, MA 01984
Tel: 1 978 468 8734
Fax: 1 978 468 1133
www.mullen.com

Muller & Company
4739 Belleview
Kansas City, MO 64112
Tel: 1 816 300 6281
Fax: 1 816 531 6692
www.mullerco.com

Noble BBDS
20 West Kinzie Suite 1400
Chicago, IL 60610
Tel: 1 312 670 2900
Fax: 1 312 670 7420
www.noble-bbds.com

Olson & Company
1625 Hennepin Avenue
Minneapolis, MN 55403
Tel: 1 612 215 9807
Fax: 1 612 215 9801
www.oco.com

Planet Propaganda
605 Williamson Street
Madison, WI 53703
Tel: 1 608 256 0000
Fax: 1 608 256 1975
www.planetpropaganda.com

Publicis
950 Sixth Avenue
New York, NY 10001
Tel: 1 212 279 5244
Fax: 1 212 279 5593
www.publicis-usa.com

Publicis & Hal Riney
2001 The Embarcadero
San Francisco, CA 94133
Tel: 1 415 293 2447
Fax: 1 415 293 2620
www.hrp.com

R&R Partners
615 Riverside Drive
Reno, NV 89503
Tel: 1 775 323 1611
Fax: 1 775 334 6797
www.rpartners.Com

Rainey Kelly Campbell Roalfe/Y&R
Greater London House
Hampstead Road
London, NW1 7QP
England
Tel: 44 20 7611 6569
Fax: 44 20 7611 6011
www.rkcryr.com

RDW Group
125 Holden Street
Providence, RI 02908
Tel: 1 401 533 5184
Fax: 1 401 521 0014
www.rdwgroup.com

RMG David
274 Captain Gaur Marg Srinivaspuri
New Delhi, India 110065
Tel: 91 11 26 331226
Fax: 91 11 26 924938
www.ap.rmgint.com

Rodgers Townsend
1310 Papin Street
Saint Louis, MO 63103
Tel: 1 314 436 9960
Fax: 1 314 436 9961
www.rodgerstownsend.com

Sawyer Riley Compton
3423 Piedmont Road
Suite 400
Atlanta, Georgia 30305
Tel: 1 404 479 9849
Fax: 1 404 479 9850
www.brandstorytellers.com

Sukle Advertising and Design
2430 West 32nd Avenue
Denver, CO 80211
Tel: 1 303 964 9100
Fax: 1 303 964 9663

Syllabus Communications
Badenstrasse 571
Zunch, Switzerland 8048
Tel: 41 04 33 220 012

TBWA/Chiat/Day
488 Madison Avenue
New York, NY 10022
Tel: 1 212 804 1083
Fax: 1 212 804 1448
www.chiatday.com

Team One Advertising
1960 East Grand Avenue
El Segundo, CA 90245
Tel: 1 310 615 2000
Fax: 1 310 322 7565
www.teamoneadv.com

The Richards Group
8750 North Central Expressway 1200
Dallas, TX 75231
Tel: 1 214 891 5700
Fax: 1 214 891 2911
www.richards.com

Vibes Communications Pte Ltd
Blk 55 Lorong 5-04-180
Toa Payoh 310055
Singapore
Tel: 65 98 77 4239
www.ronaldwong.com

Wendt Kochman
615 2nd Avenue North
Great Falls, MT 59403
Tel: 1 406 456 8500
Fax: 1 406 771 0601
www.wendtkochman.com

Westwayne
401 East Jackson Street, Suite 3600
Tampa, FL 33602
Tel: 1 813 202 1216
Fax: 1 813 202 1264
www.westwayne.com

Wongdoody
83 South King Street, Suite 814
Seattle, WA 98104
Tel: 1 206 624 5325
Fax: 1 206 624 2369
www.wongdoody.com

Young & Laramore
310 East Vermont Street
Indianapolis, IN 46204
Tel: 1 317 264 8000
Fax: 1 317 264 8000
www.youngandlaramore.com

Young & Rubicam
285 Madison Avenue
New York, NY 10017
Tel: 1 212 210 3000
www.yandr.com

Young & Rubicam Chicago
233 North Michigan 1600
Chicago, IL 60601
Tel: 1 312 596 3139
Fax: 1 312 596 3129
www.yandr.com

Graphis Book Order Form

DESIGN TITLES	ISBN no.	Price	Quantity	Total
Annual Reports 8	1-931241-17-1	$70.00		
Brochures 4	1-888001-51-8	$70.00		
Corporate Identity 4	1-888001-70-4	$70.00		
designing: (Chermayeff and Geismar)	1-932026-14-2	$60.00		
Design Annual 2004	1-931241-32-5	$70.00		
Design Annual 2003	1-931241-13-9	$70.00		
Exhibition: The Work of Socio X	1-931241-28-7	$45.00		
Language Culture Type (ATypI)	1-932026-01-0	$60.00		
Letterhead 5	1-888001-73-9	$70.00		
Masters of the 20th Century (ICOGRADA)	1-888001-85-2	$80.00		
New Talent Design Annual 2003	1-931241-30-9	$70.00		
New Talent Design Annual 2001	1-888001-84-4	$60.00		
Poster Annual 2003	1-931241-21-X	$70.00		
Poster Annual 2002	1-931241-06-6	$70.00		
Poster Annual 2001	1-888001-72-0	$70.00		
Product Design 3	1-931241-15-5	$70.00		
Promotion Design 2	1-931241-28-7	$70.00		
The Graphic Art of Michael Schwab	1-888001-96-8	$60.00		
The Illustrated Voice (Craig Frazier)	1-932026-08-8	$40.00		
12 Japanese Masters (Maggie Kinser Saiki)	1-931241-08-2	$60.00		
ADVERTISING TITLES				
Advertising Annual 2004	1-931241-34-1	$70.00		
Advertising Annual 2003	1-931241-14-7	$70.00		
What's a Saatchi ... ? (Tom Jordan)	1-932026-02-9	$45.00		
PHOTO TITLES				
Bird Hand Book (Victor Schrager, A.S. Byatt)	1-931241-04-X	$60.00		
Flora	1-931241-09-0	$40.00		
Jayne Hinds Bidaut: Tintypes	1-888001-79-8	$60.00		
Night Chicas (Hans Neleman)	1-932026-05-3	$50.00		
Nudes 1	3-857094-35-4	$70.00		
Nudes 1 (paperback)	0-8230-6459-X	$40.00		
Nudes 3	1-888001-66-6	$70.00		
Photo Annual 2004	1-931241-33-3	$70.00		
Photo Annual 2003	1-931241-16-3	$70.00		
Photo Annual 2002	1-931241-03-1	$70.00		
Sporting Life (Walter Iooss)	1-932026-00-2	$35.00		
OTHER GRAPHIS TITLES				
Prayers For Peace	1-932026-04-5	$15.00		
Something to be Desired (Veronique Vienne)	1-888001-76-3	$15.00		
Shipping & Handling (See Instructions on Right)				
New York State Shipments add 8.25% tax				
ORDER TOTAL				

Method of Payment: Orders payable in US dollars to Graphis

☐ AMEX ☐ Visa ☐ MC ☐ Check/Money Order Enclosed

Card # _____ Exp Date _____

Cardholder's name _____ Telephone # _____ Fax # _____

Cardholder's signature _____ Email Address _____

Ordered By:
Customer Number (found on the back cover) _____ BKST

Name _____ Title _____

Company _____

Street Address _____

City _____ State _____ Zip _____

Telephone # _____ Email Address _____

ORDERING INFORMATION

By Telephone in the US, call
1-800-209-4234

By Telephone outside the US, call
+1-412-741-3679

Hours: Monday through Friday,
9 am to 5 pm EST

By Fax
Fax completed form with
credit card information to:
+1-412-741-0934

By Post
Mail completed order form
with payment to:
Graphis
c/o ABDI
P.O. Box 1020
Sewickly, PA 15143-1020

By email
graphisorders@abdiintl.com
Or visit **www.graphis.com**.

PAYMENT METHODS
By Credit Card
American Express, Mastercard
and Visa accepted. All orders
are debited in US Dollars.
By Check or Money Order
Please make check payable to Graphis.
Check must be payable in US Dollars
and be drawn on a US bank. International Money
Orders are accepted in US Dollars.
We are sorry, but all orders
require prepayment.

MISCELLANEOUS
Delivery Information
All orders are packed and shipped within two
business days of receipt. Please allow 5-7
business days for US continental delivery.
Call for international delivery, express service,
surcharge handling and shipping fees apply.
Shipping & Handling Expenses

Country	First Book	Additional Books
USA	$8	$3 per book
Canada	$15	$5 per book
International	$25	$15 per book

Advance Orders
An order placed for a book in advance of its
publication will be billed to the customer's
credit card upon the book's release.

BOOKSTORES AND WHOLESALERS
Ordering Policies
Pre-payment is required for any bookstore
order under $500.00, not including shipping
and handling (S&H).
Authorized purchase orders are accepted for any
bookstore order over $500.00, not including S&H.
Payment is net 90 days.
Orders will be shipped either prepaid traceable
freight or UPS, depending upon the order and
which is more reasonable. The customer will be
billed the actual shipping charges PLUS a $10.00
handling fee. If the customer uses their own ac-
count number for shipping, there will be no ship-
ping fee, however, the $10.00 handling fee will
still be charged to the order.
Discount Schedule

01 – 04 books	25%	050 – 099 books	43%
05 – 24 books	40%	100 – 249 books	44%
25 – 49 books	42%	250 or more books	45%

Products are returnable within 90 days of the
original purchase (order) date only if the books
are received in excellent, resalable condition.
Items that are shop-worn or received damaged
due to improper packing, etc., will not be credited.
If requested, the damaged returned items will be
sent back at the sender's expense.
- When returning products, a copy of the original
packing slip or the original Graphis order numbers
must be included with the returned items to allow
for proper crediting to the bookstore's account.
- A credit of the purchase price of the returned
items, excluding S&H, will be applied to the book-
store's account.
- The bookstore must pay return shipping charges.

Thank you for your order. Visit us at www.graphis.com

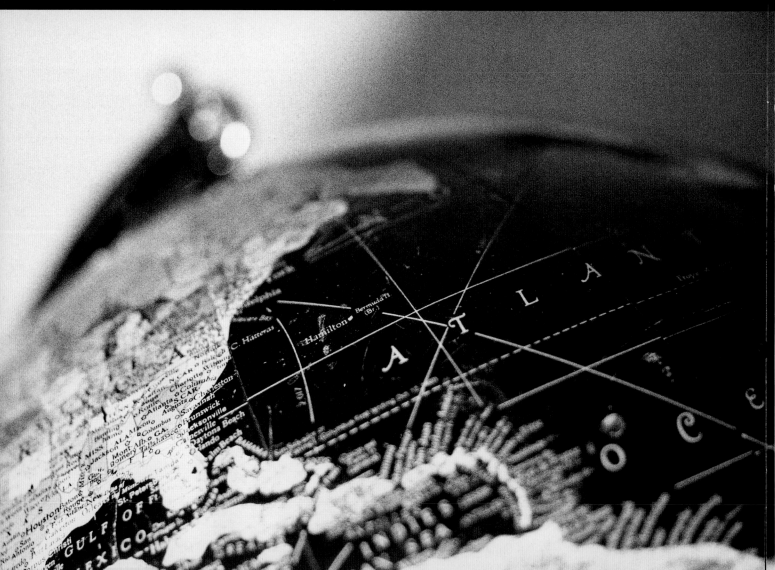